SHOOTER

COMBAT FROM BEHIND THE CAMERA

STACY PEARSALL

With words by Stacy Pearsall and Ellie Maas Davis

LYONS PRESS

Guilford, Connecticut
An imprint of Globe Pequot Press

Lyons Press is an imprint of Globe Pequot Press.

Project editor: Meredith Dias
Layout artist: Maggie Peterson

Library of Congress Cataloging-in-Publication Data

Pearsall, Stacy.
 Shooter : a woman's journey in combat from behind the camera / Stacy Pearsall ; with words by Stacy Pearsall and Ellie Maas Davis.
 p. cm.
 ISBN 978-0-7627-8018-1
 1. Pearsall, Stacy. 2. Iraq War, 2003—Pictorial works. 3. War photographers—United States—Biography. 4. United States. Air Force. Combat Camera Squadron—Biography. 5. United States. Air Force—Women—Biography. 6. Airmen—United States—Biography. 7. Iraq War, 2003—Personal narratives. I. Davis, Ellie Maas. II. Title.
 DS79.762.P43 2012
 956.7044'348092—dc23
 2012004685

Printed in China

10 9 8 7 6 5 4 3 2 1

This book is dedicated to my husband, Andy Dunaway. My better half, who has encouraged, coaxed, and supported my long journey to publication. You should be proud, honey—I didn't use the f-word once.

CONTENTS

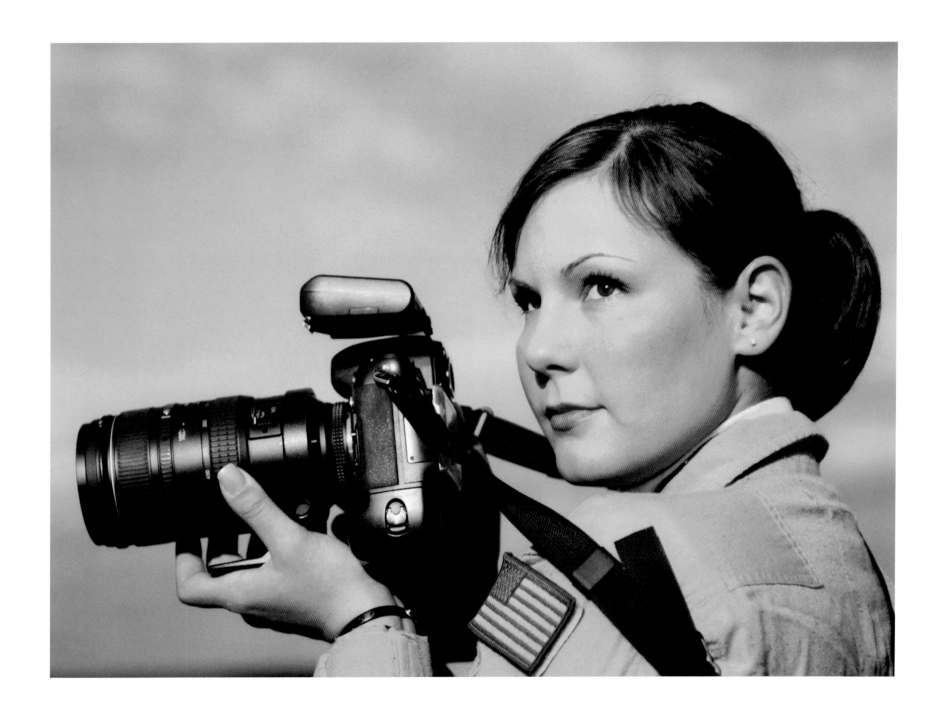

SELF (IDENTITY)

A self-portrait

Being an Airman, a woman, and a photographer gives me a triad of military challenges. Although the war in Iraq has blurred the lines that once separated the branches of the military, sibling rivalry remains. It's not that other soldiers don't like me as a person. It's that they don't like what my job represents: voyeur and outsider, someone who's there to capture the final moments of life and forever etch the face of death on record. This is only compounded by the fact that I am a woman and that most Army personnel believe anyone from any other branch of service lacks the tenacity to see the fight through to the end.

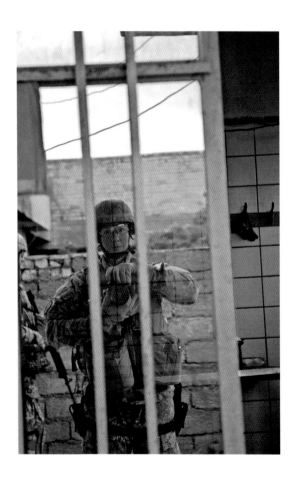 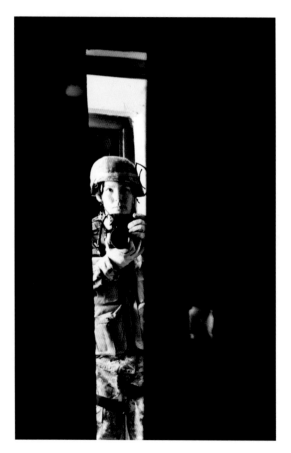 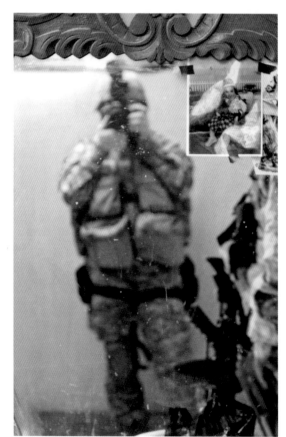

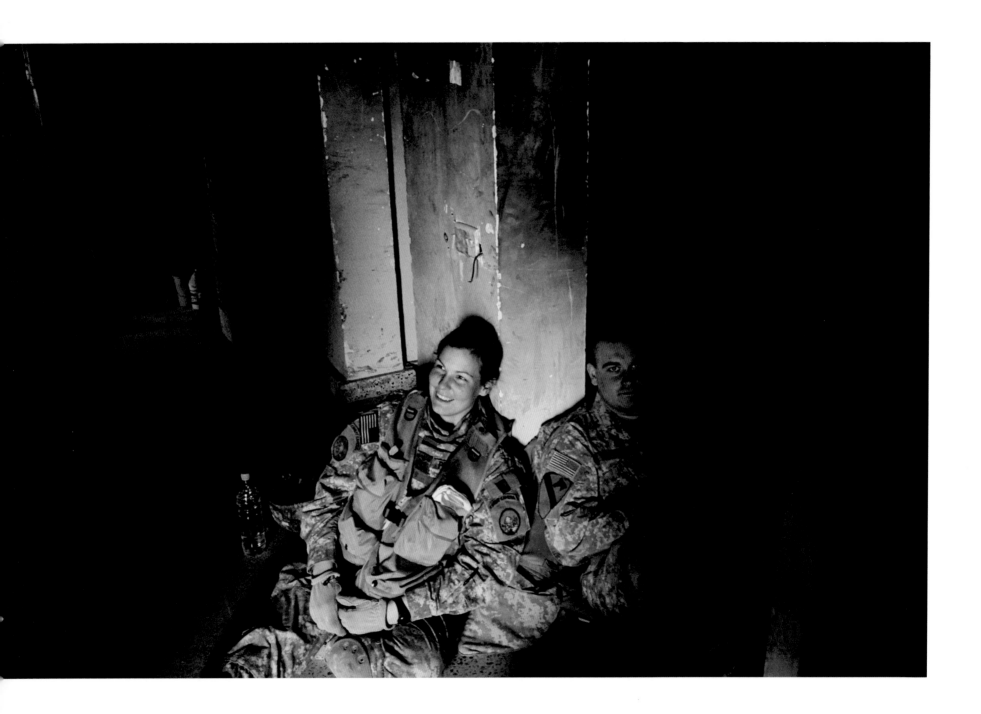

ATTACHED, NOT ASSIGNED

Due to a long-standing US military policy, women are not allowed to serve in direct ground combat roles. However, women are permitted to serve in support units during combat, which is how I slipped through the loophole and onto the frontlines of the Iraq War.

As a combat photographer with the US Air Force, I've photographed some of the most desolate places on earth. With camera in hand, I've documented water wells being drilled in Eritrea and Kenya, elementary schools being built near Baghdad, Iraq, and Djibouti City, Djibouti, as well as Special Forces' efforts to track down terrorist training cells on the borders of Somalia and Ethiopia. Until my third deployment in 2007, to Diyala Province, Iraq, I'd never actually seen face-to-face combat, though it's undoubtedly what the Air Force trained me to do. Don't get me wrong: I'm a wife, I'm a sister, I'm a daughter, and I'm a friend. But above everything else that defines me, I'm an Airman. I carry a gun, but my real weapon is my camera.

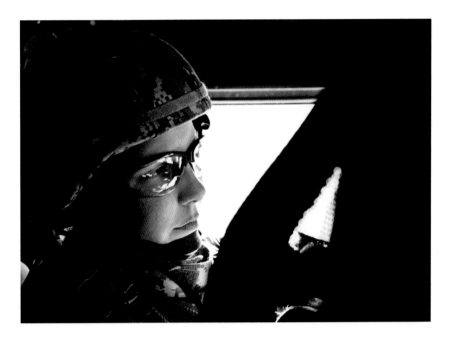
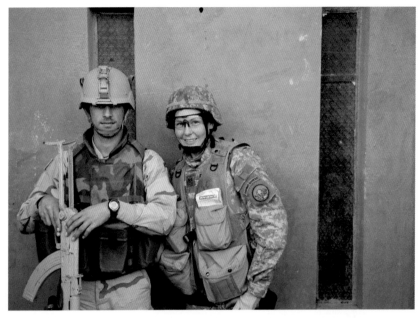
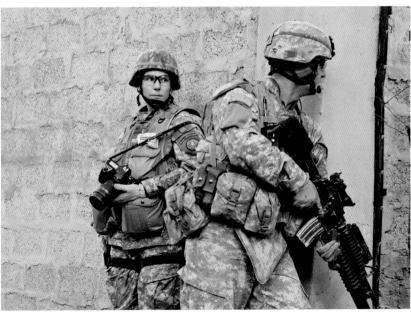
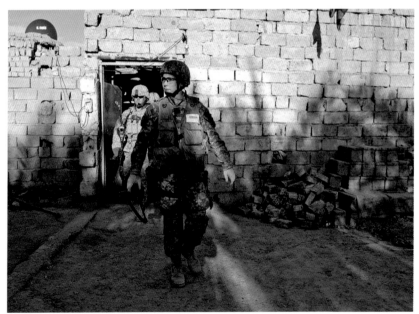

I come from a deeply rooted military family. On the maternal side, my great-grandfather served as a Marine in World War I. His son survived the attack on Pearl Harbor. Two of my mother's brothers both served in the Air Force, and some of their sons serve. My paternal grandfather served in the Army, and he had three sons who enlisted. Each son served in a different branch: one in the Army, another in the Marine Corps, and my father, who was in the Navy. Joining the military was something nearly every male in my family did—that is, until 1997 when my sister became the first active duty A-10 crew chief in Air Force history.

In 1948, both of my grandfathers observed, as the rest of America did, the Department of Defense's (DOD) official integration of women into military service. It was clear that Congress would not allow women into any occupation that brought them remotely near combat. Around the time of my dad's service as an air traffic controller for the Navy, bans on women piloting fighter aircraft and serving aboard combatant ships were lifted. The DOD adopted the Risk Rule to help determine whether jobs women might potentially occupy put them near direct combat and whether the risk was worth the reward for the combat units they supported. Each branch, including the Air Force, used the risk assessment tool to determine whether a job should or shouldn't be open to women. This included photography.

Around the time I signed my enlistment papers in late 1997, politicians and key military leaders realized there wasn't a single place in a theater of war that wasn't hazardous, and thus, no job was safe. Consequently, any job a woman was qualified to occupy was opened to her—with one caveat. Women were still excluded from assignments involving direct combat, such as infantry, artillery, and Special Forces. This left 221,000 of the DOD's 1.4 million positions closed to women.

The DOD's definition of direct ground combat includes a statement that ground combat forces are "well forward on the battlefield." As a female combat photographer, I could not be *assigned* to any infantry unit because they are considered a combat unit. However, I could be *attached* to them as a supportive unit under Joint Combat Camera Deployed and join them on operations that way. It's a matter of being attached rather than assigned.

That's how, in 2007, I ended up on Forward Operating Base Warhorse in Diyala Province, Iraq, located just outside the city of Baqubah. I augmented Army Combat Camera and attached to the 1st Calvary, 12th Infantry Regiment for the sole purpose of photographing combat operations. In combat, I was never isolated from male soldiers, and they never made me feel inferior because I was a woman. In fact, I often felt they forgot I was a female; it didn't seem to matter. I had a job to do, and so did they. I made lifelong friends, whom I consider to be my brothers for life. I believe they feel the same.

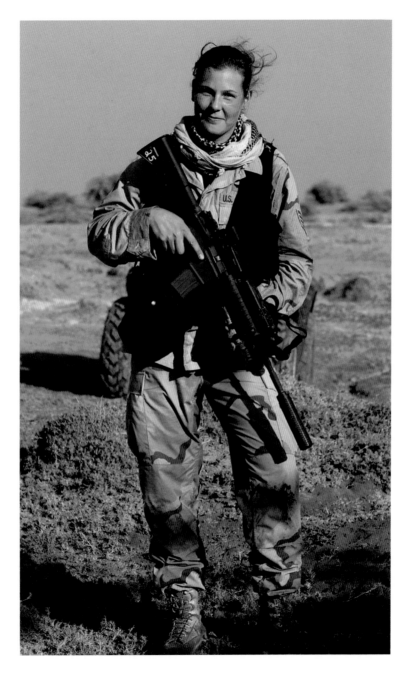

Toting eighty pounds of gear is a normal day. Between my body armor, Kevlar helmet, combat load of ammunition, weapon, camera, spare camera, camera batteries, two lenses, flash cards, water, and food, the weight adds up quickly. When the mission lasts several days, I bring my sleeping bag, underwear, T-shirts, socks, and baby wipes. Some of the guys don't bother with a stash of clean undies, but as a woman, I don't risk it.

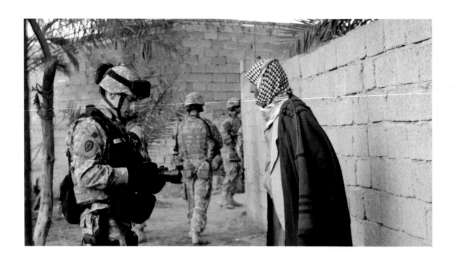 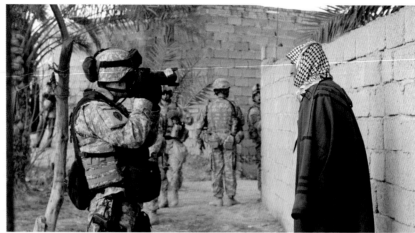

BUCKETS

I imagine the majority of troops serving in Iraq enjoy some amount of peace knowing their spouse is stateside, but besides being an Airman, I married one: Master Sergeant Andrew N. Dunaway II. So, really, what I left behind wasn't nearly as sacred as what I brought with me.

Years before we were married, Andy and I knew one another professionally. Back then, I called him Andy Funaway. He can be one serious dude. He's certainly not someone who discusses fate, destiny, providence, or chance at length. He's a good man with a level head and an eye for detail. To him, an Airman's bucket, which is what career military folks call their shifts of deployment during times of war, is his or her bucket. It's as simple as that, and to deviate from the military's plan is to invite trouble.

We were certain I'd have my third deployment at some point, probably at about five months out, but I took an earlier bucket upon the request of Katie, a videographer I'd become friends with over the past year. My husband Andy was none too keen on switching up any unscheduled deployment, but once Katie convinced me, I, in turn, persuaded him. We three would leave together, and God willing, we'd return together. Perhaps we toyed with what was meant to be, but the world's a complicated place. Who's to say now what might have been, or whether, had we waited for our rightful bucketed turn, Katie and I might not have been wounded.

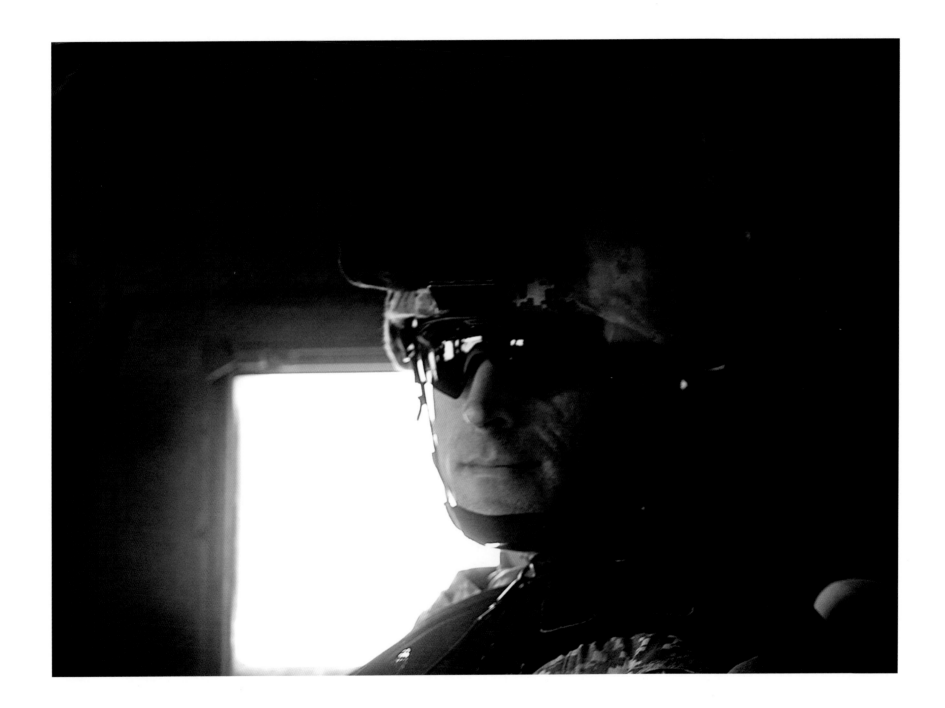

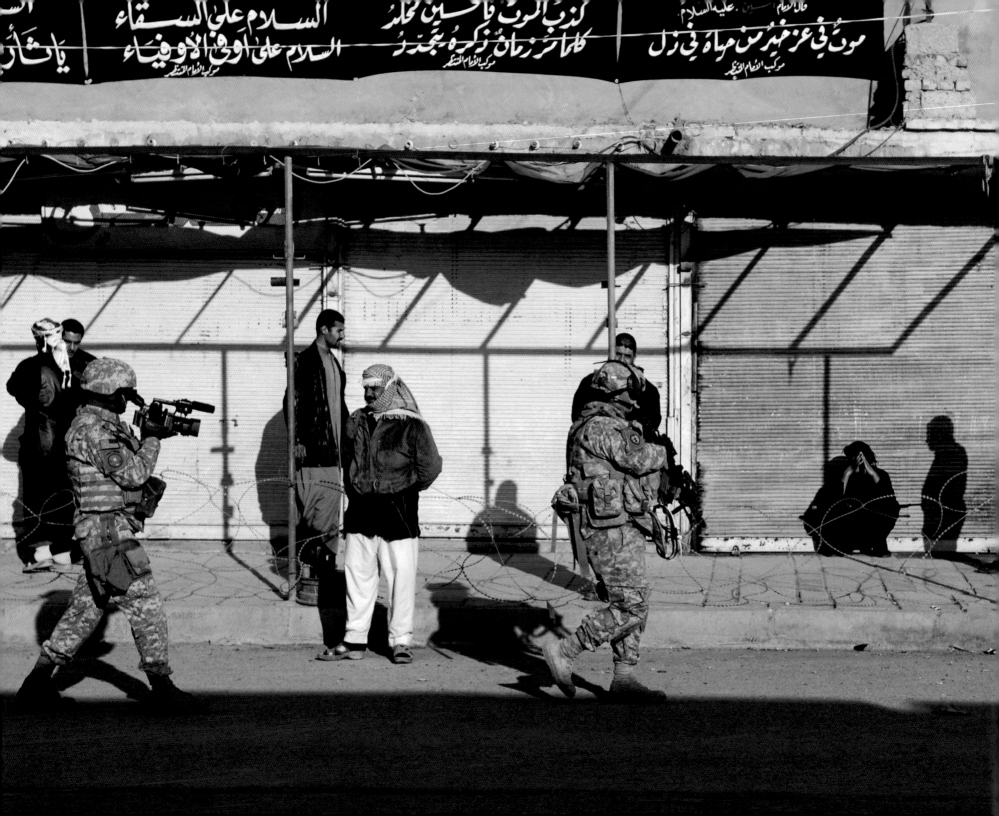

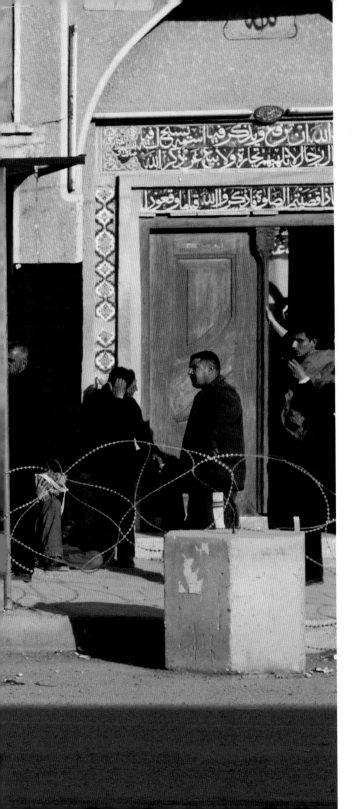

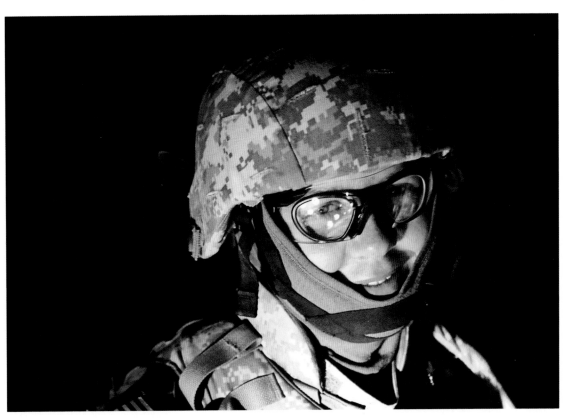

When it comes to combat imagery, a photographer and videographer normally work as a team. During a combat deployment in support of Operation Enduring Freedom 2005 and 2006, I worked with Staff Sergeant Kathryn "Katie" Robinson. We first met on the Navy base in Virginia while waiting for a flight to the Republic of Djibouti, a Muslim country in the Horn of Africa. She'd been on the pay phone making her last call home before the long journey. I had rolled my eyes. Some career Air Force men and women are of the opinion that those in the Reserve Air Force don't have as good a work ethic as those on active duty; at the time, I happened to be one of them. Over the next five months, Katie and I traveled to Kenya and Ethiopia documenting relief missions—she with video, I with still photography. A friendship flourished between us, and she changed my mind about our Air Force Reserve component.

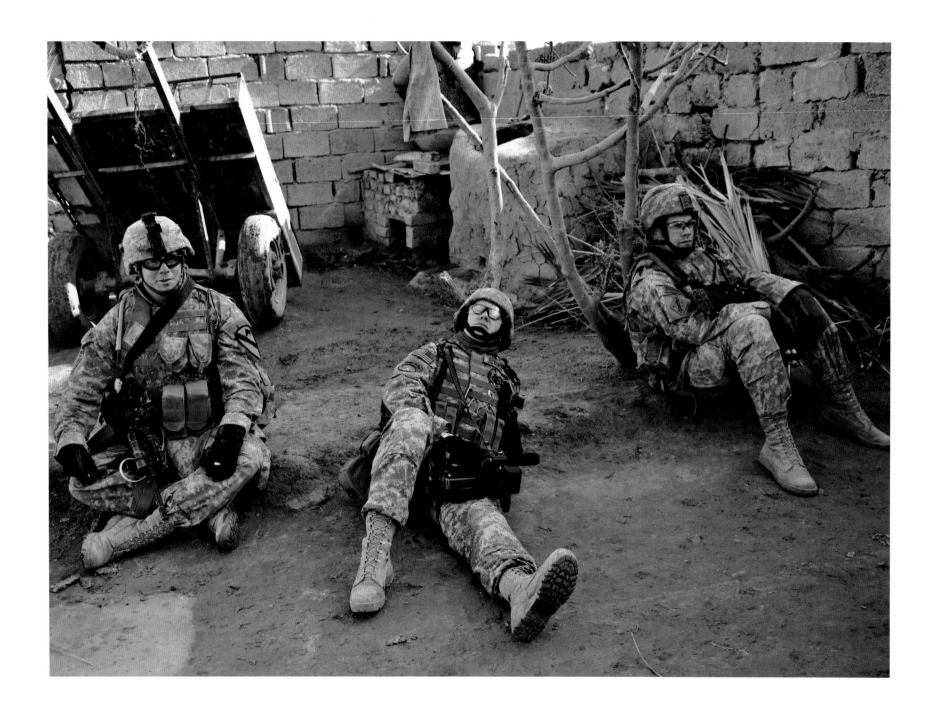

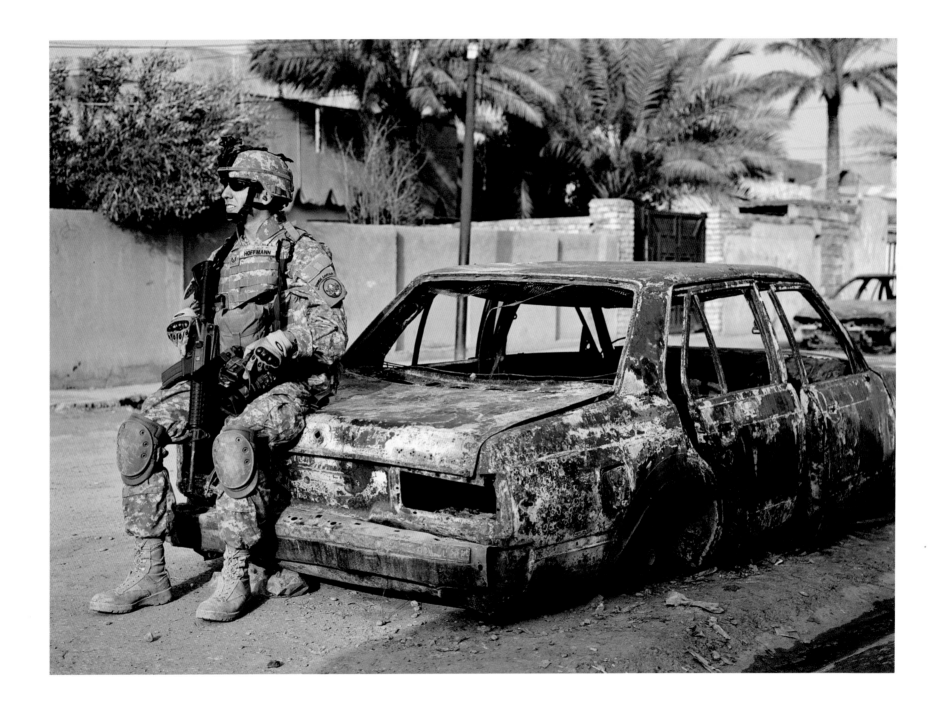

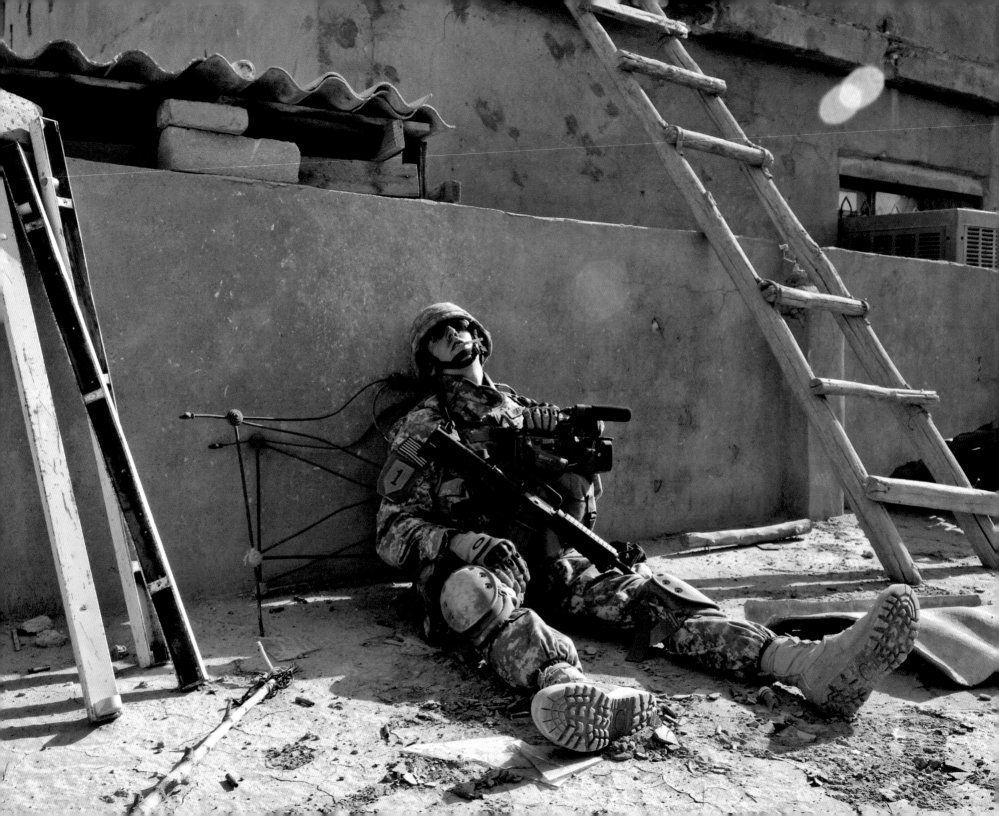

COMBAT CAMERA

Part of my responsibility as a military combat photographer is to bring the war to the American people. I also gather images that help inform the President, Secretary of Defense, Joint Chiefs of Staff, battlefield commanders, and war fighters. Another facet of my job is to gather photographic intelligence and record the war for historical preservation.

Of the thousand plus images you take a day as a combat photographer, you cut it down to the fifteen to twenty best images to send up to the satellite and across the ocean. Before you upload them, you type up the metadata—who's in the image, where it's taken, what happened: all the reporter questions. You rarely hear back from the other side. When you do, though, it can be sweet: "Three of your photographs are on the President's desk today, Sergeant Pearsall." You're not allowed to edit the photos beyond what you can do in a darkroom with film. Our job is to document what happened, not rewrite it.

The other soldiers get to decompress. I, on the other hand, still have another part to my job: reliving everything that just happened, one image at a time. Selecting. Editing. Worrying. Fifteen images from a hellish stretch of time. While the soldiers grab a hot meal and some sleep, I continue to photograph them. The Pentagon relies on me to show their living conditions. However, most generals prefer to see their soldiers in action and not reading books. Afterwards, it's about looking around for trouble. Until we get accepted/invited by a unit, we'll go around knocking on doors, trying to find action. After you get to know a couple guys well enough, they call you: "We're heading out to Buhriz, want to tag along?"

It's the quiet time when soldiers begin to reflect on the lives they've left behind for this hell on Earth. I'm their vessel, their messenger, and their conduit home. Over time, the lines become blurred and I'm not just the person who takes their photographs. I'm their sister or mother figure, and in some instances, their therapist. The trusted someone outside their inner circle, in whom they can confide their deepest secrets, when they have time on their hands, when they're down.

NECESSARY RISK

The soldier's job is to engage the enemy. My job is to document the action.

Mortars explode and guns chatter, and yet there are moments on the battlefield when time stands still. On the street in New Baqubah, an ominous sky turns ginger. Sand and smoke hang in the air. I can't tell where houses end and the heavens begin. With every drop of rain, wet sand turns to red clay. I trust the soldiers I'm documenting to protect me. They rush past me as I calculate my next photograph.

Geometric lines create a silhouette of a dwelling. On the open-air top floor made of cinderblocks lies a rusted window frame with the glass broken out. Knowing I'll be blind for the second it takes to snap the shot, I put the camera to my face only when I need to. I compose each shot in my head before I take it. I consider every square inch of the frame. I use just enough building and sky to give perspective.

I decide to make a window with two large, fifty-caliber holes punched into the wall next to it my point of focus. My subject is a soldier who isn't there yet. To get my shot, I stand exposed, alone, with no protection. The soldiers who'd been my security are now clearing the house in front of me. I remain with my feet firmly planted in the sloppy earth, because I know this shot will be worth the danger, and I wait. The toll of expended brass grows louder. I check my camera settings. I don't want a lot of depth of field, so I set it to F-2.8, place my ISO on 200, and my shutter speed to 1/1000th of a second. I check and recheck my composition.

To my left and right, I see soldiers scramble from house to house. Still, I wait. It's strange. I can hear everything and see everything—yet, I don't. A calm quiet takes over. As with any job that requires concentration, my body blocks unnecessary information. Everything I don't need falls away.

Again, I look to the rooftop—still no soldier. I can hear the squad as they make their way up each flight of stairs. They'll soon be there. I position my left eye behind the viewfinder's rubber eyepiece, like blinders on a racehorse; I see only the picture I've composed—a spooky, haunting, evocative image. I refocus, compose, and set the exposure as a soldier walks out. He stands for a brief moment, gazing through the window over the horizon of Diyala Province. He's there and gone. For all the time, anticipation, and risk, in one frame at 1/1000th of a second, I capture it.

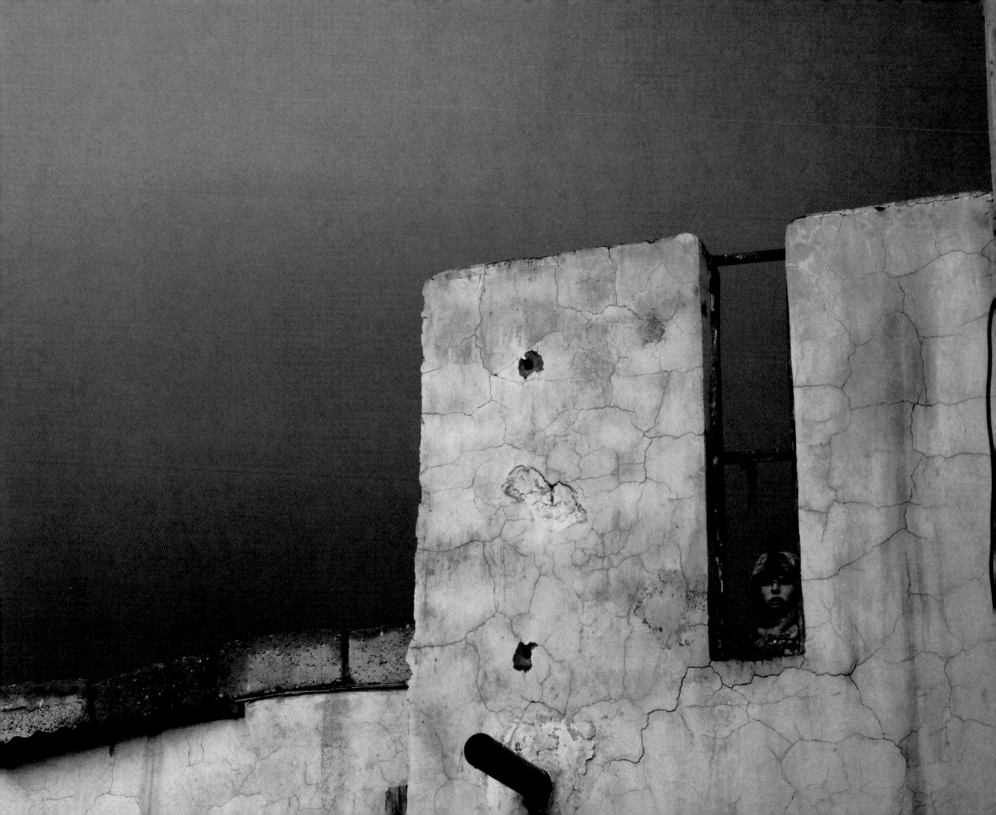

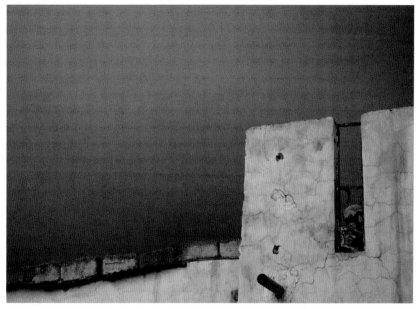

WARSCAPE

Black smoke, sand, and more sand. Sand is stone. This war has changed how I feel about the shoreline of the ocean and the sandboxes of my youth. Of all that remains of all the battles, nothing endures more than this full moon of heartache. It, too, is made of sand.

In Iraq, sand is emblazoned by sunlight. Date palms and orange trees decorate cracked earth. Mud huts and the occasional village interrupt farmland. Beauty is pretty hard to come by in such a dour place, so when you happen upon it, it shouts to you. Perhaps that's its charm.

I've done three stints in Iraq. During the months upon months that I clicked away at the "Cradle of Civilization," this place that boasts being home to the world's first written history, I'm so thankful to have had more than a pen and paper to map what I came to record. I'm eternally grateful for all the images I've captured that have left me speechless, because for me a picture isn't worth a thousand words—it's all we've got when no amount of words will do.

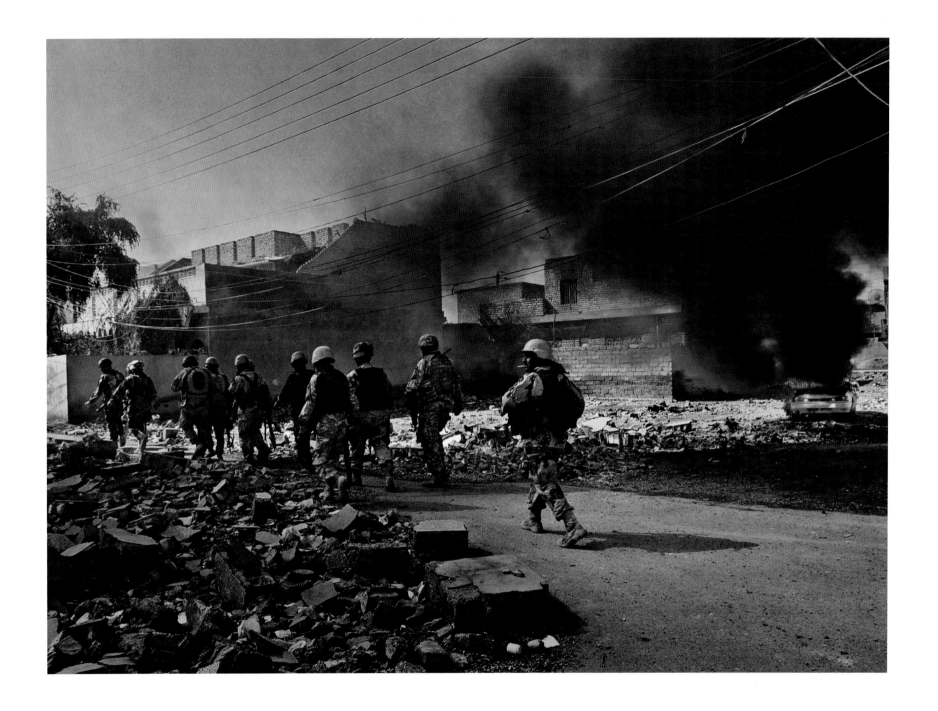

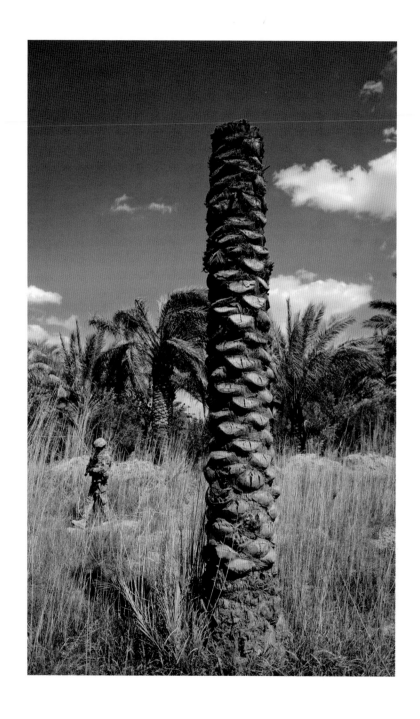

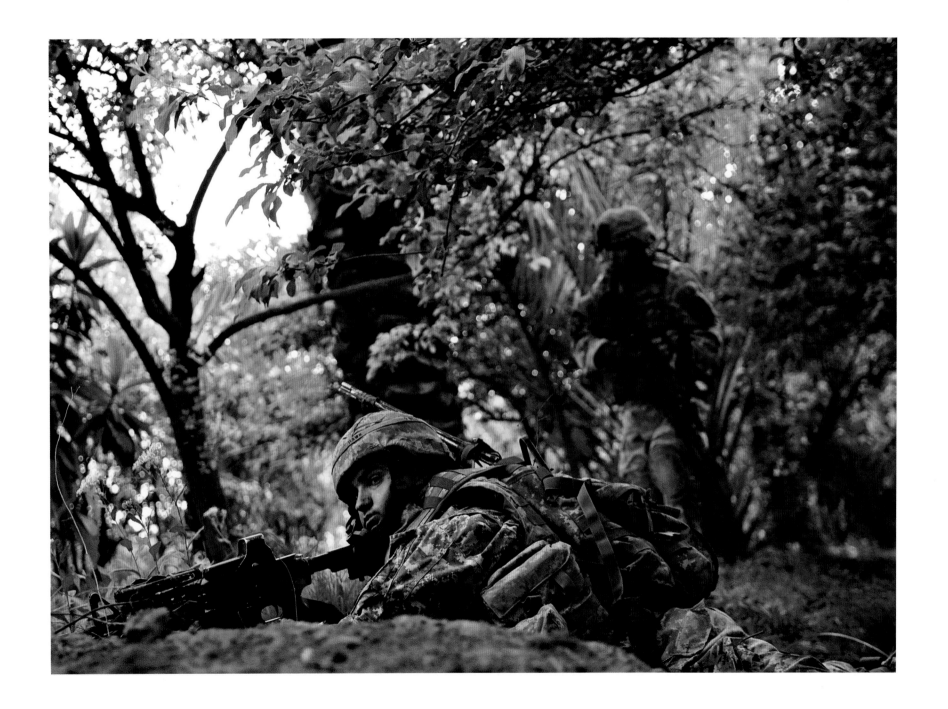

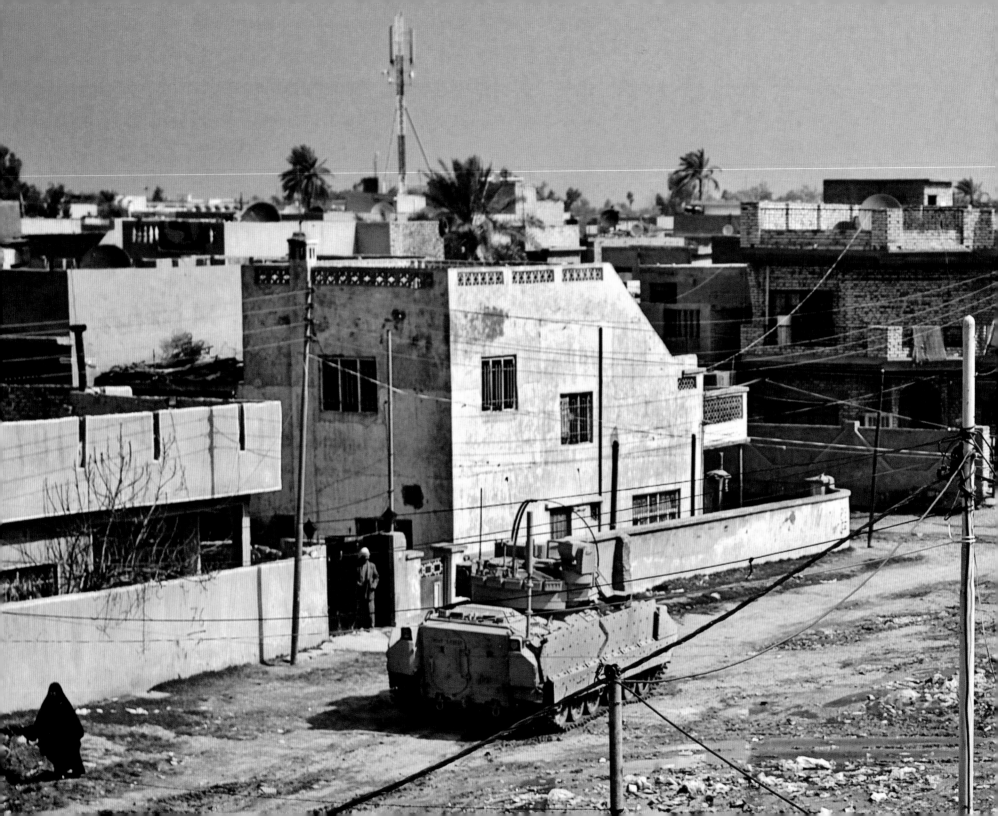

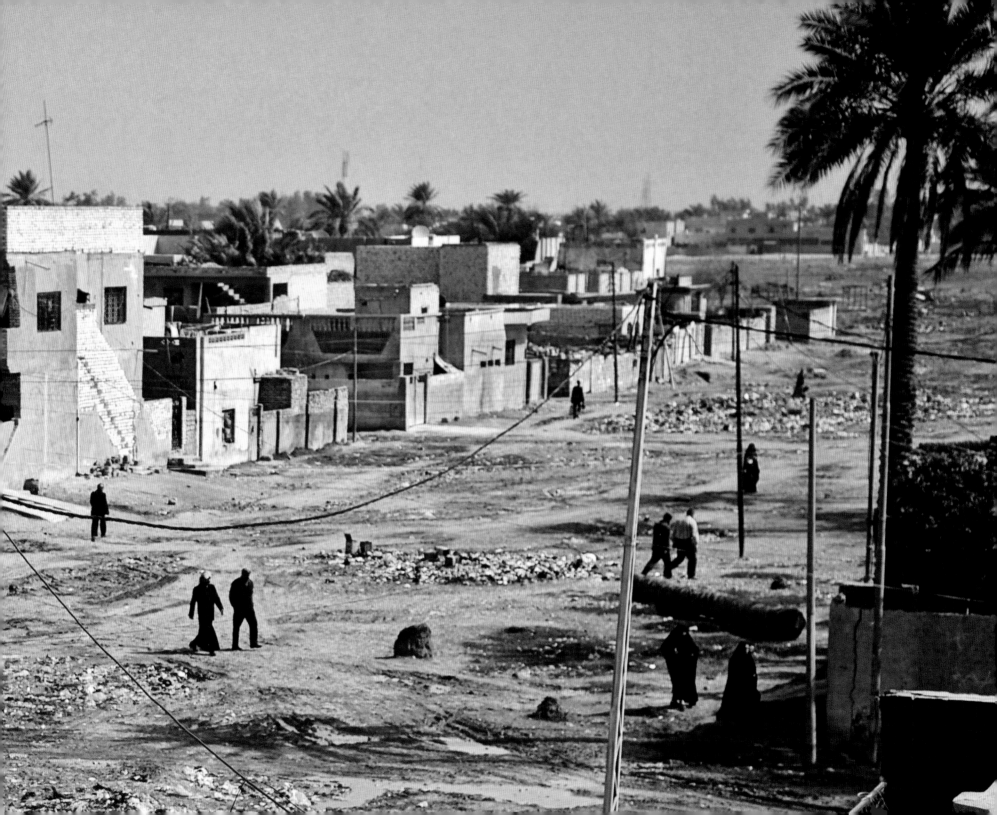

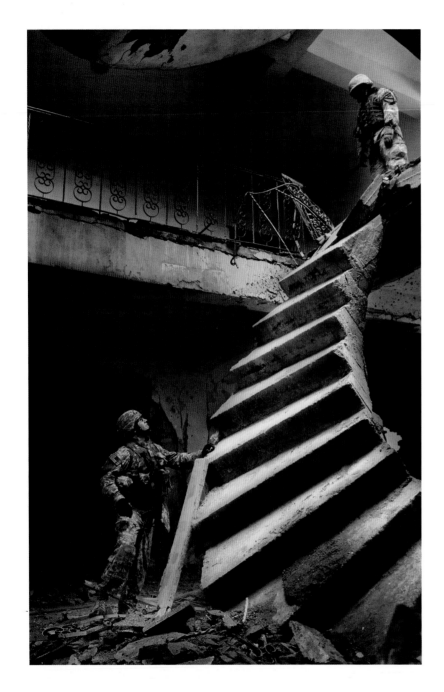

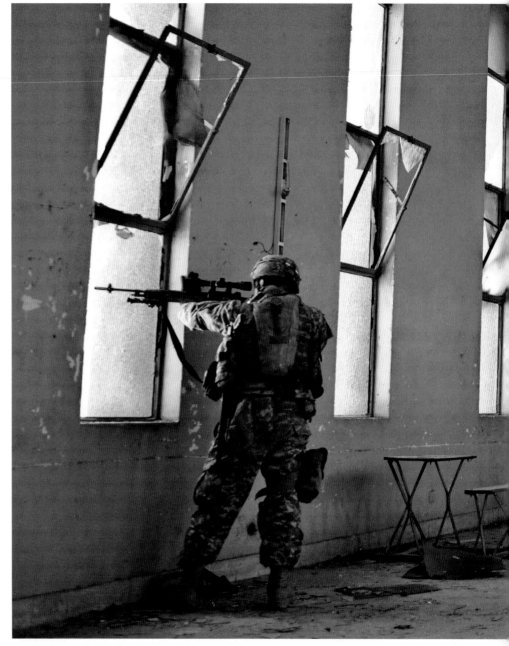

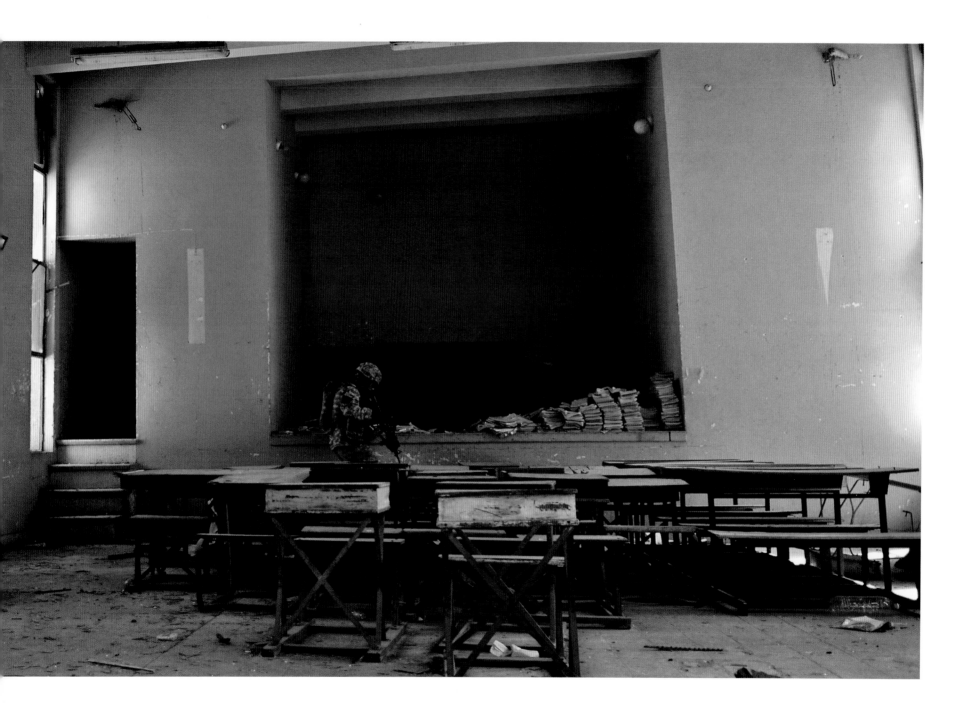

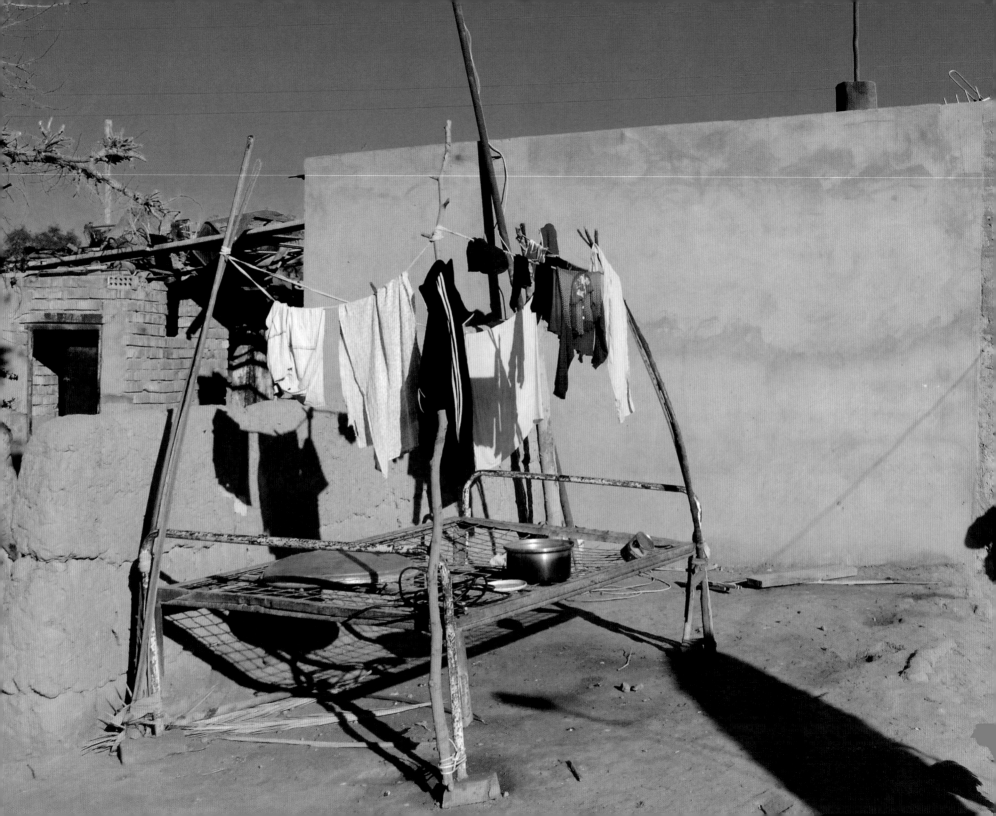

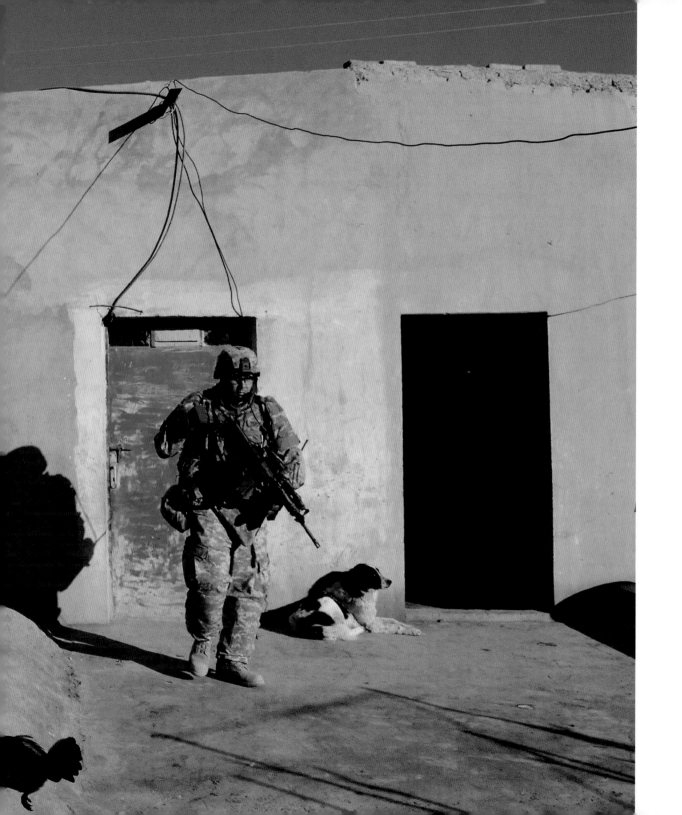

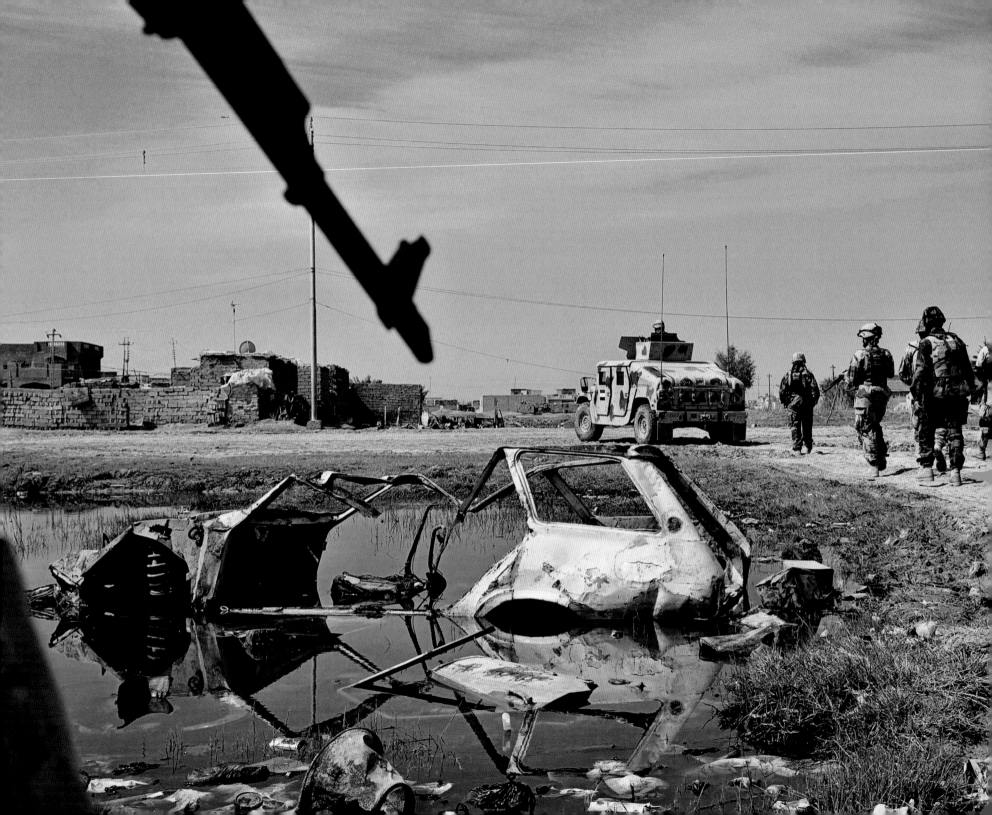

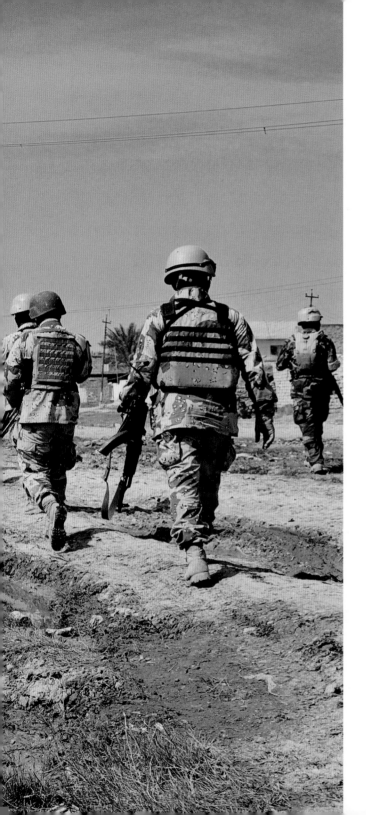

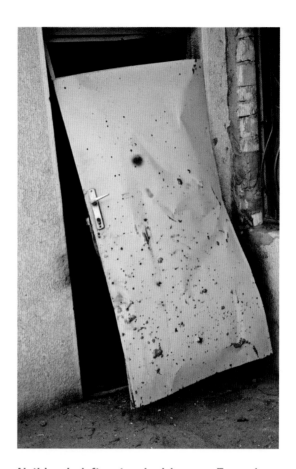

Nothing is left untouched by war. Everywhere in Baqubah, doors, walls, cars, and bodies are riddled with bullet holes. Burning skeletons of cars mar the scenery amidst heaps of trash and debris. It's what I imagine the world would look like after the apocalypse.

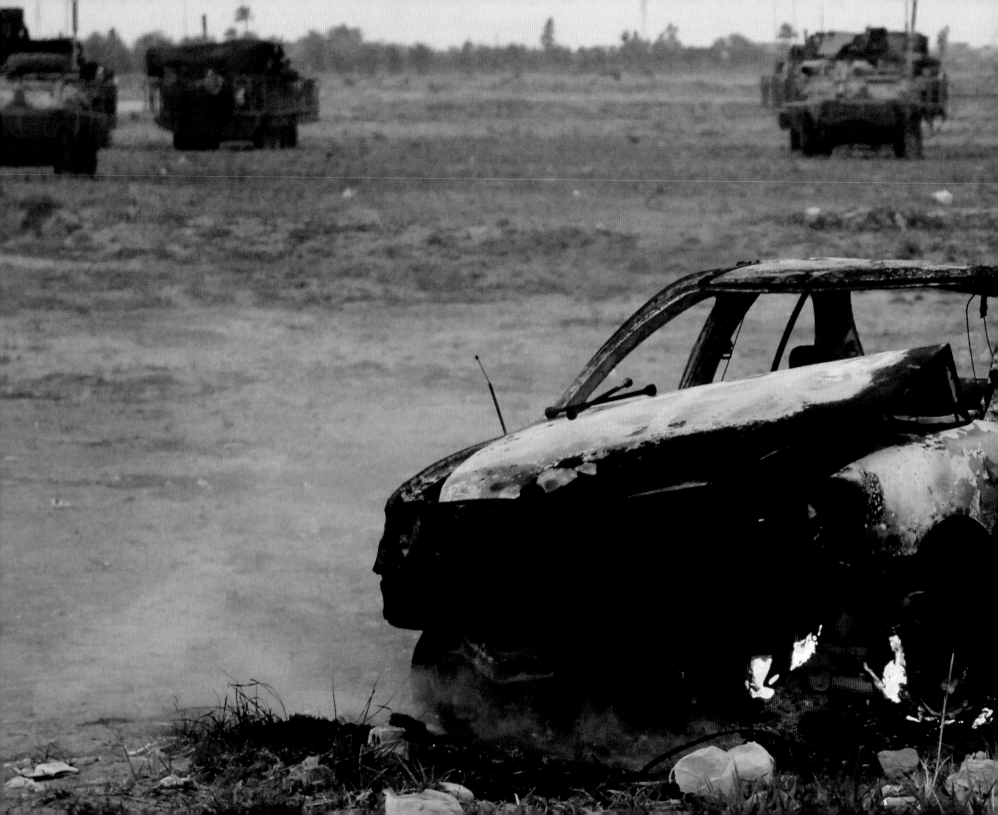

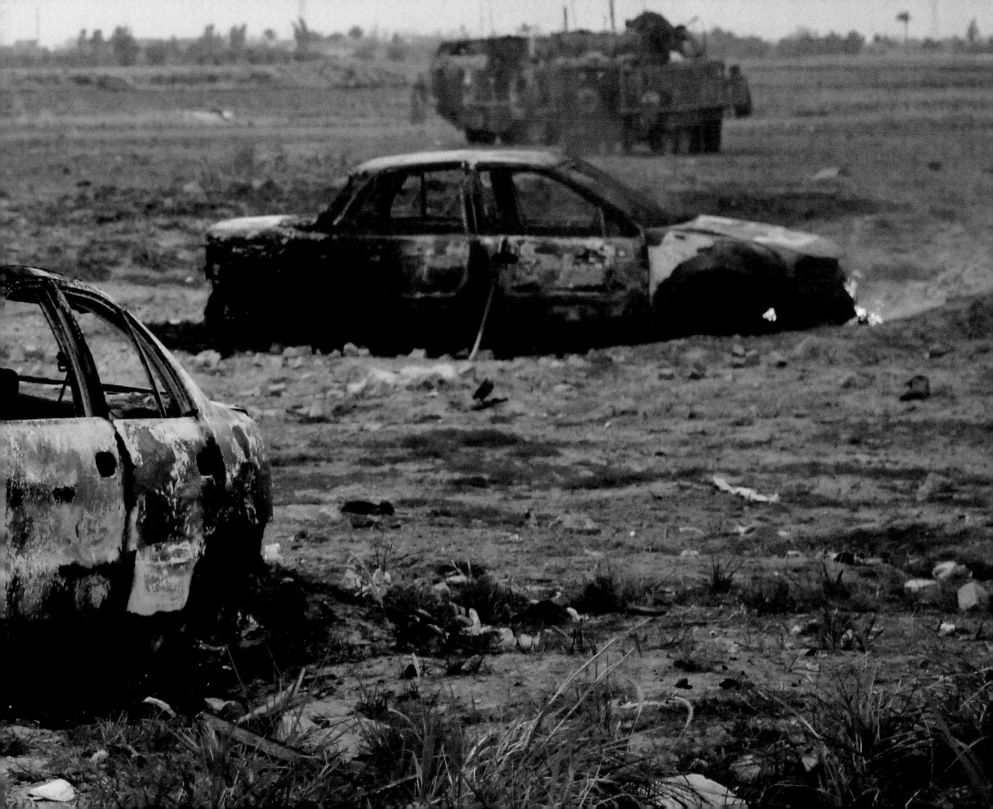

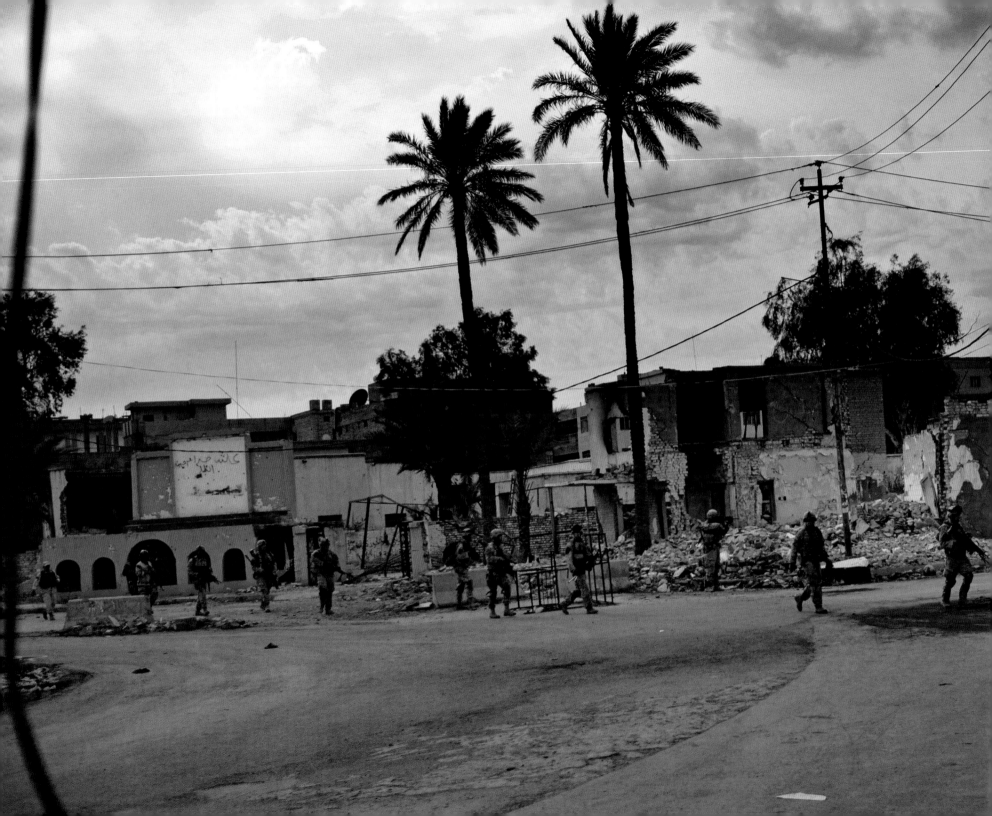

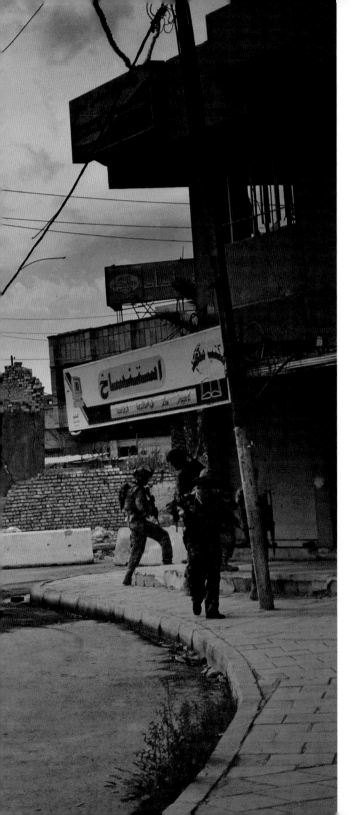

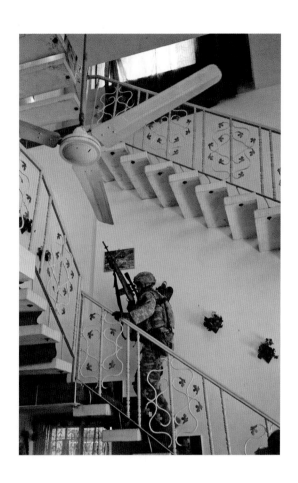

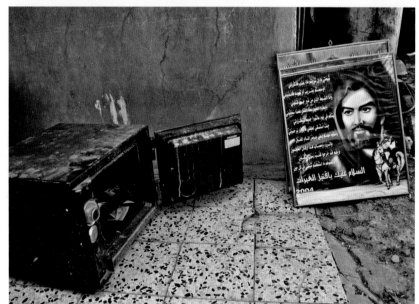

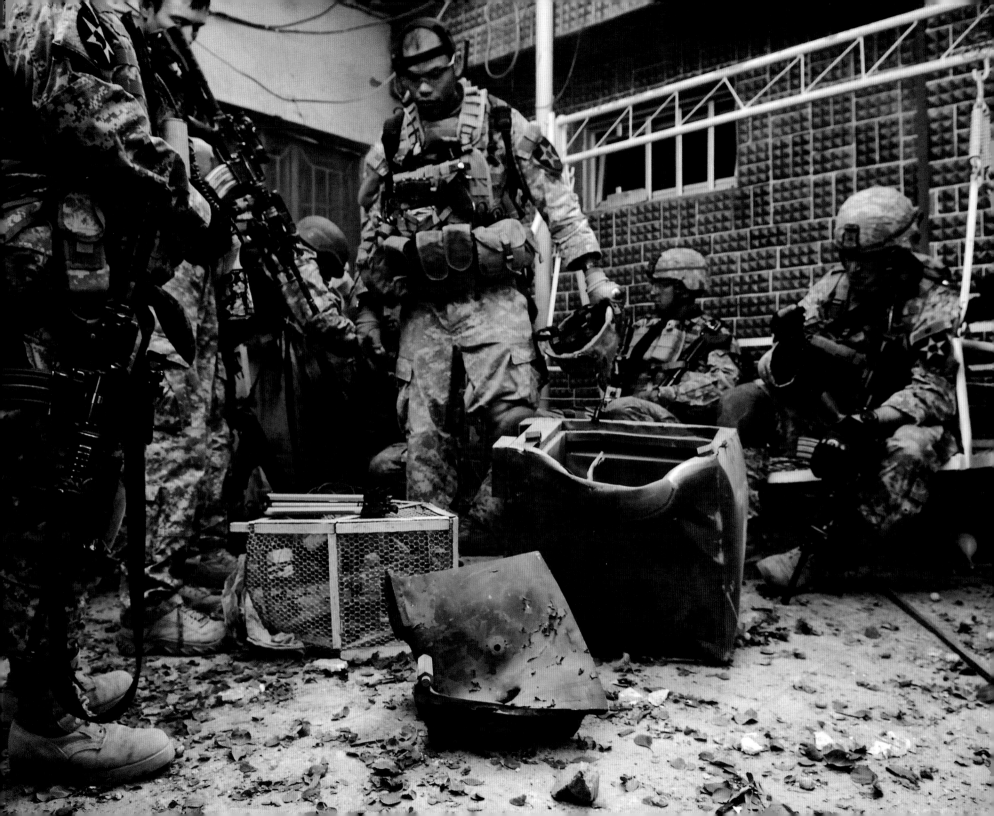

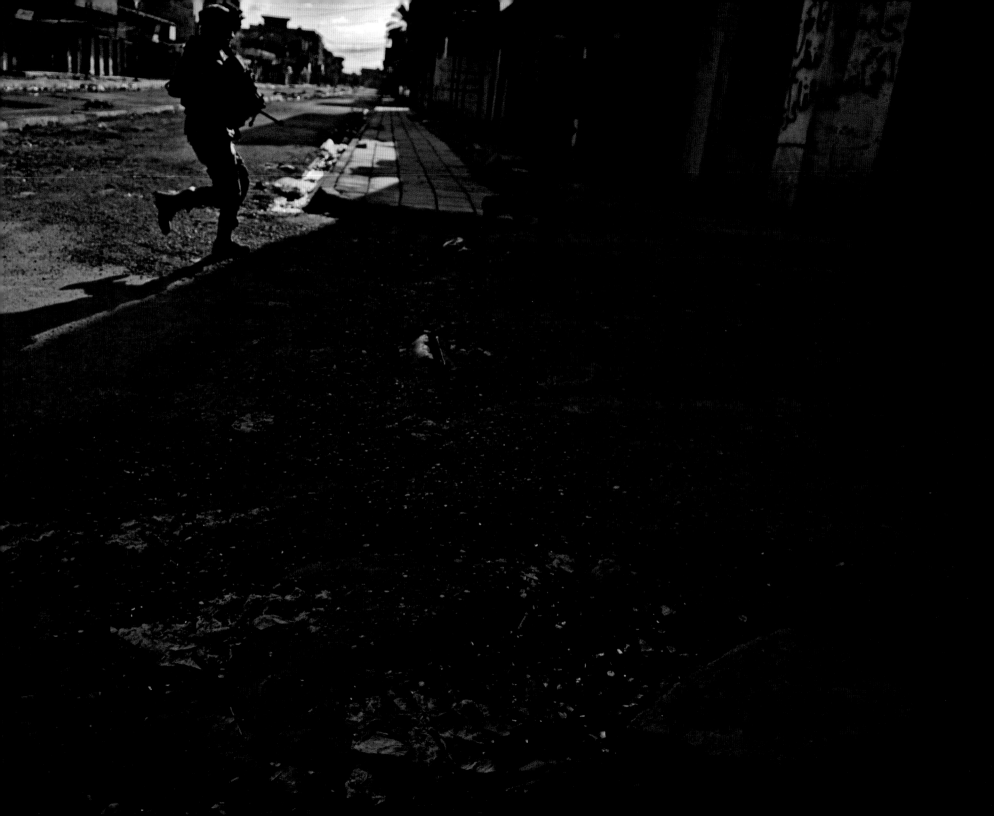

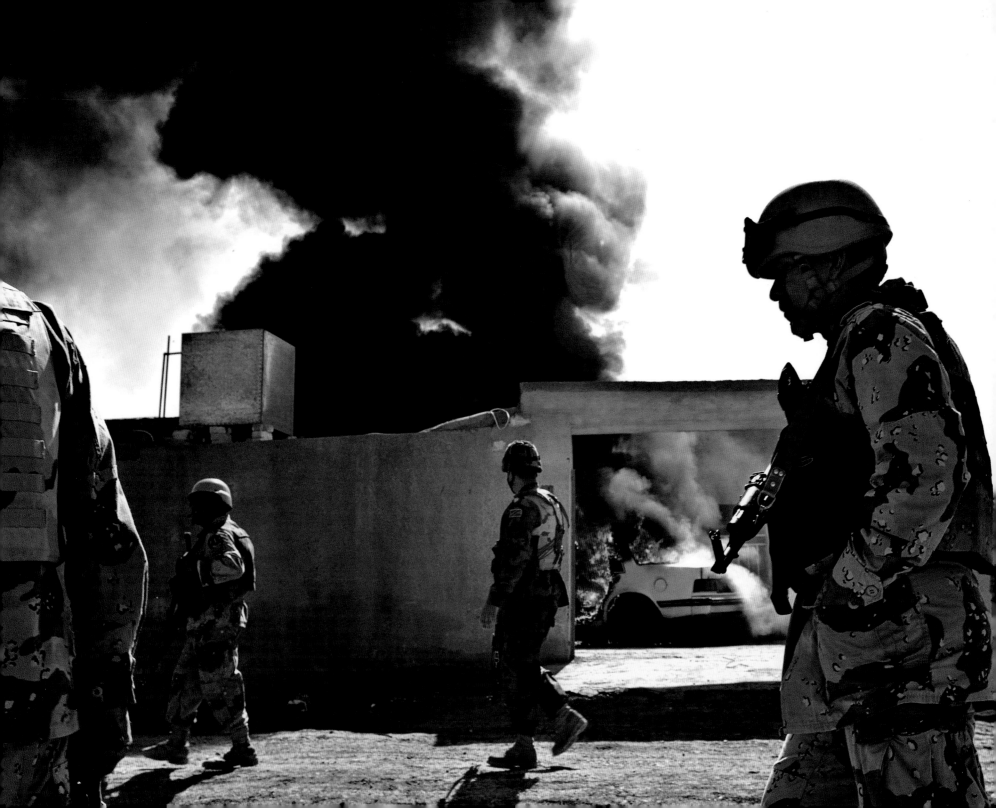

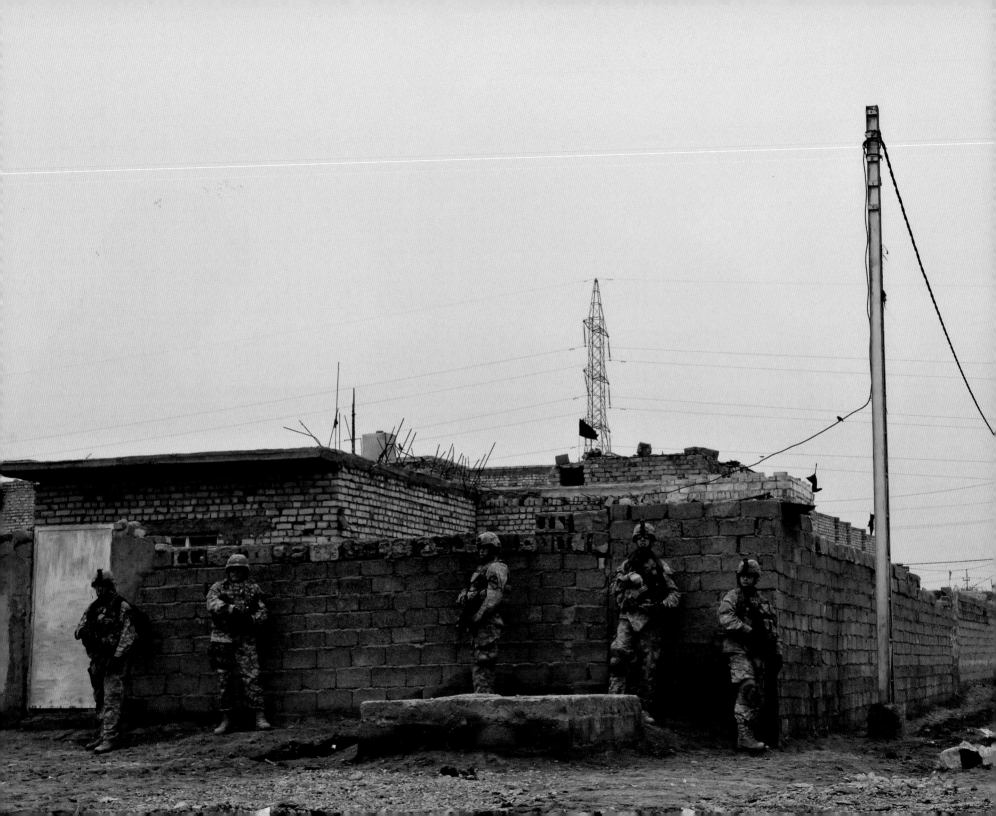

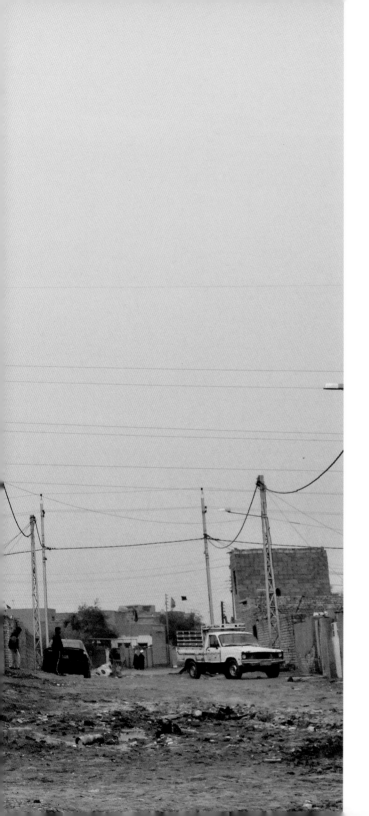

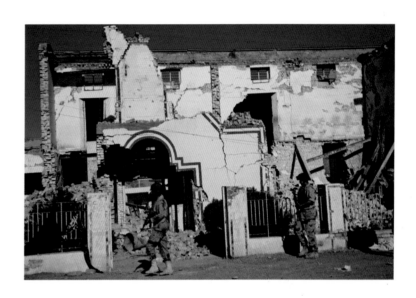

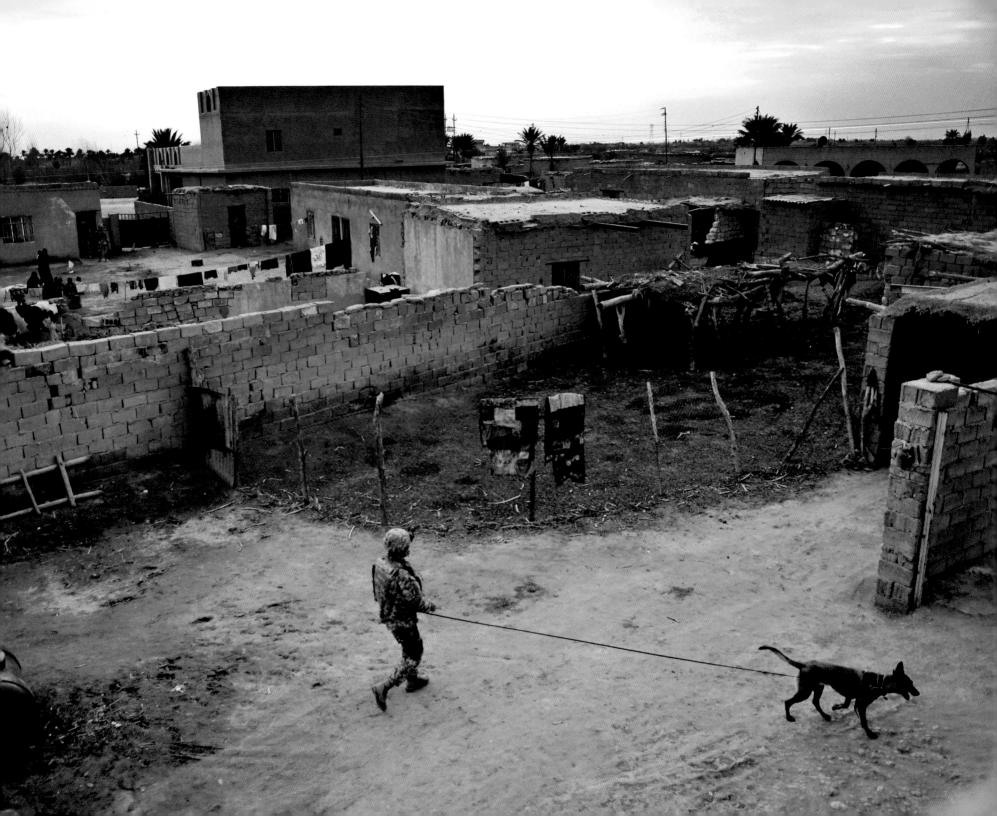

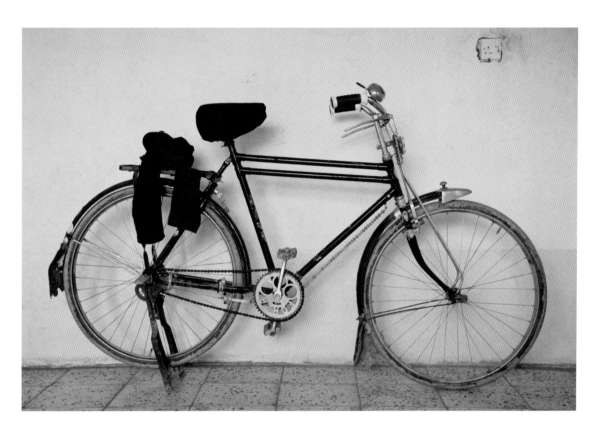

It is hard to imagine anyone enjoying a bicycle ride down the streets of Buhriz when improvised explosive devices (IEDs) lie waiting to surprise their next victims. Perhaps, though, it's more a symbol than a means of transportation—a reminder that brighter days are ahead.

Light makes the exposure, but shadows create dimension—and that's where I live, in the shadows. Some days I'm caught up in the heat of battle and light up like the sun or a muzzle flash, while others I simply stalk my subjects like a shadow to its maker.

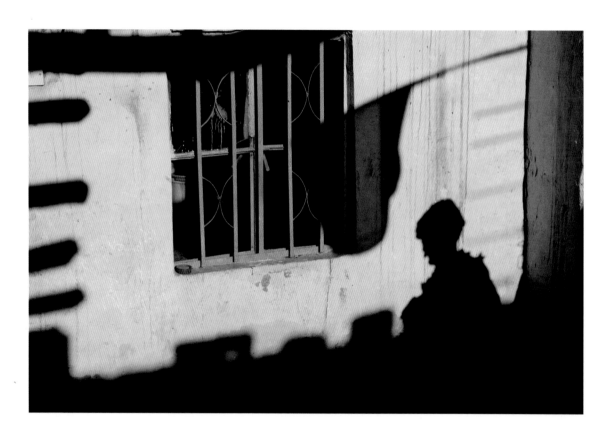

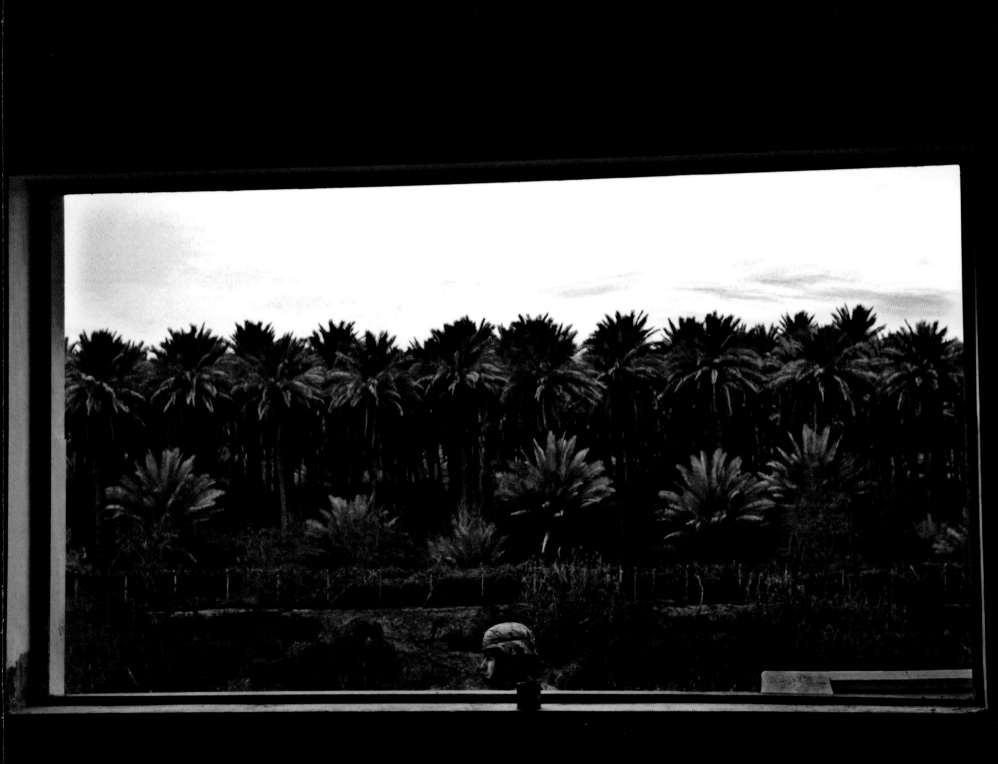

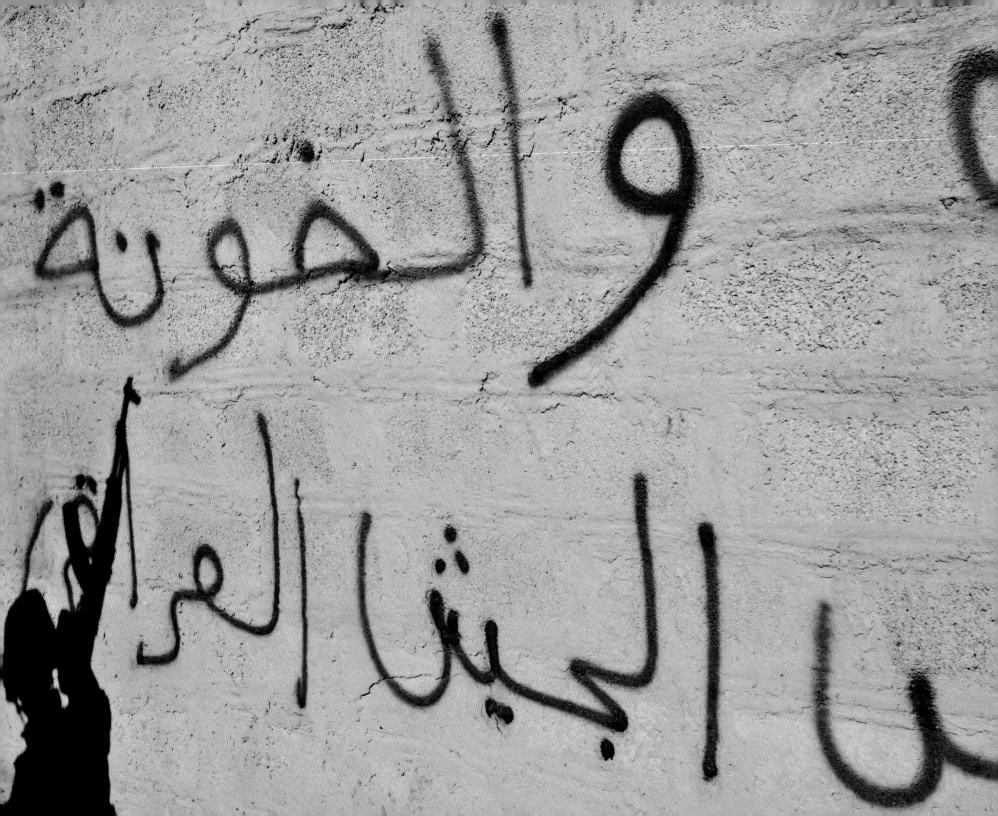

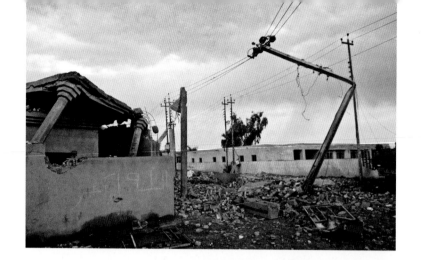

Buildings barely hold together, clutching to their last bits of mortar, and shards of glass lie below empty window frames on the houses the panes once sheltered. Shooting these bent, warped, war-ravaged objects is like walking through the real-life melting landscape of a Salvador Dali painting.

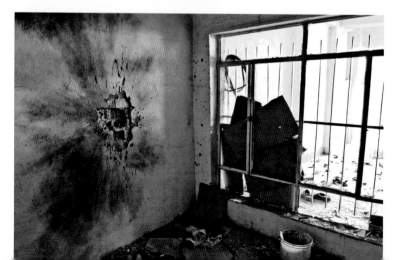

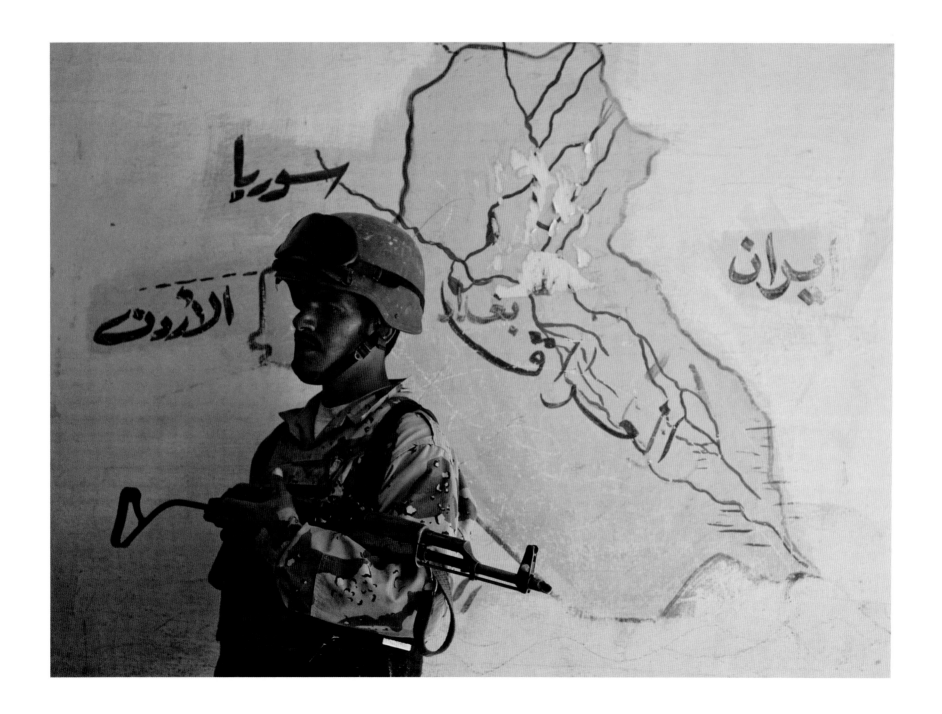

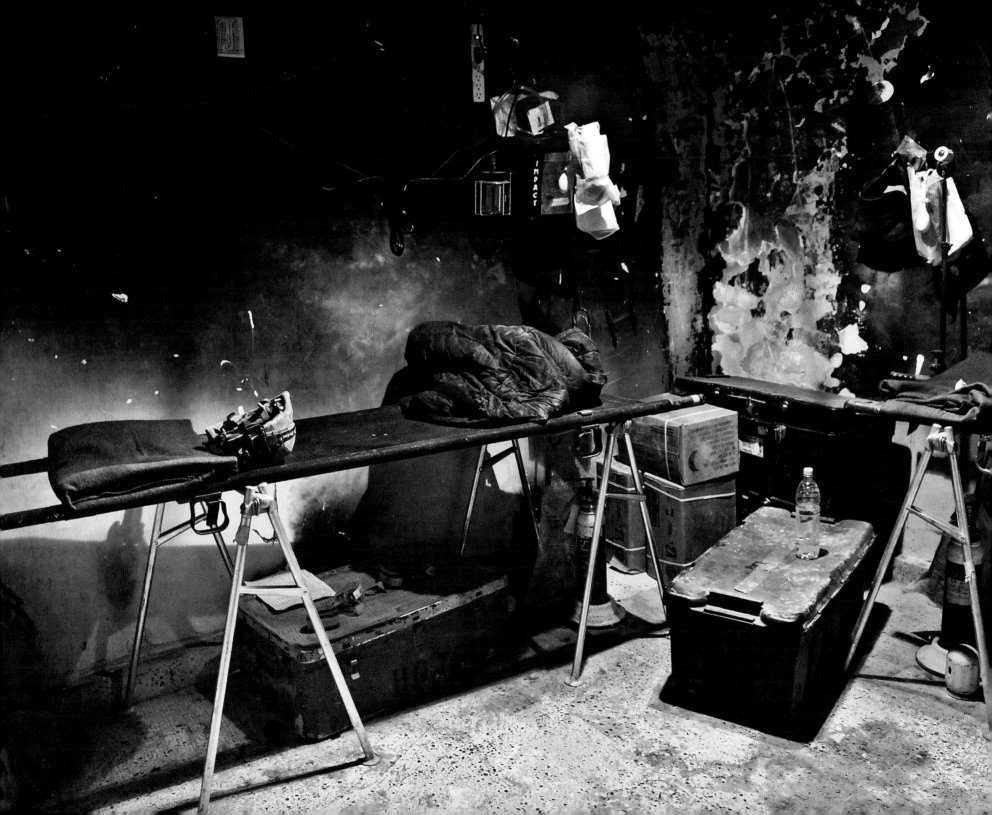

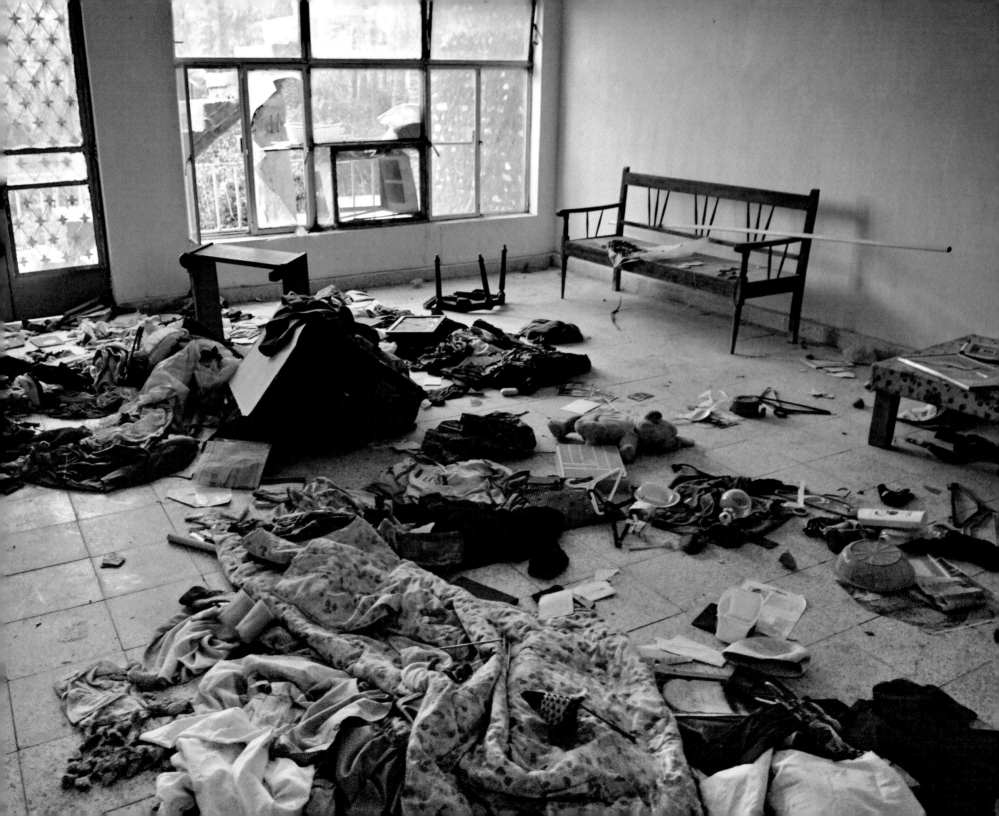

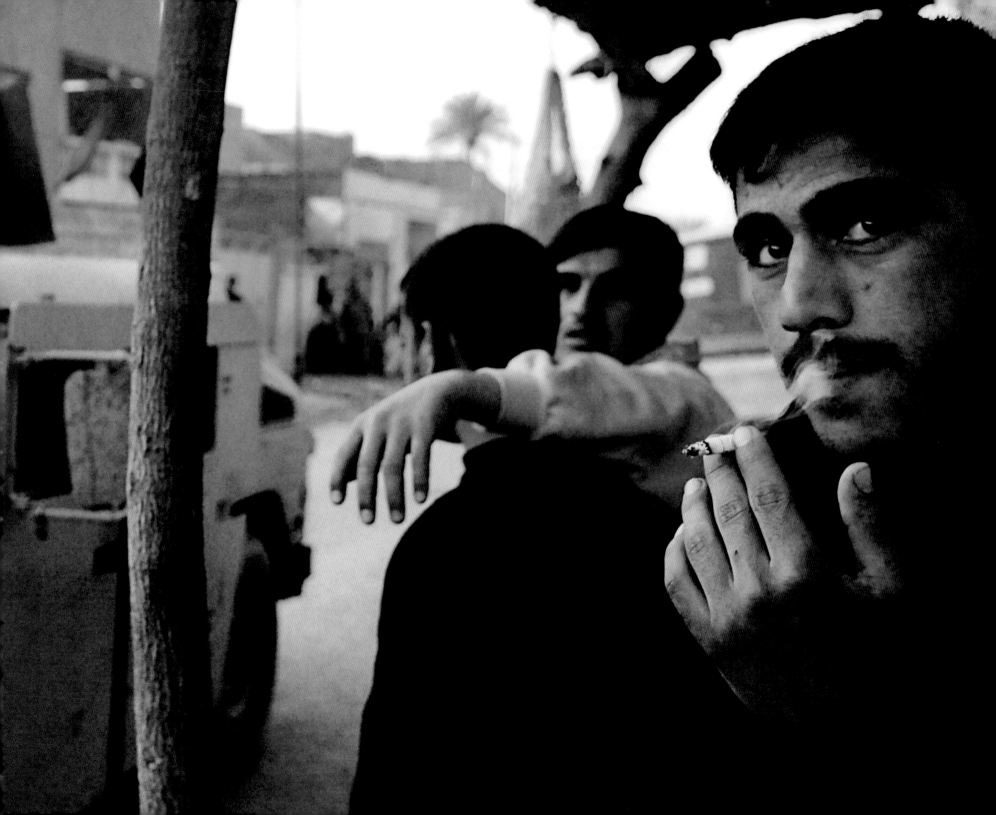

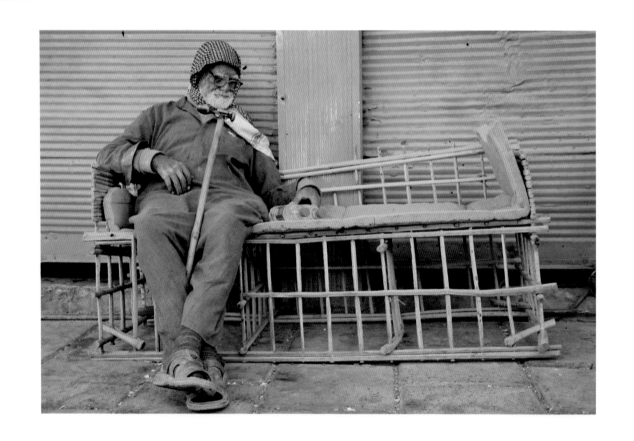

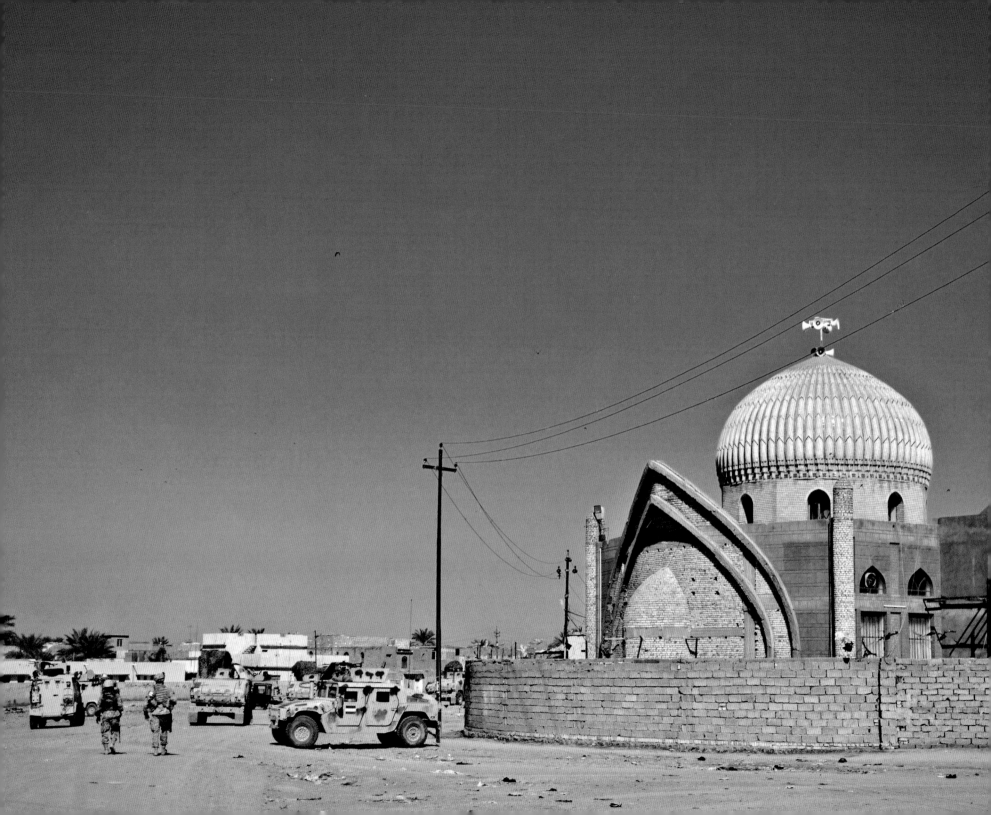

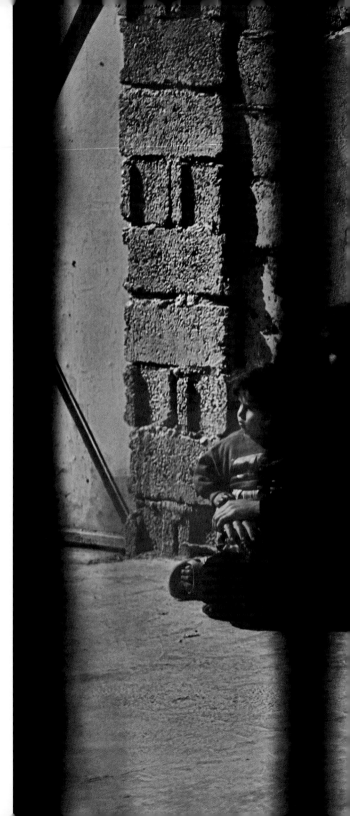

SORROW REMAINS

There are no photos I don't take.

Whatever grief or tragedy transpires, I document it all. What I think about is technical: the way the image is composed, the quality of light, where the shadows fall, the message the image contains. My goal is to tell the story in one picture by layering information in the foreground, middle ground, and background.

I've been told I "taste light" and "arrest the emotion" of a moment. When it comes to shooting Iraqi women, as one woman to another, I feel their pain. From my observations, most women in Iraq are property to be branded and tattooed, sold and bartered. They are forced to rely on men who, as a result of their culture, have little regard for females. They are not the enemy. I've seen young women, not even twelve, being pimped out by their husbands and fathers, or worse, sold into enemy hands as bomb fodder. Girls rarely have a choice. I have a choice, an obligation, to share their story—or to at least take candid shots of what I witness.

I have photographed a distressed Iraqi woman as she realizes she'll have no way to feed her children after her guilty husband is taken away by coalition forces for launching mortars on patrolling Iraqi army soldiers. I've observed the anguish of her starving children as she begs outside the prison where her husband will most likely remain for years. There are no photos I don't take, but I cannot be everywhere at once. The photos I don't get are hidden moments I never actually witness.

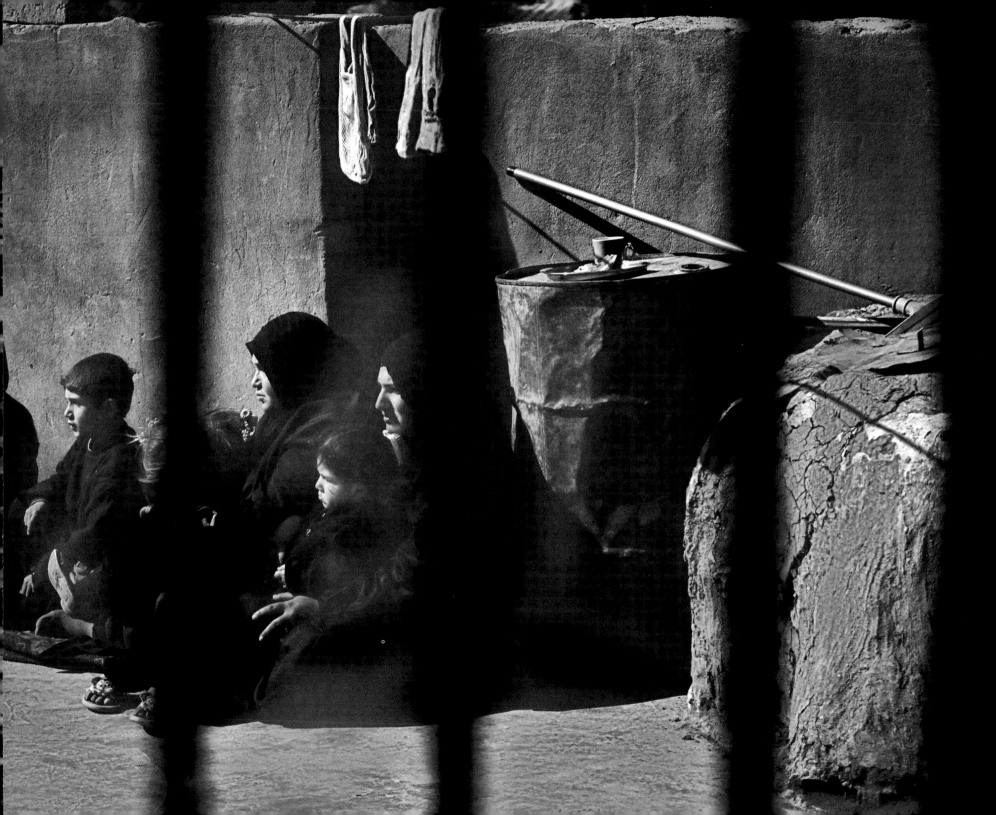

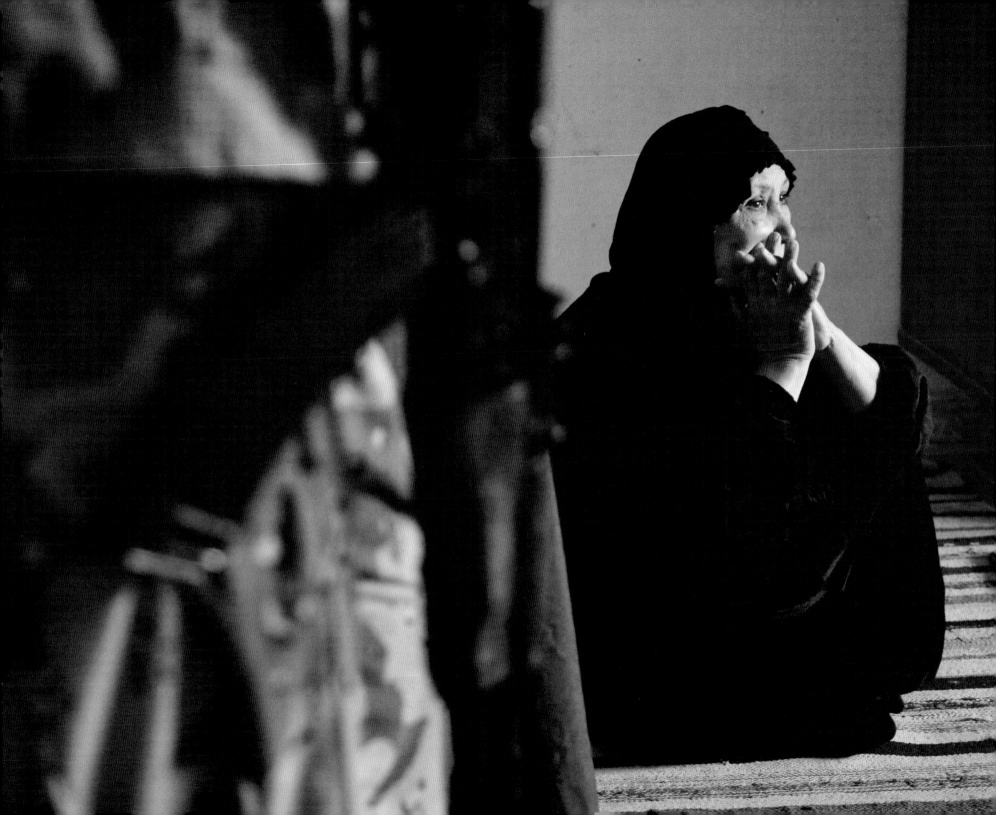

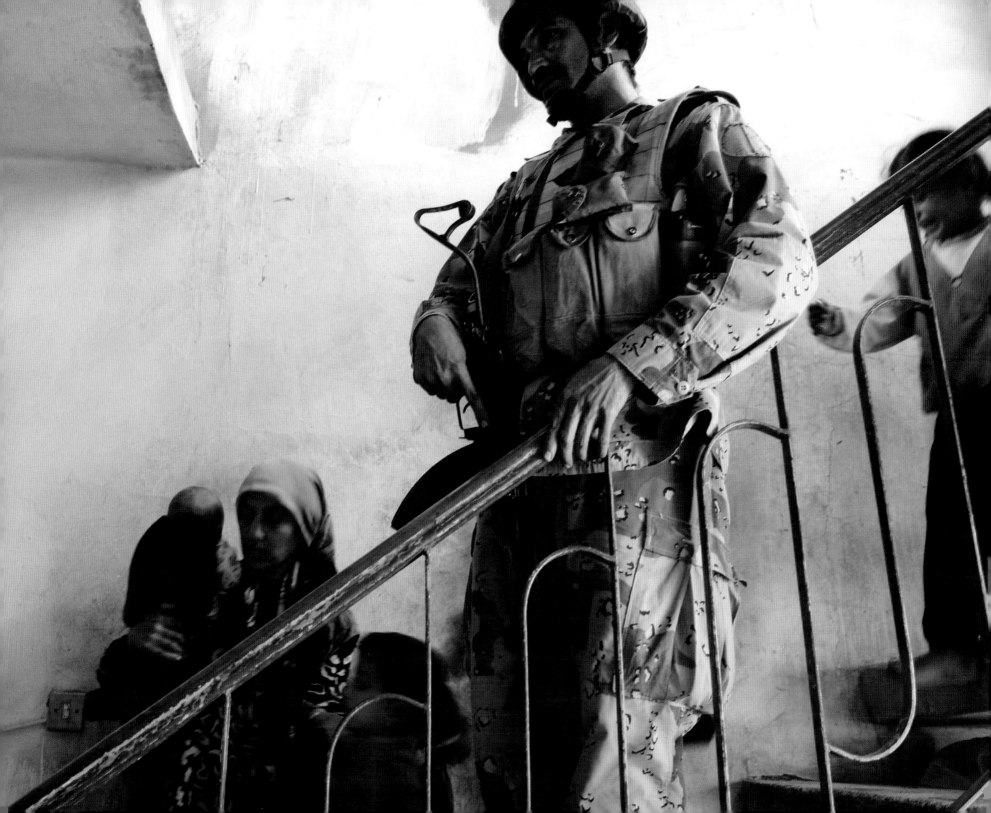

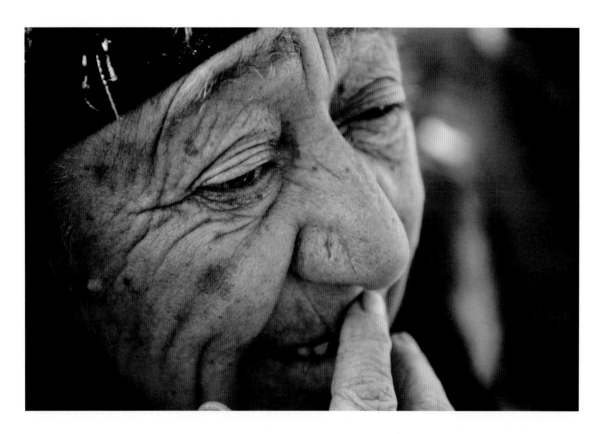

When we search a house, the families are brought outside while we rummage through every room, mattress, kettle, and crib. The women in their veils sit anxiously with children watching our every move. Their eyes widen when they realize I am a woman. Smiles break across their faces, and they begin to chatter in Arabic and point in my direction. I imagine they are saying, "We are safe, there's a woman here," or "Why is a woman a soldier?"

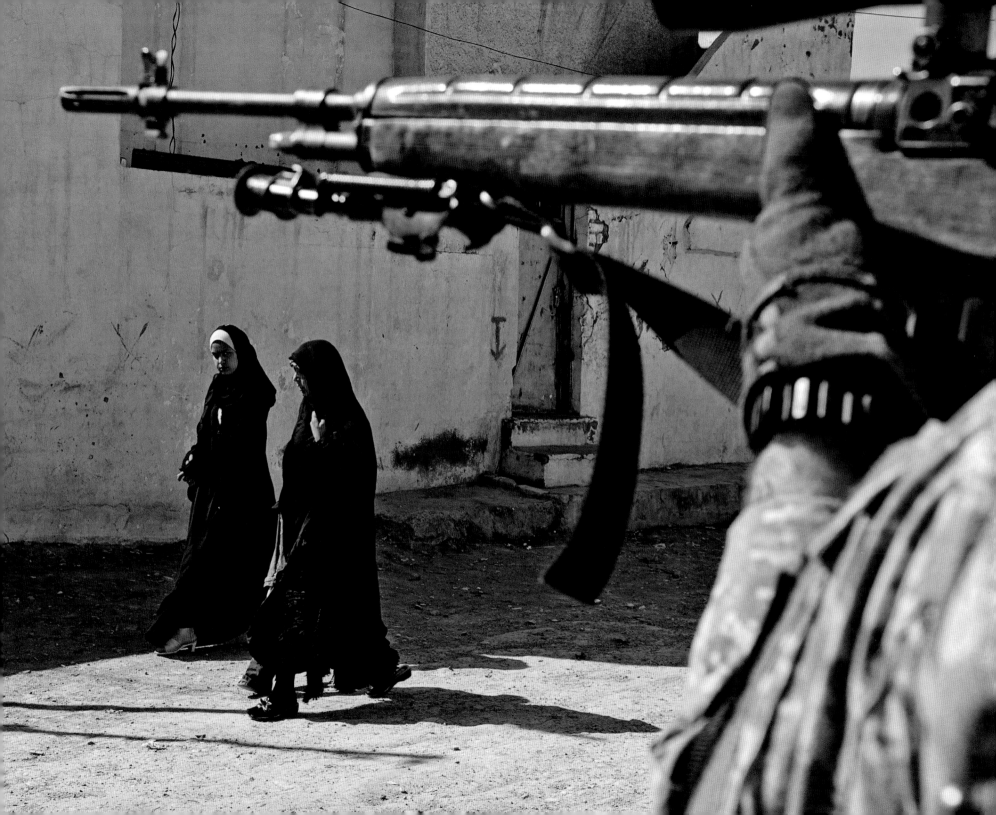

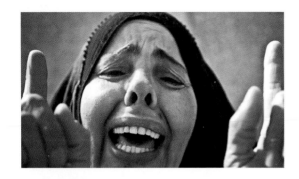
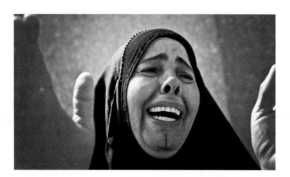
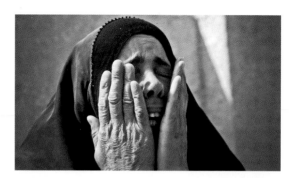
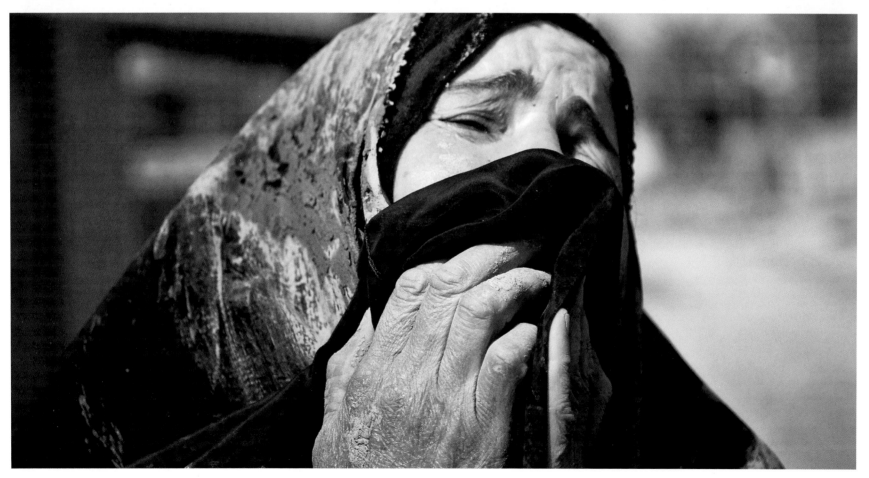

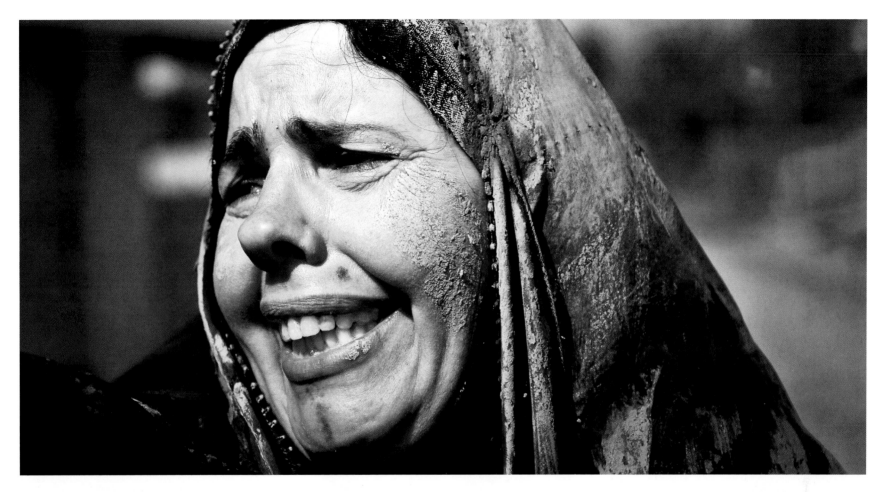

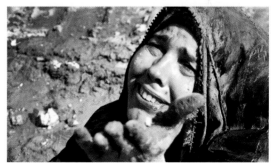

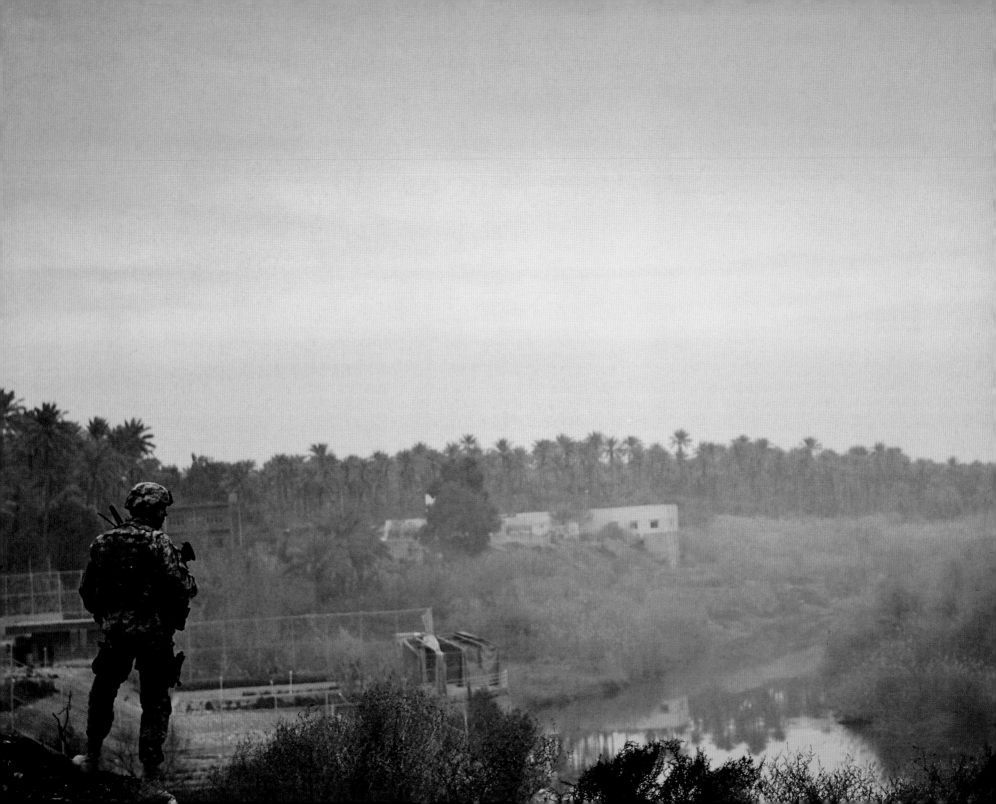

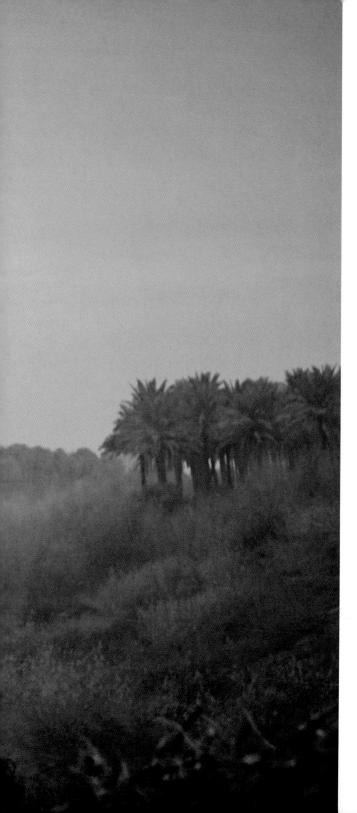

SOLITARY CONFINEMENT

Only one person fits behind a camera.

You find yourself alone in a room, cataloguing the day's images by a glimmer of the sunlight creeping through a small window. The images are easier to think about here in the grey light rather than the hours spent shooting them. They can be reduced to the quality of color and composition.

In the Iraq war zone, you are not confined by walls. You are trapped by sounds, sand, and time—time spent waiting for orders to arrive. Time wondering when the next explosion will come and how you'll shoot it. Time yearning for the touch of those back home.

In a way, it's all solitary confinement. Sometimes, the feeling comes when you are separated from your unit or when you are clearing a stairwell, not knowing what's above you. Is it a man? Is it God? Who will you meet around the next corner? I capture their aloneness. I compose what surrounds them—the light as it falls on the barrel of their rifles, the look in their eyes. I've seen it so many times before. The world closes down to what you have been trained to do. There is no room for what you love, only duty. My camera and I are one.

When I am looking with one eye through a viewfinder, I focus only on the simplest things. Everything outside of my scope falls away. I fall away. I am outside of the action, yet I am part of the action. The world becomes four-cornered and clear in a way that it can't otherwise. Life is rimmed by a square of simple black.

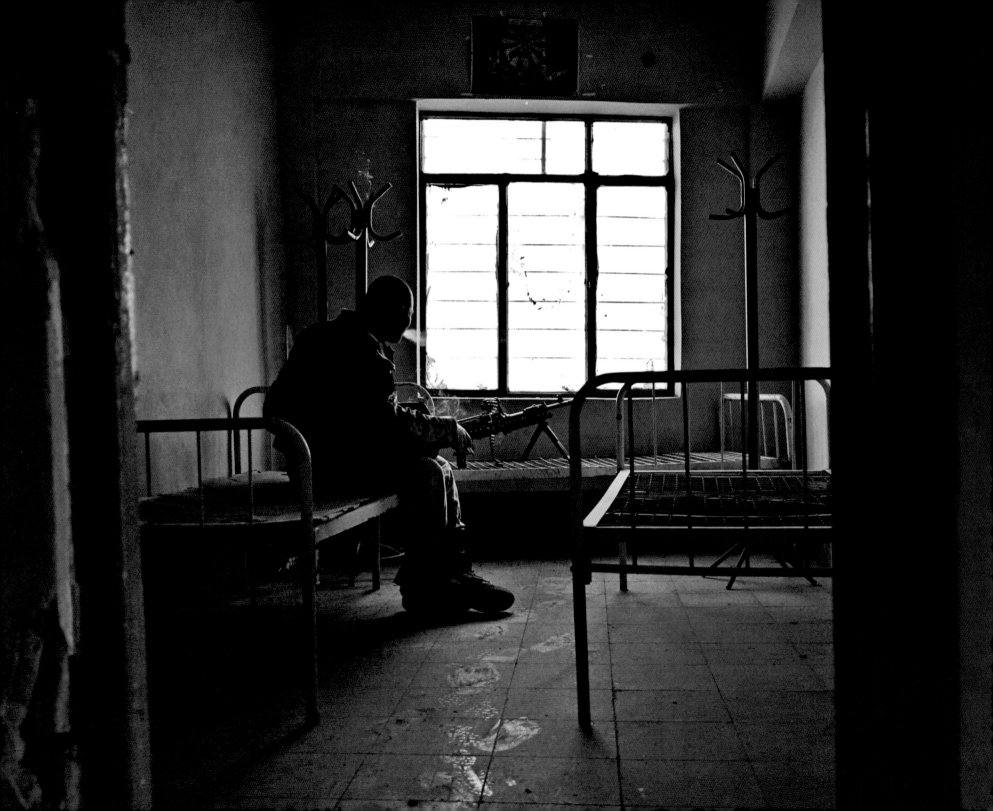

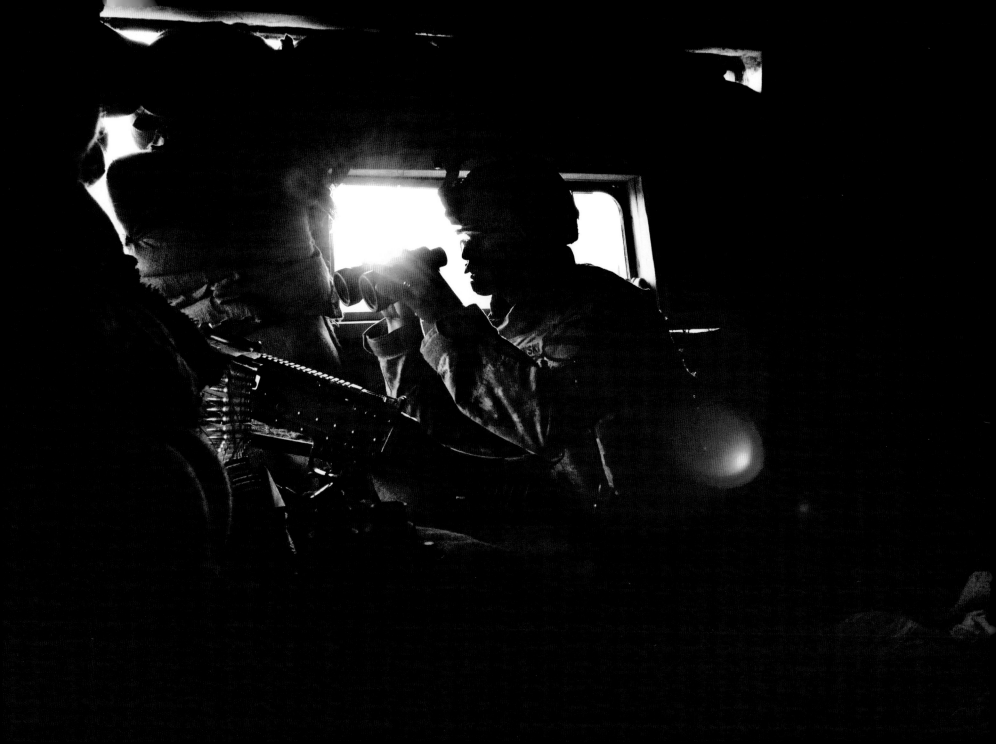

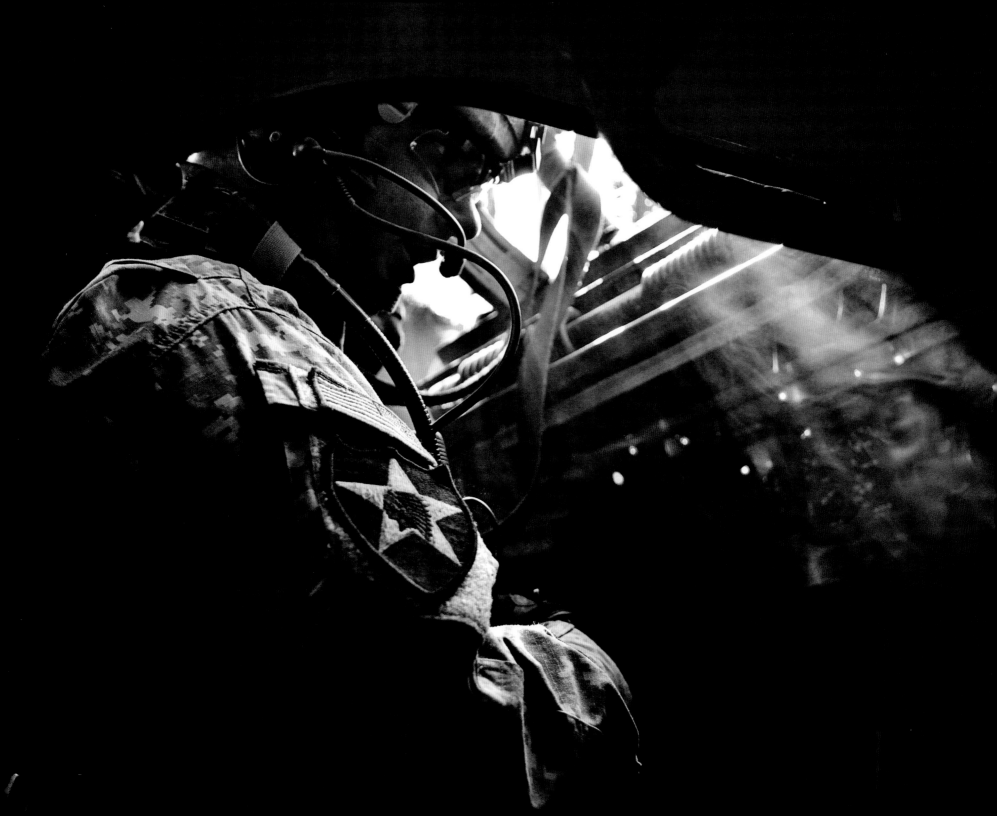

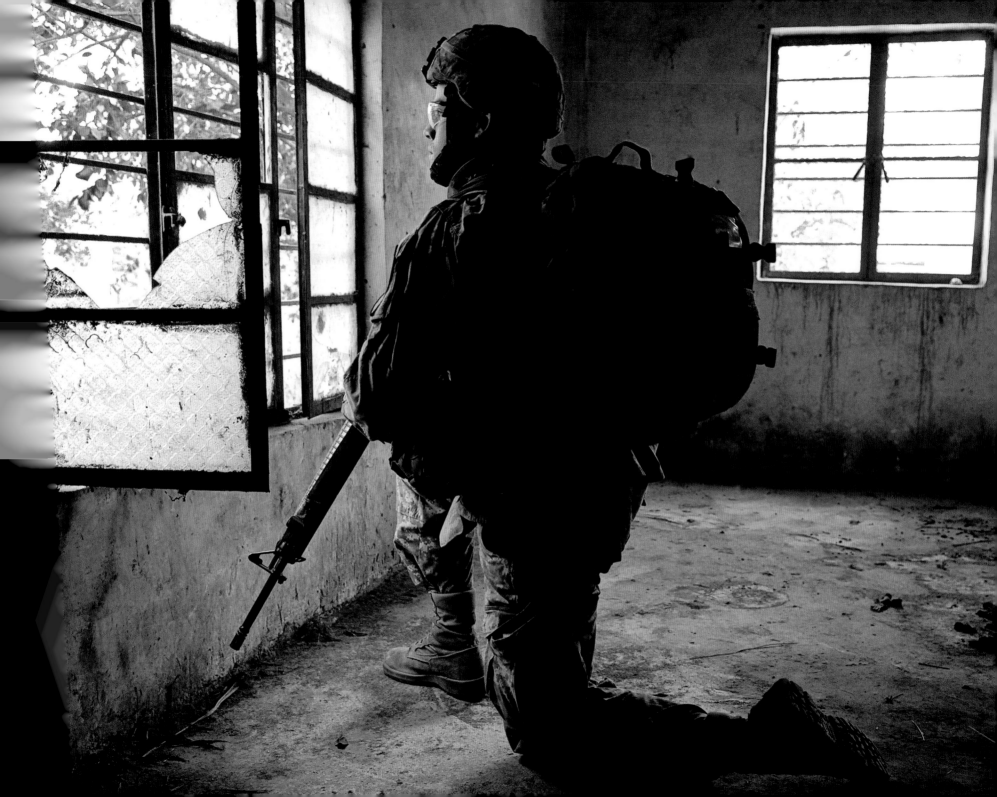

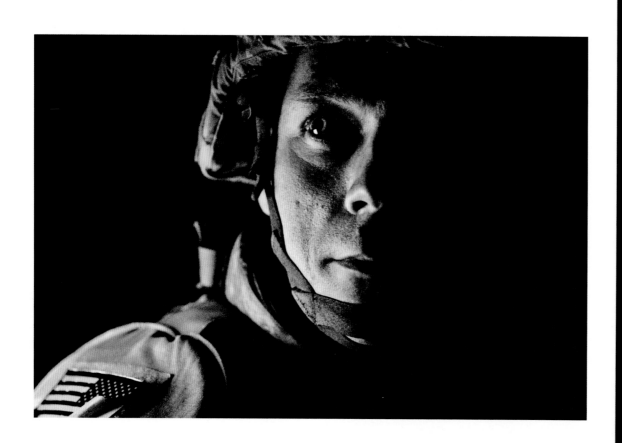

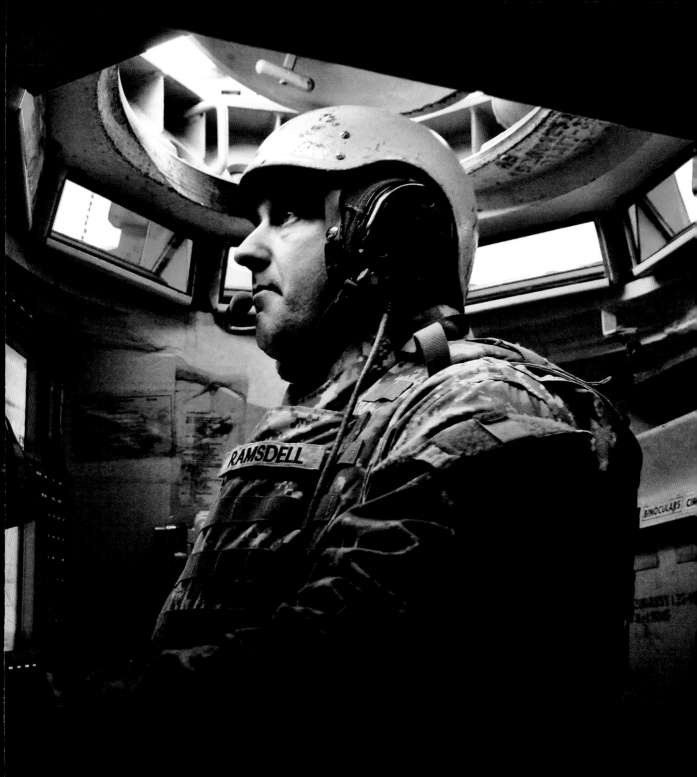

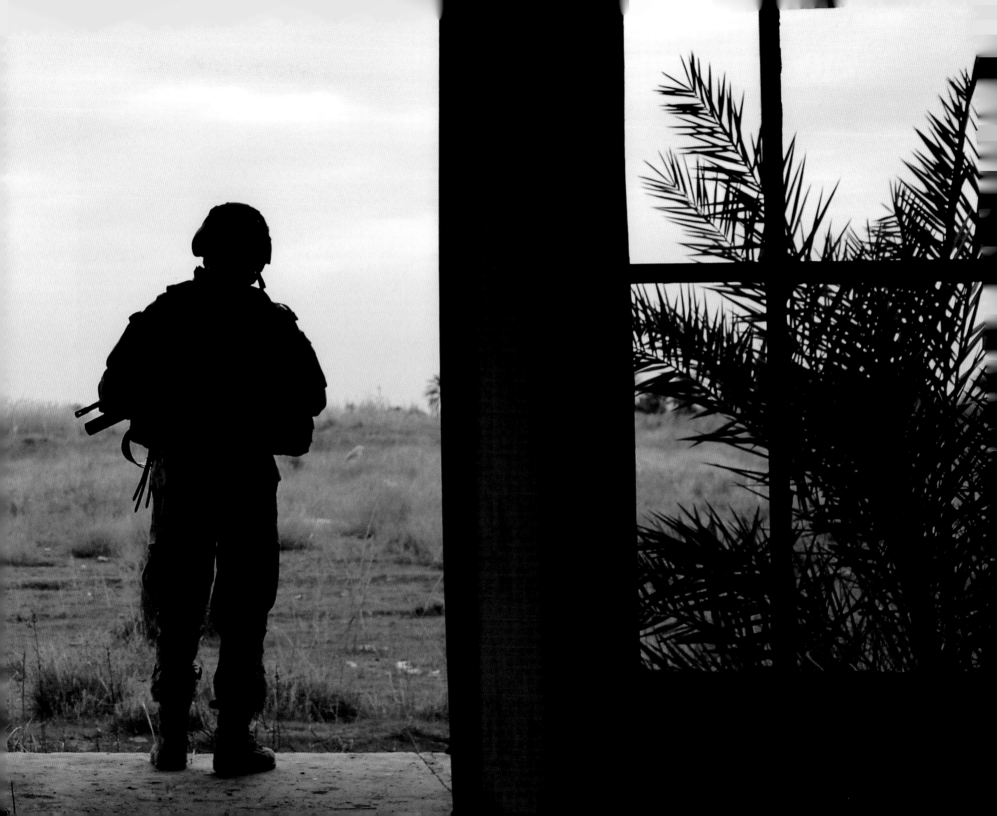

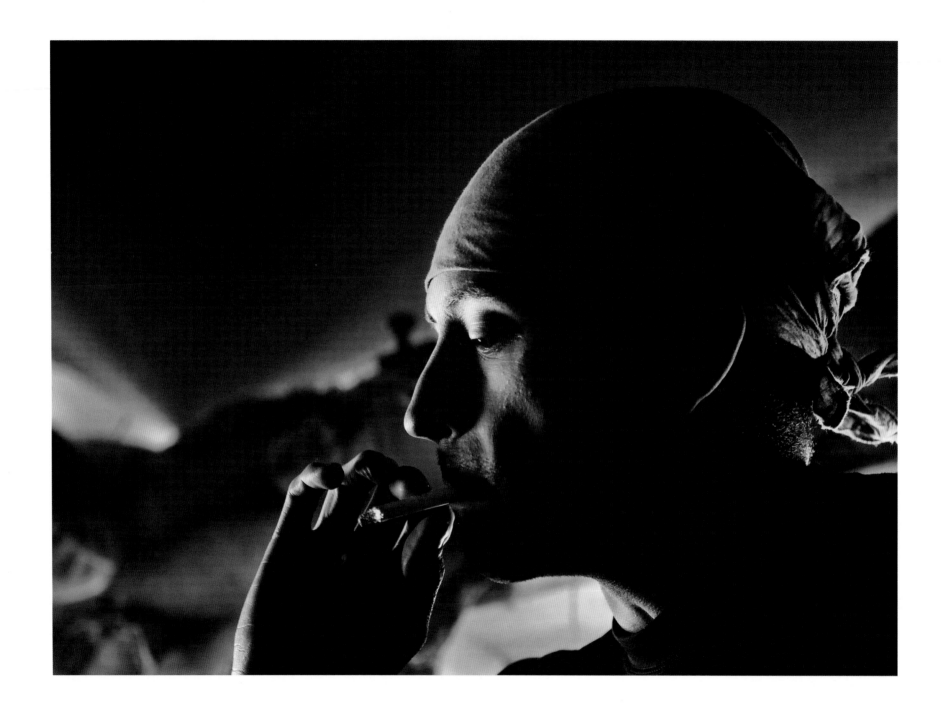

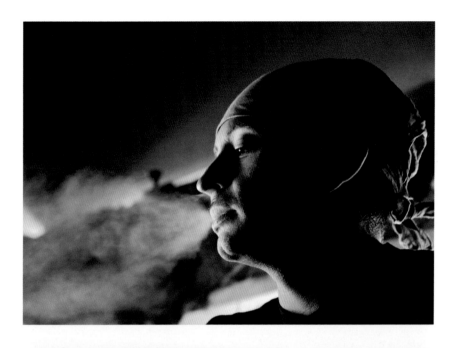
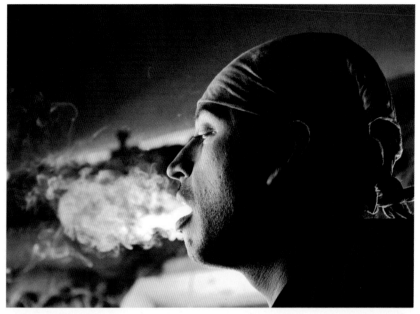
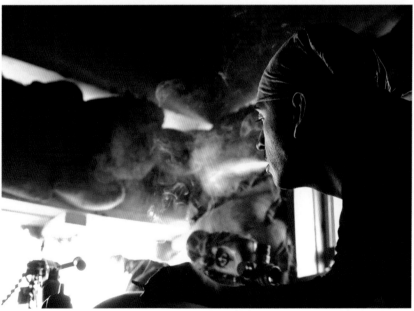

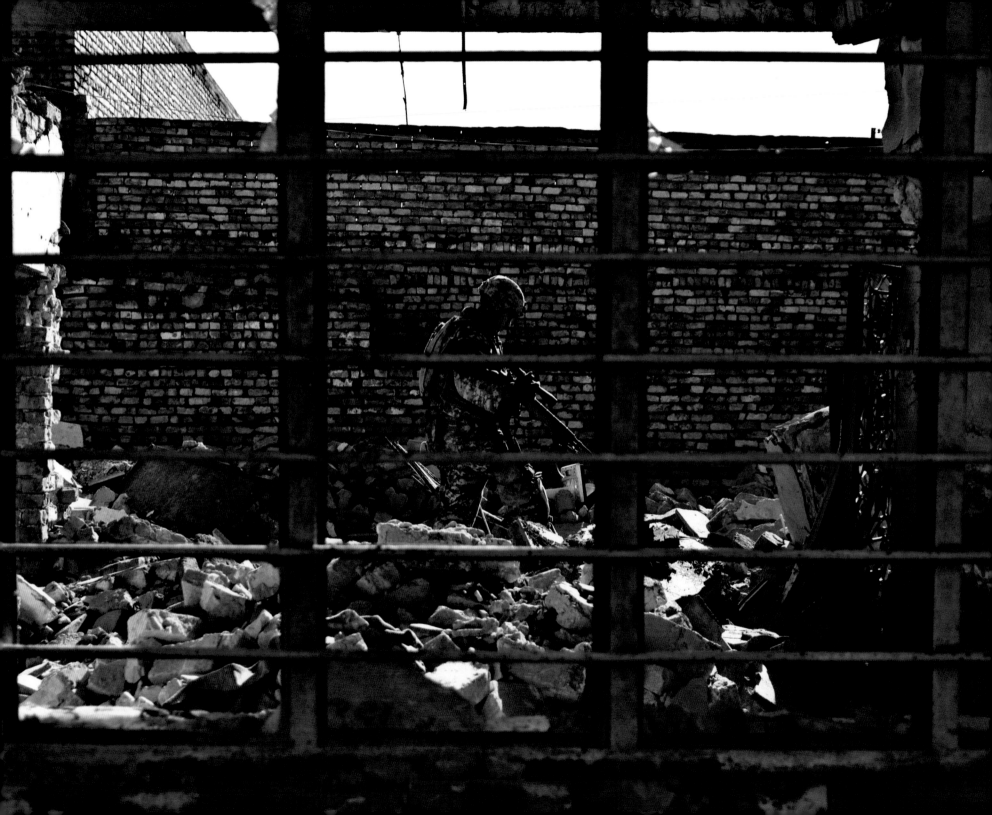

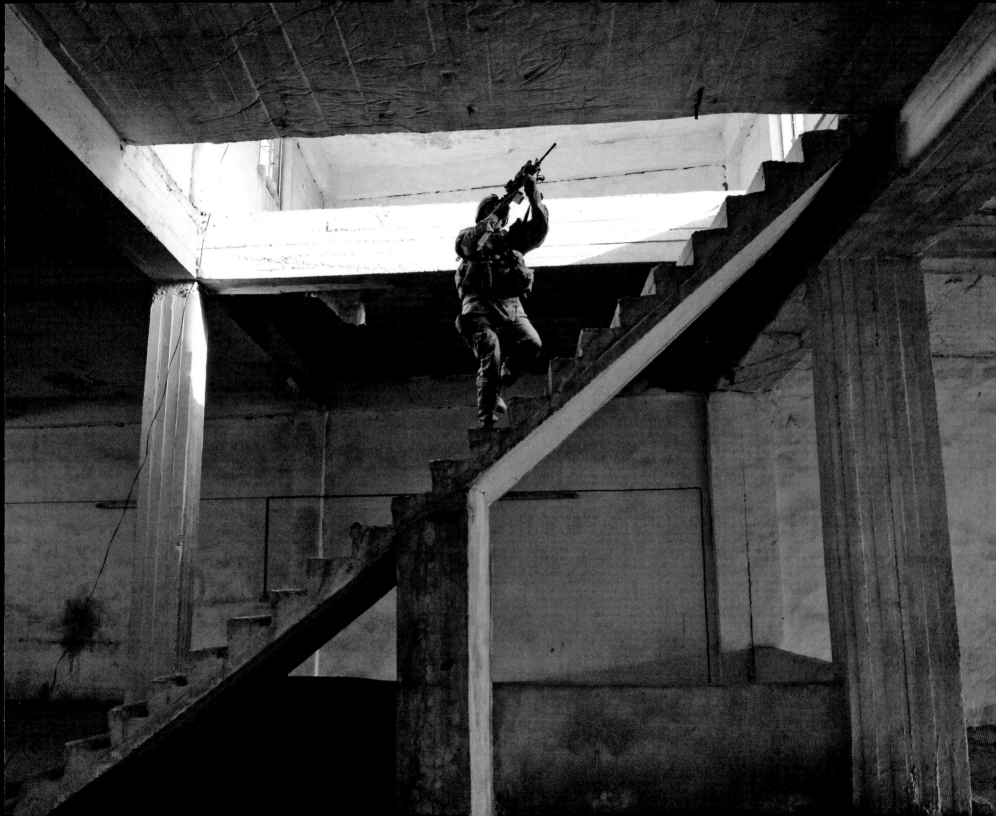

I'm isolated in more ways than one. I'm an individual; they are a unit. I'm Air Force; they are Army. I'm a woman; they are men. People surround me, and yet I couldn't feel more alone. I'm the outlet, the confidant to whom soldiers confide, but when people look up to you, there's no way to let them know when you're down. Venting or showing emotion isn't an option; I keep my fear, frustration, anger, and anguish locked tight, out of sight, in the shadows.

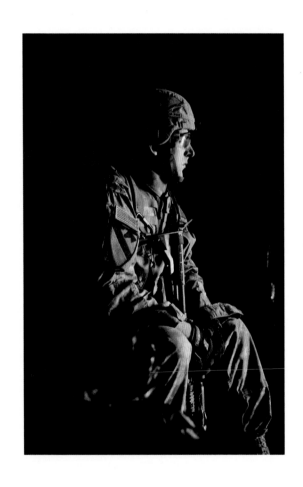

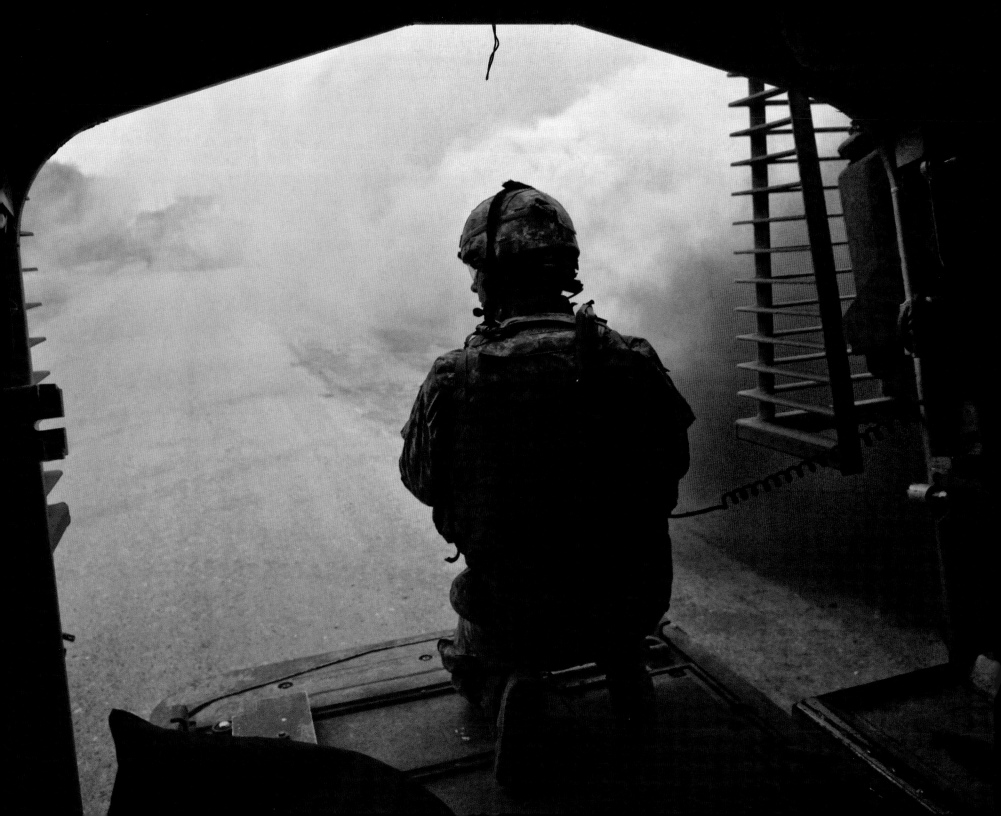

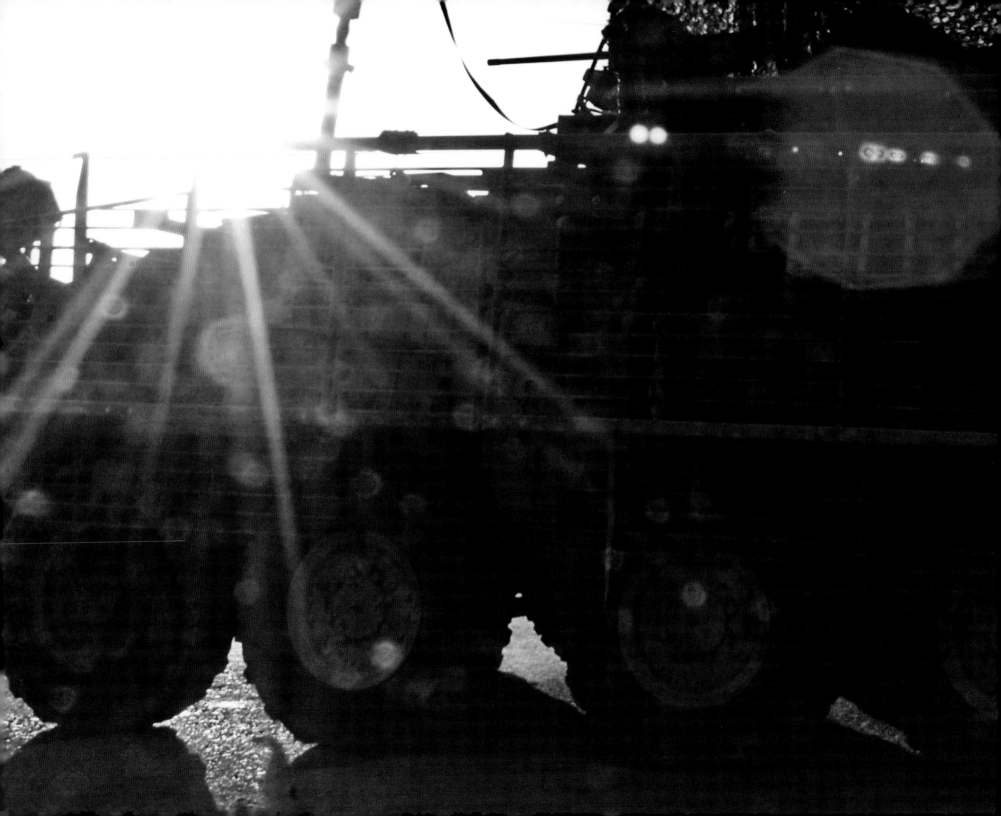

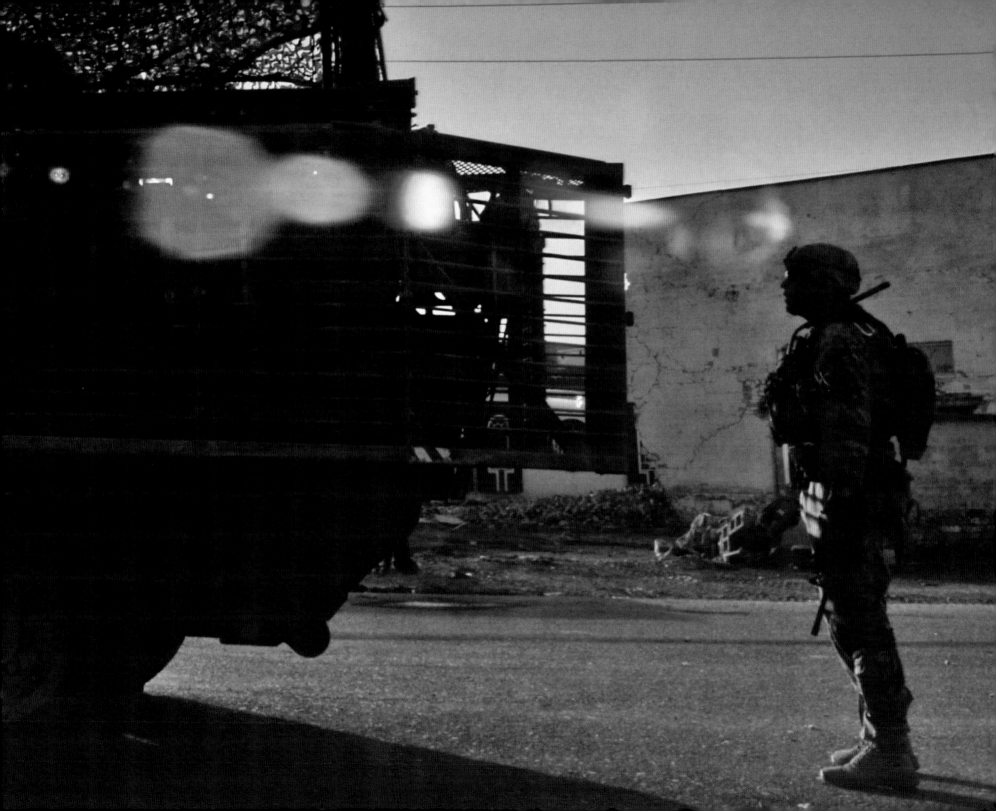

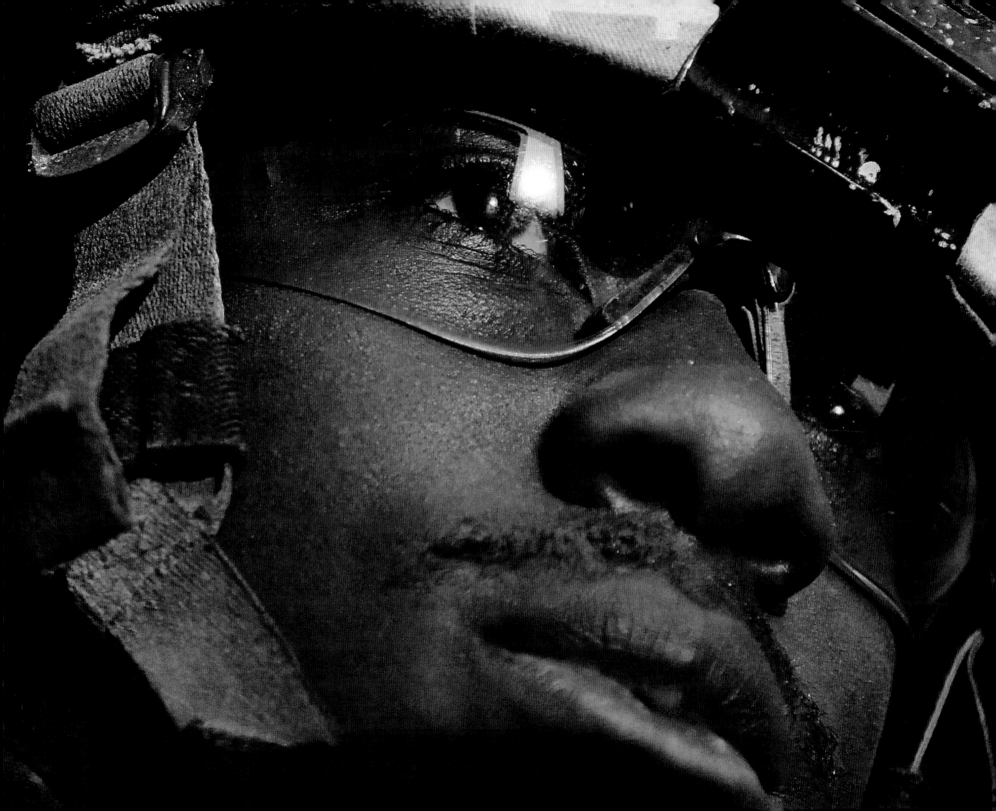

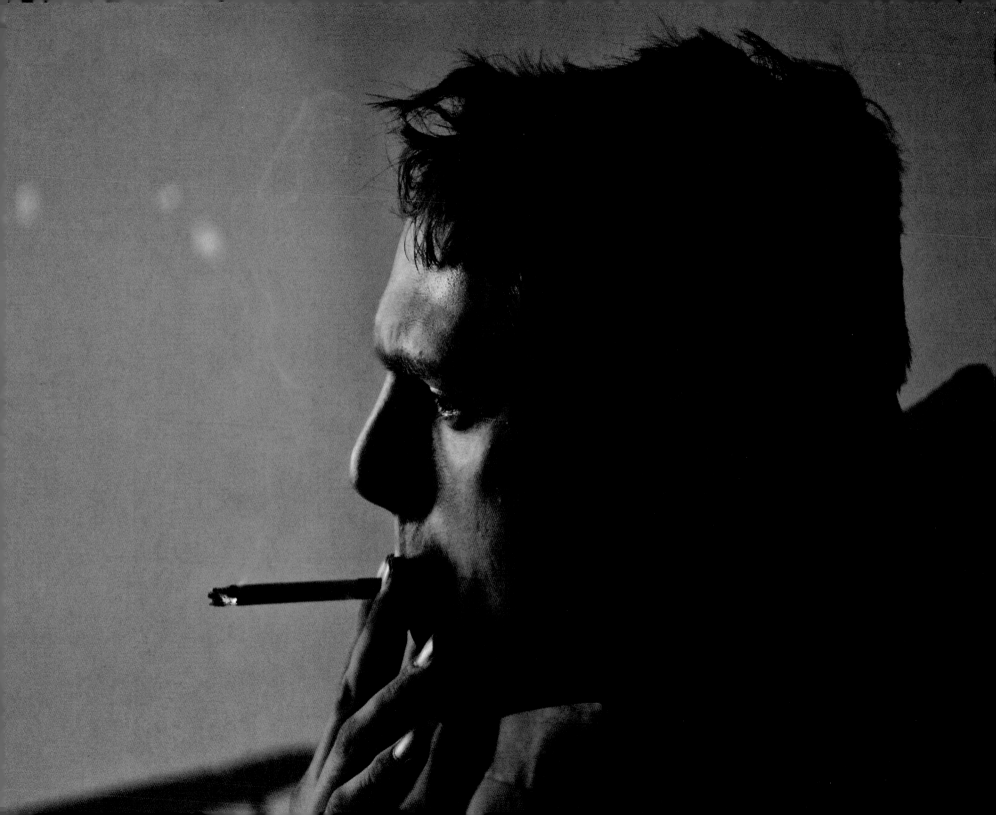

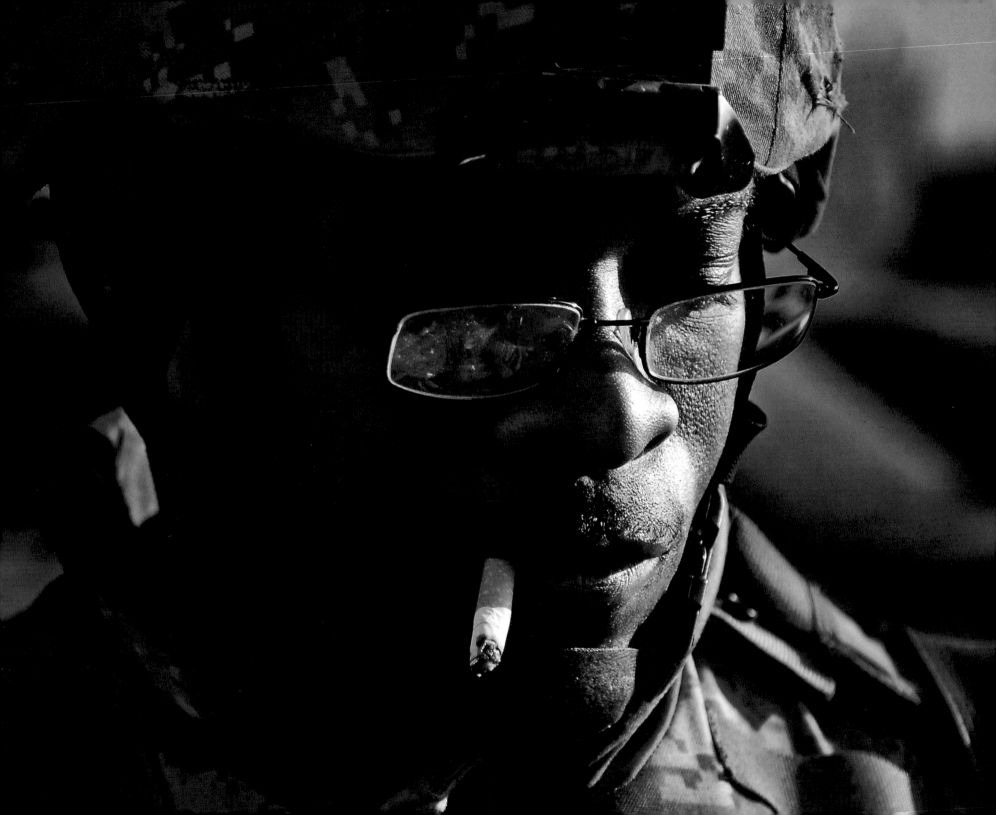

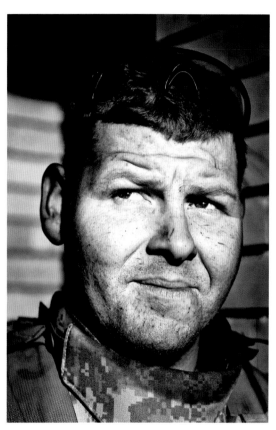

I gave up smoking after my second deployment. On my third, I smoke one cigarette after another. They say the devil finds work for idle hands, and I've proven that cliché to be true. I could be killed a minute, an hour, or two days from now, so smoking won't make a difference at present. Many of my fellow soldiers feel the same.

MEET THE NEIGHBORS

Most Iraqis live in clean cinderblock houses. Others live in straw and mud shacks.

They're terrified of pistols. Saddam Hussein's execution squads used them; they'd put people on their knees and shoot them in the back of the head for reasons known only to Hussein. The enemy we're fighting now has picked up where he left off.

When we walk along the edge of the Diyala River, we see stains of blood on the riverbank where local citizens have been lined up, shot, and pushed into the rushing water. Their unidentifiable bodies wash ashore downriver in Baghdad, a symbol of the enemies' strength and resolve. The bloated corpses are like messages, saying, the surge may have driven enemy forces from Baghdad, but it didn't drive them completely out of Iraq. The fighters are ruthless, and innocent people die for no other reason than having a house located in a strategic part of town, suitable for watch positions or patrol bases.

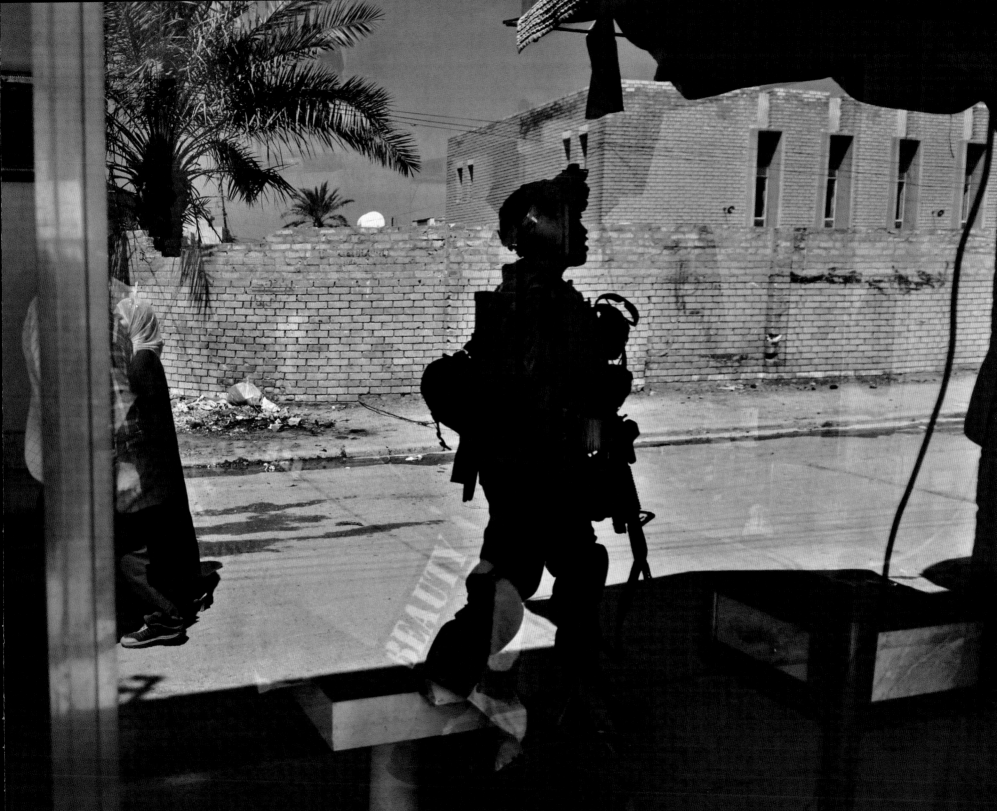

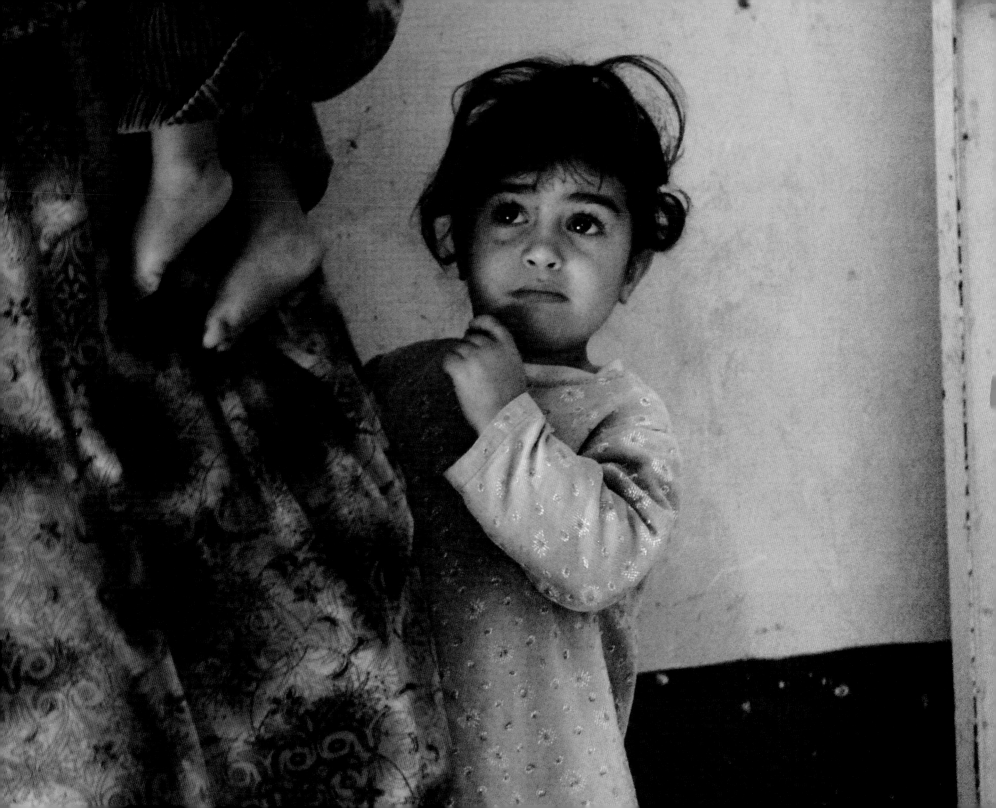

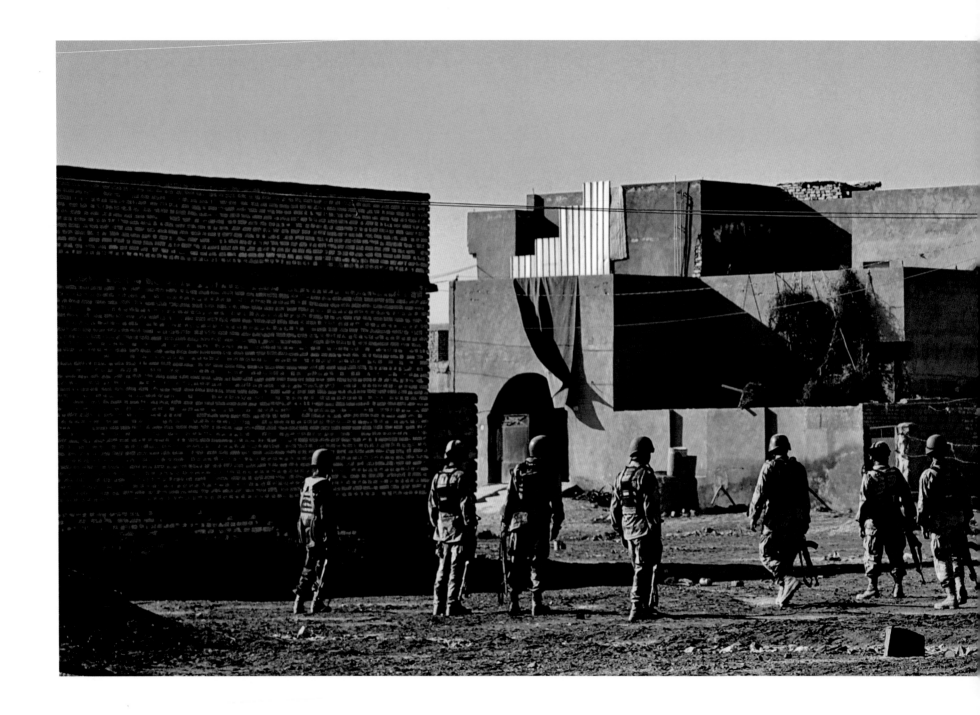

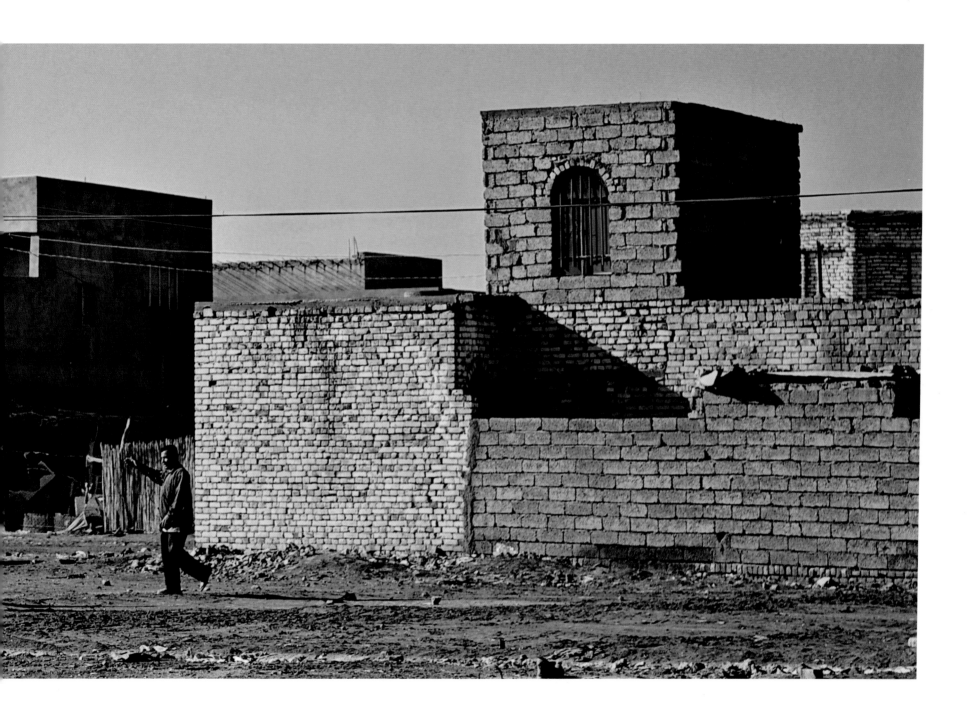

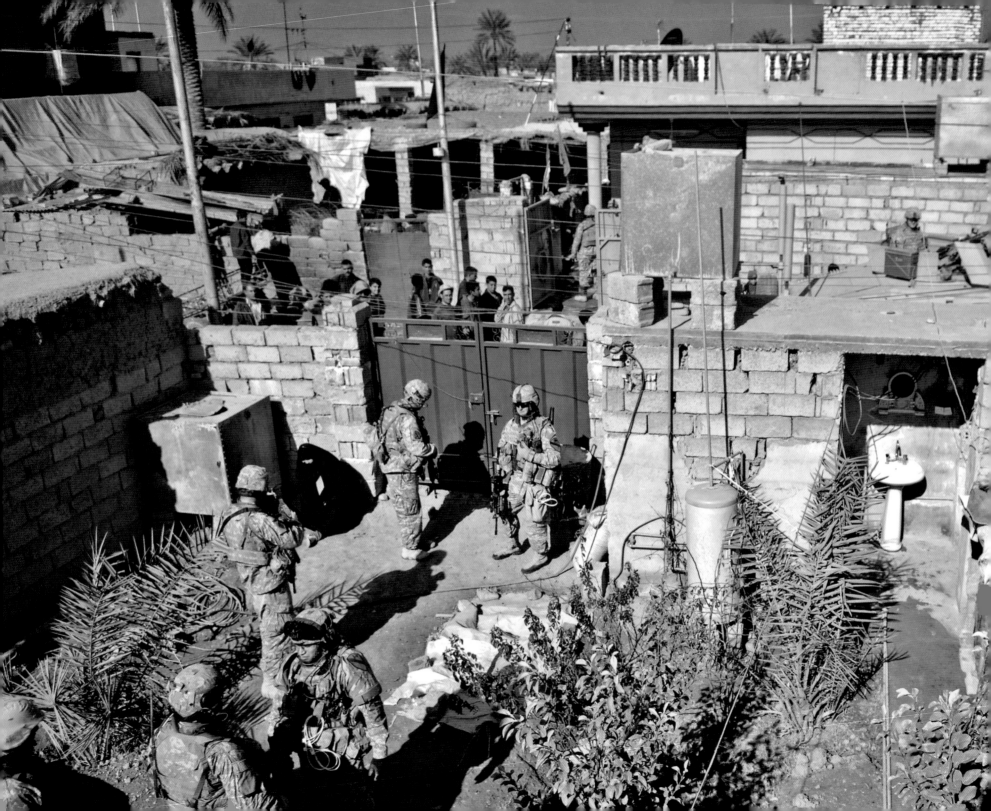

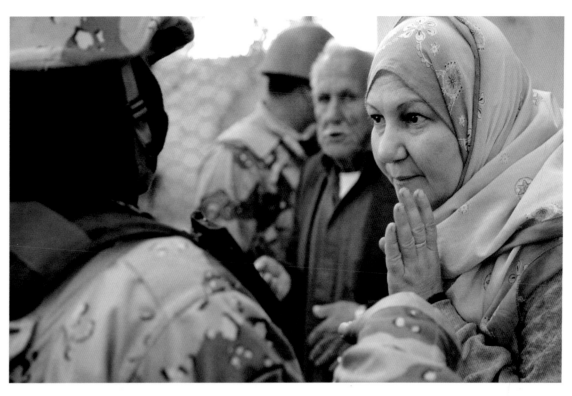

As the executions increase, more families flee. Those who cannot afford to leave are caught in the crossfire. A constant tension plagues their expressions as we pass through their houses searching for the enemy. The markets are abandoned; where advertisements once hung, now spray-painted anti-coalition graffiti reigns. Trash is piled high on every inch of open space in town because no one is collecting or burning trash, and feral dogs and cats make meals of the rotting food. Raw sewage runs the lengths of gutters along either side of the village roads. The stench is unbearable.

Families that have remained are happy to see us and greet us civilly if not jovially. They are anxious to speak with us in private so they may relay intelligence on the movements of the enemy. They, like us, want the insurgents to leave Iraq, and they are our willing accomplices. Surprisingly, many men who fought us during the invasion now have alliances with the coalition; they are our guides and informants. These Iraqi men and women simply want a better future for their country.

During an average patrol, we typically knock on the outer door as a neighbor would, versus on combat missions when we kick it in. We exchange pleasantries, drink tea, and ask after their children. For some of the kids, war is all they've ever known. They've grown up hearing the distinctive hum of helicopters and fighter jets circling overhead. As fixtures in their lives, we do our best to treat them as we'd treat our own children. I always have a cargo pocket full of treats to make our reunions and farewells sweet.

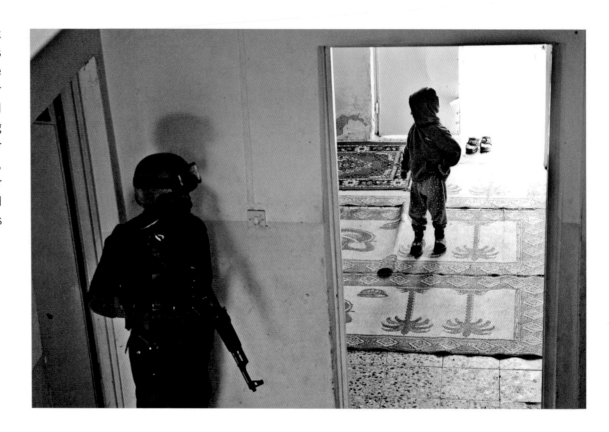

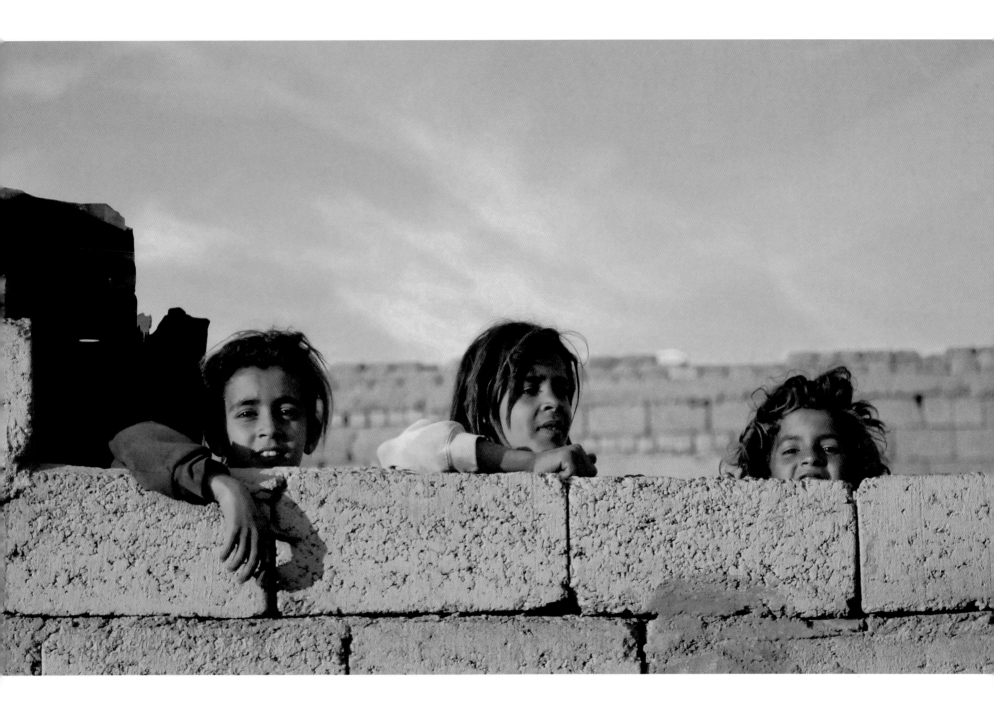

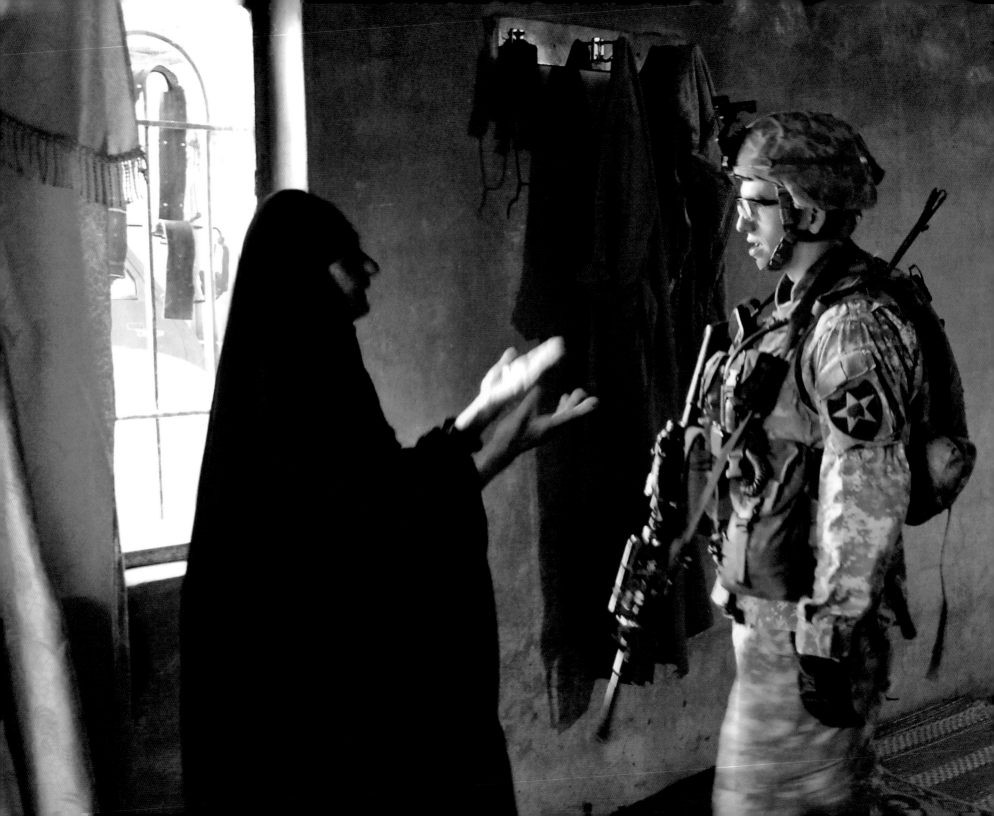

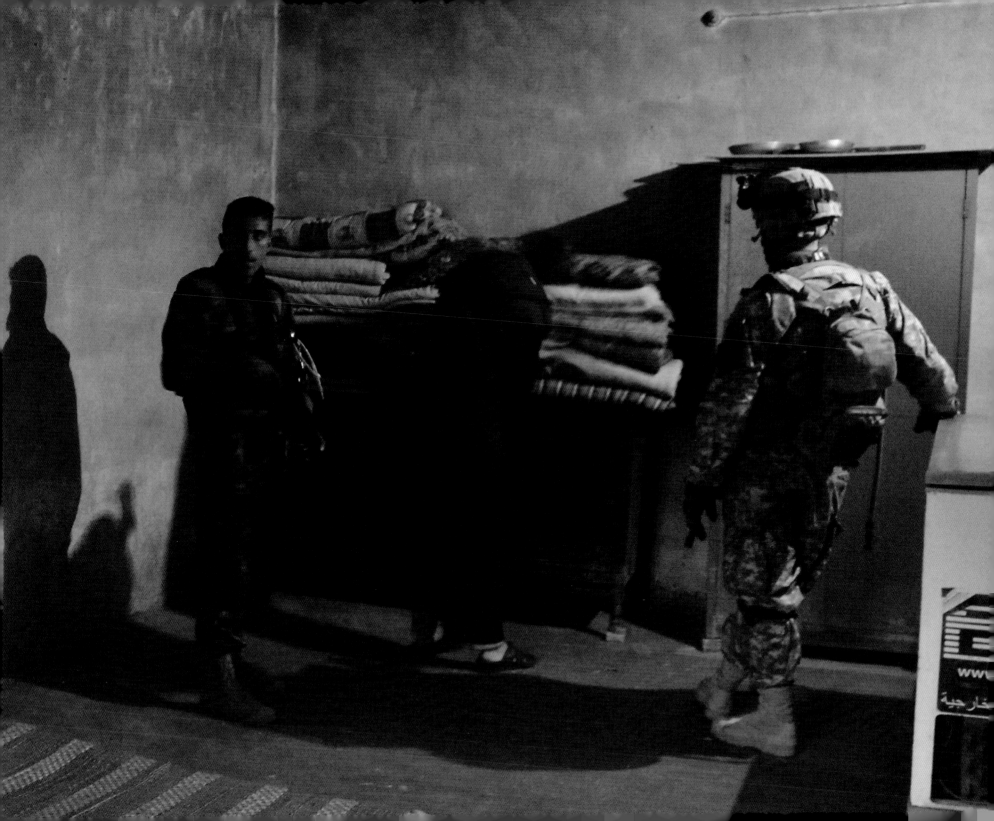

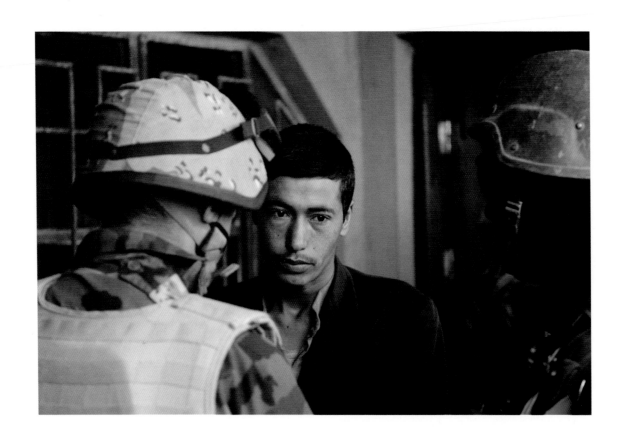

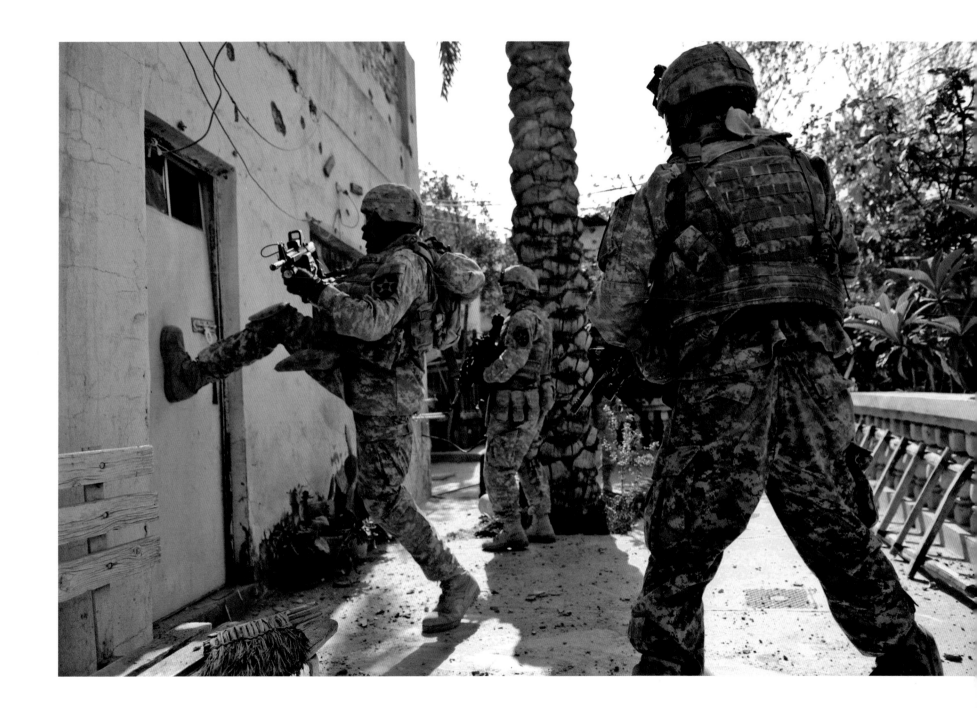

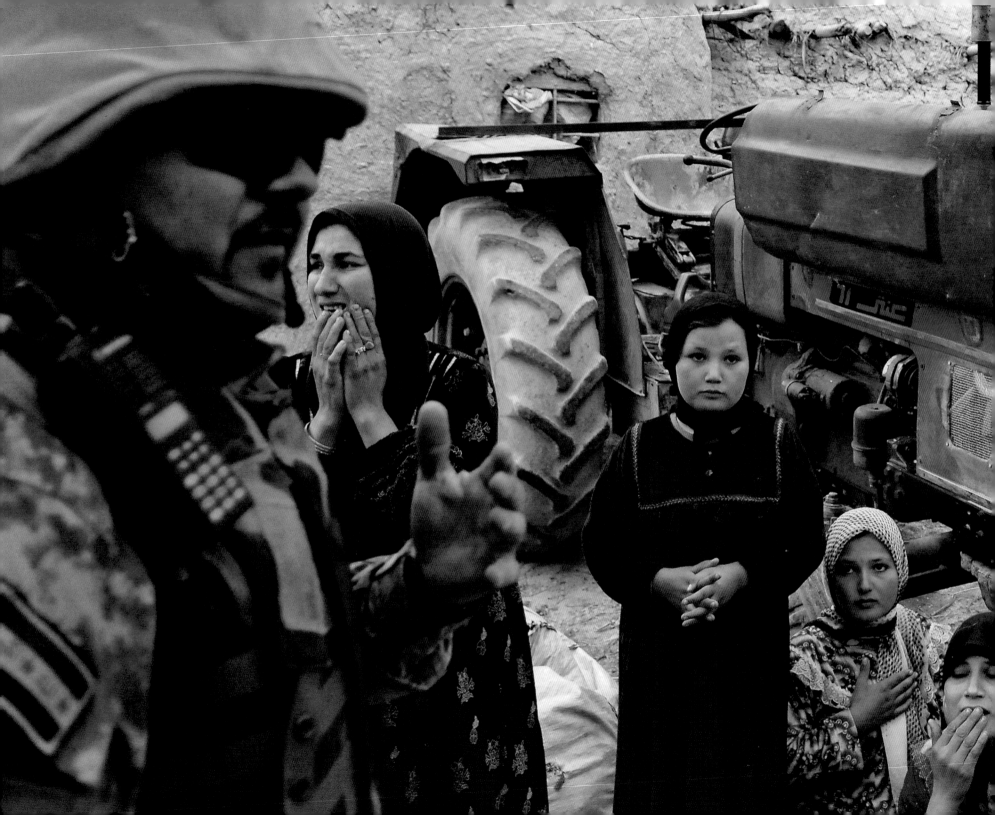

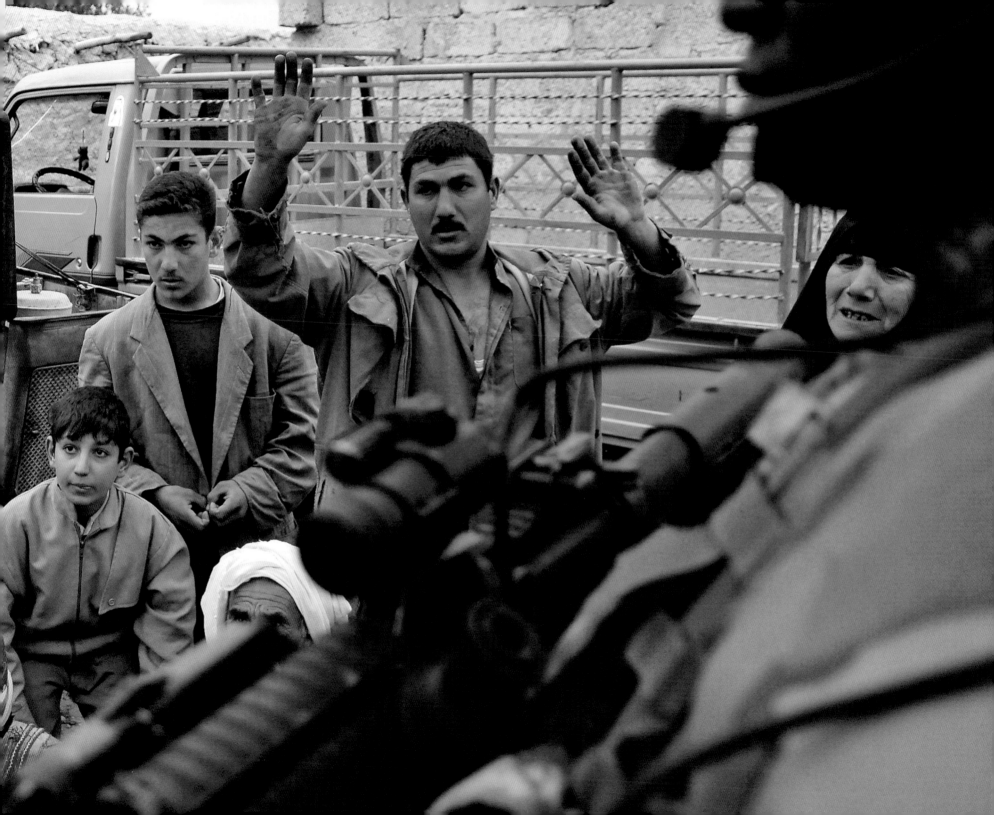

WHY WE FIGHT

Iraqi soldiers work hard to take back control of their country while trying to maintain trust among their fellow countrymen.

Think about it this way: Everything you've heard is shaped by the government that's lived off you like a parasite for thirty years, and there are no jobs. When a man with a Mercedes offers you a gun and steady hot meals, you sign up—your mother and wife and children heavy on your mind. How else do you care for them? And beyond that, how do you maintain your sense of belonging, this idea of homeland, of nation, of a place where you've grown up and tried to make a living?

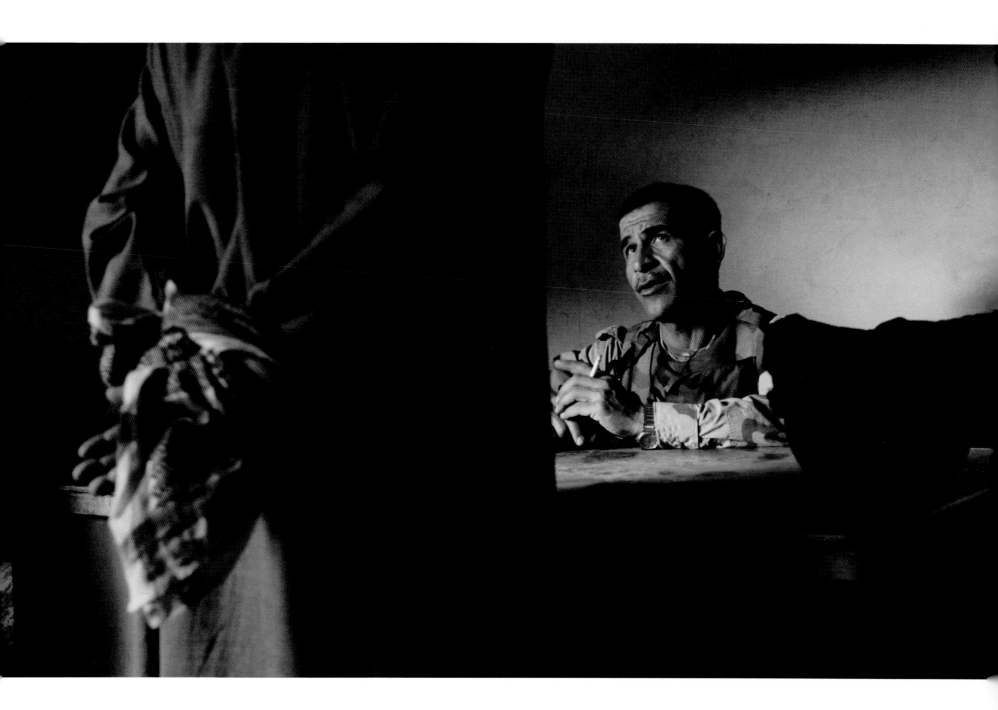

The Iraqi Army has few soldiers I'd call professional. The best I've seen are the guys who've been trained and have served with American Special Forces. They go out and do their business as they were trained. Overall, the rest are pretty indolent. Some are paid for basic training and then go home, never to return. Others leave their posts and gear on the battlefield. These guys—the ones who stay—often look at me as if they think a girl couldn't do their job. The irony is, most of them can't do it, and that gets people killed.

In terms of military tactics and skill, I don't really trust them, with the exception of a select few soldiers and the translators. At least with the translators we can communicate our frustrations for putting us in danger and not being able to help out.

For many, it seems, being a soldier means getting a handful of hot meals and then going back home feeling like a man. The thing is, they're raised to believe they're born warriors. The Iraqi culture is thick with warrior tales. A few thousand years ago, they beat up some Greeks and have been drinking the wine of that victory ever since. So it's an insult to be taught by Westerners to be warriors.

I've seen this more than once: A group of Iraqi soldiers will be standing together talking, and suddenly shots will ring out. They open fire in whatever direction they happen to be facing, oblivious to fellow soldiers or civilians. We grab cover and curse them for their stupidity. More than once, they've mown down a guy who'd been laughing only a moment earlier. US soldiers call it the Iraqi Death Blossom. How are they going to secure a country when they can't secure their chinstraps?

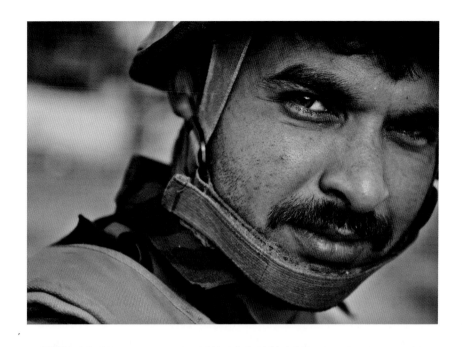
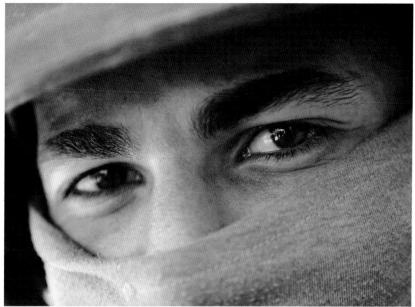
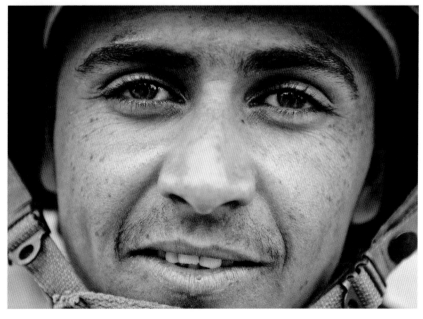
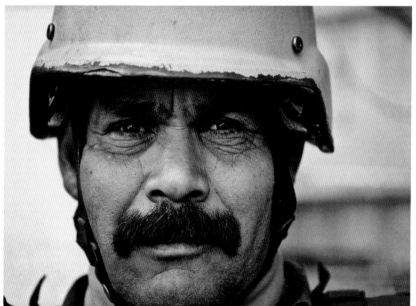

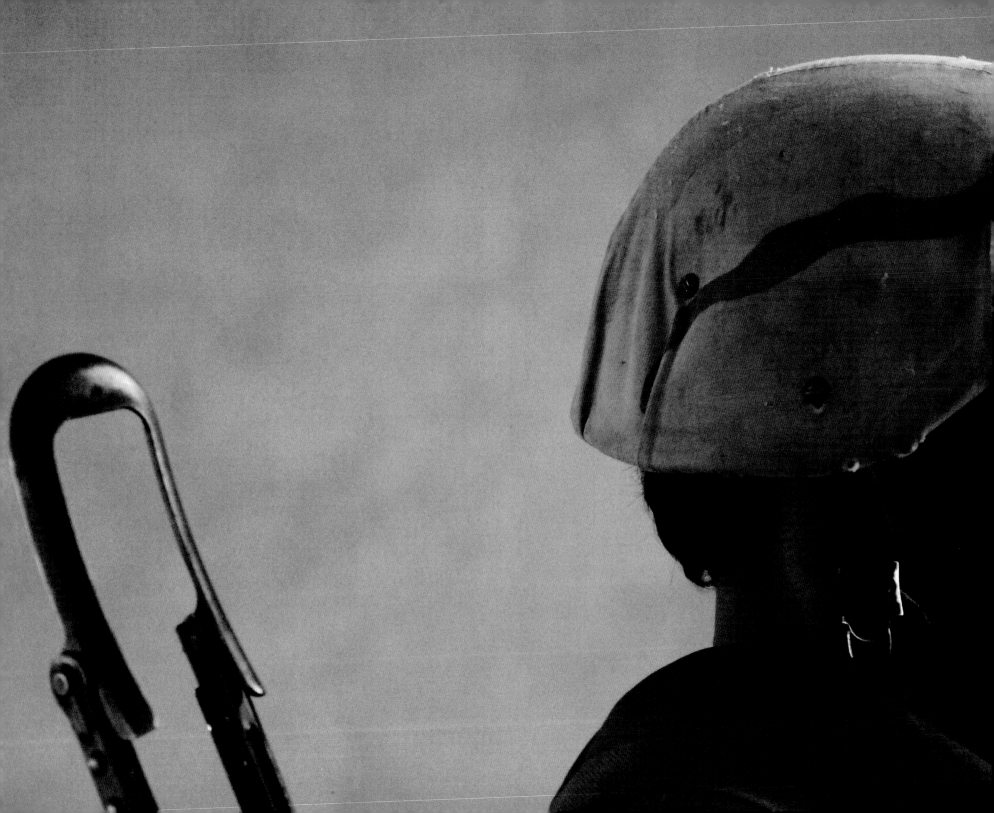

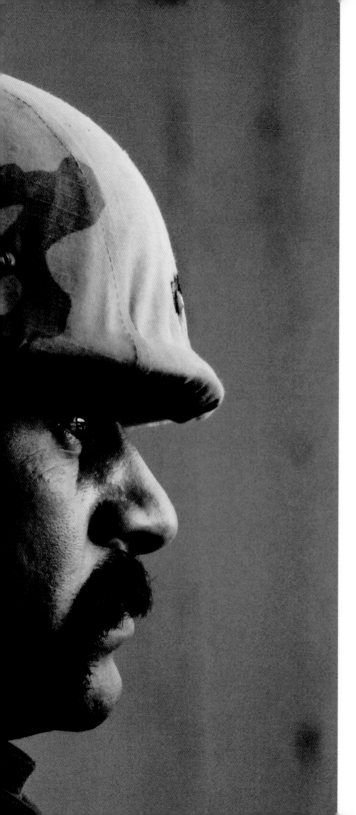

We rarely correlate the Iraq war with Iraqi Army casualties, but there are many. Their soldiers ride around in ancient vehicles that are no match for increasingly lethal roadside bombs, and their personal body armor protects their vital organs and nothing else. For every one of our casualties, they appear to have two.

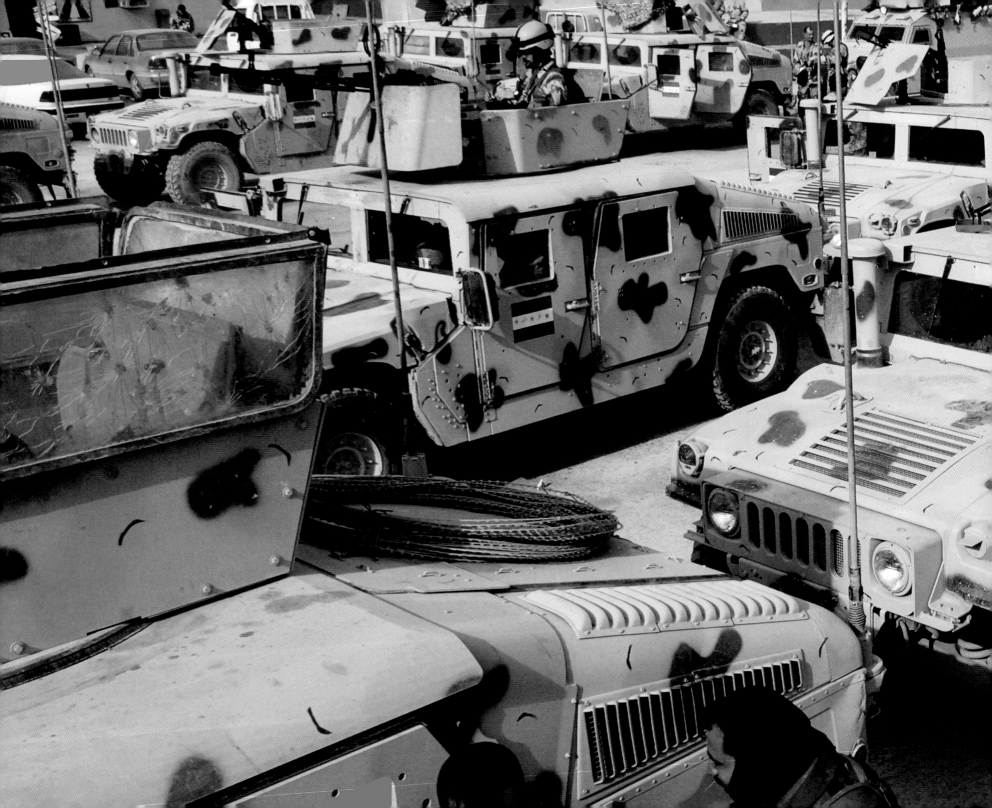

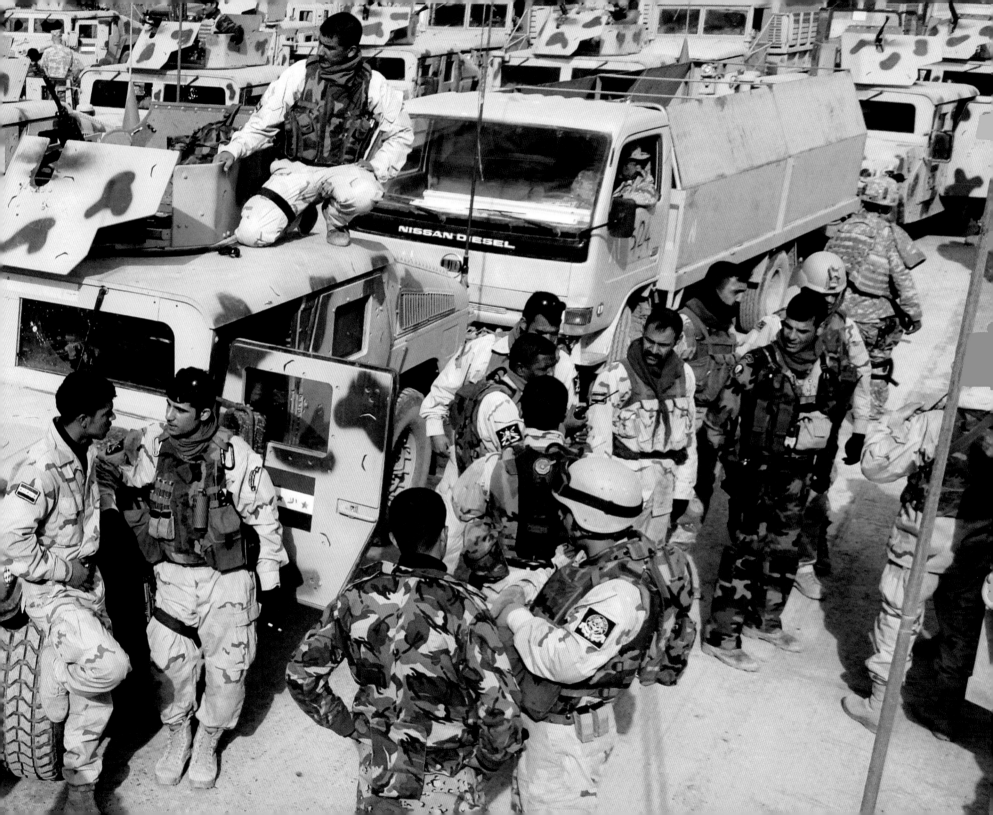

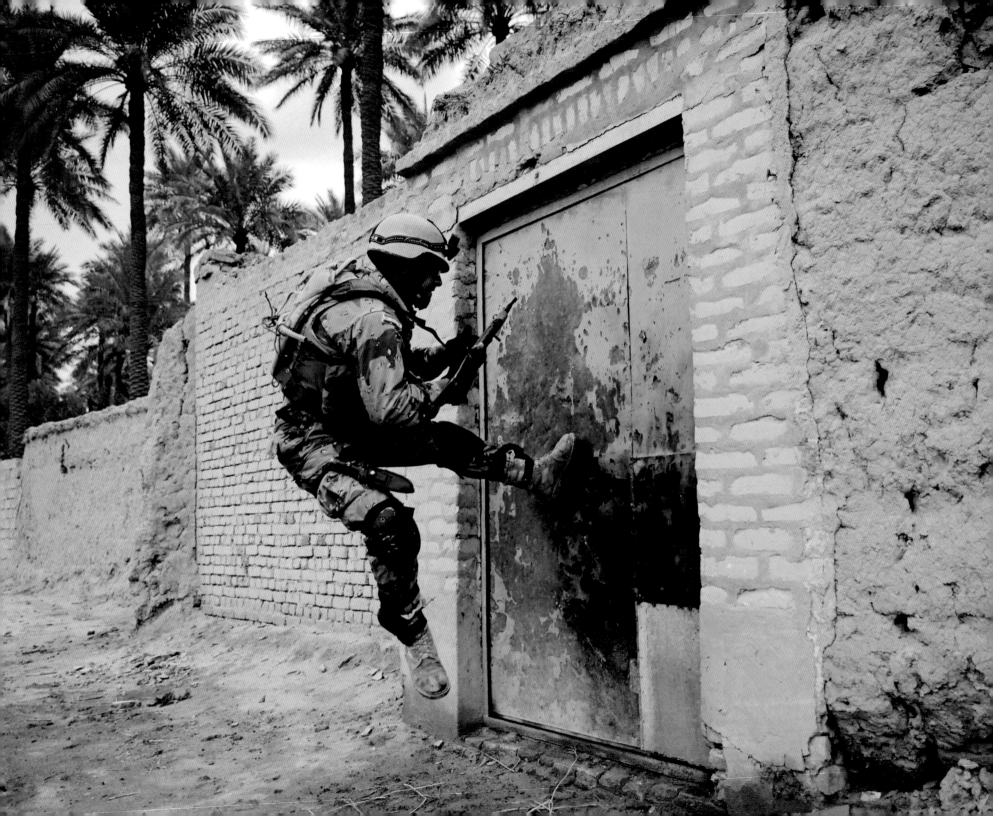

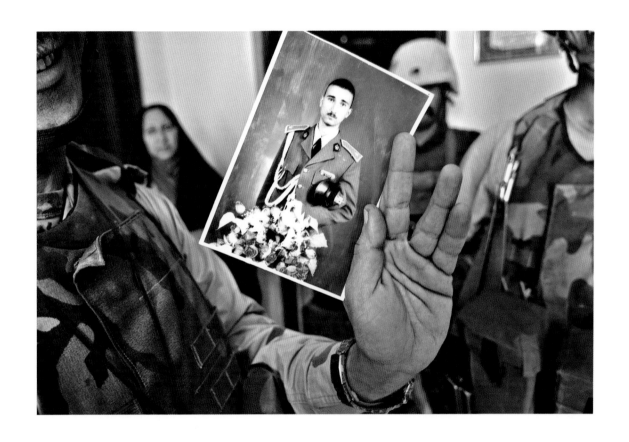

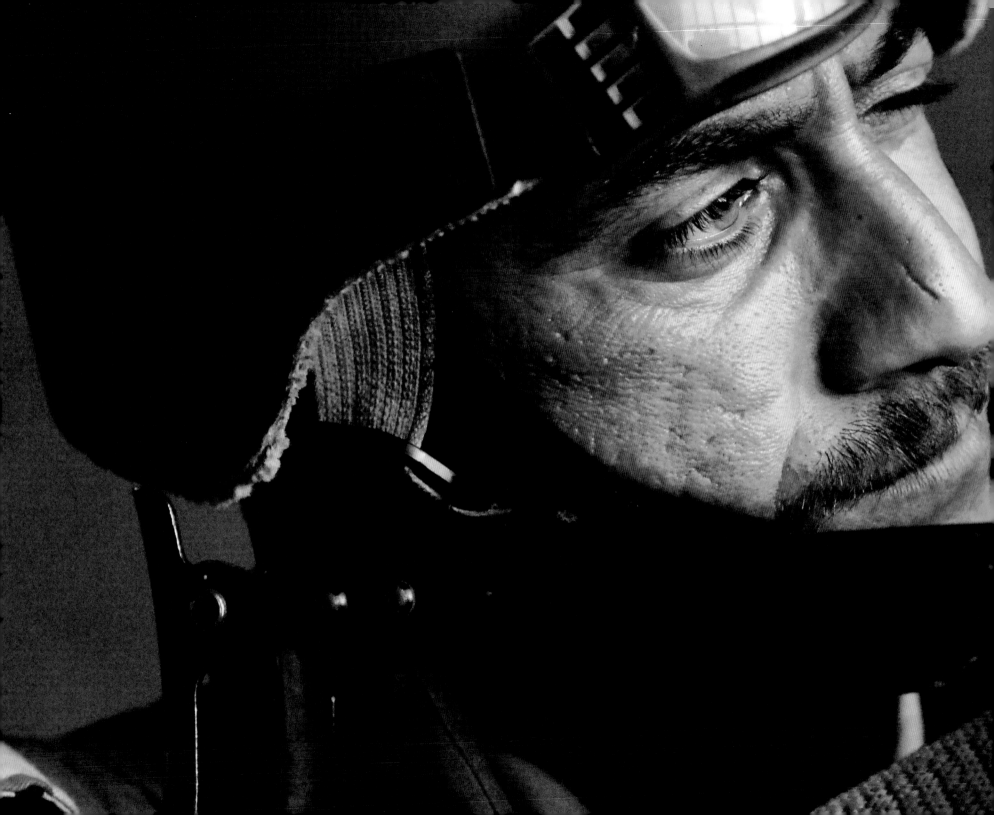

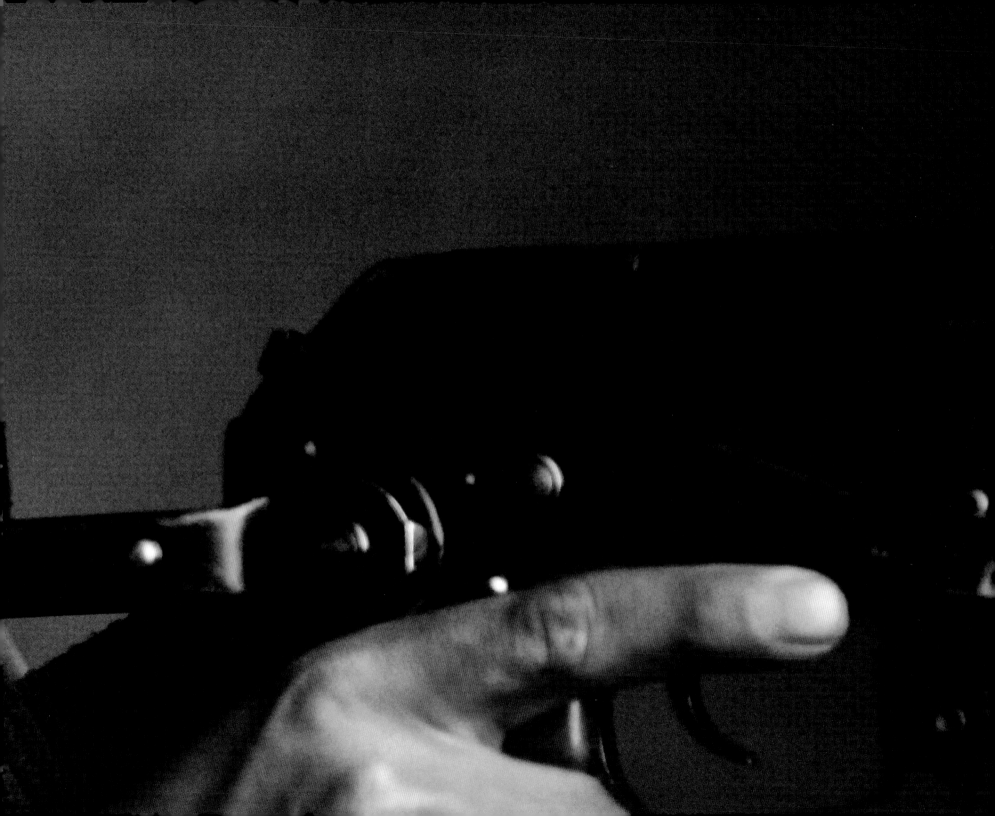

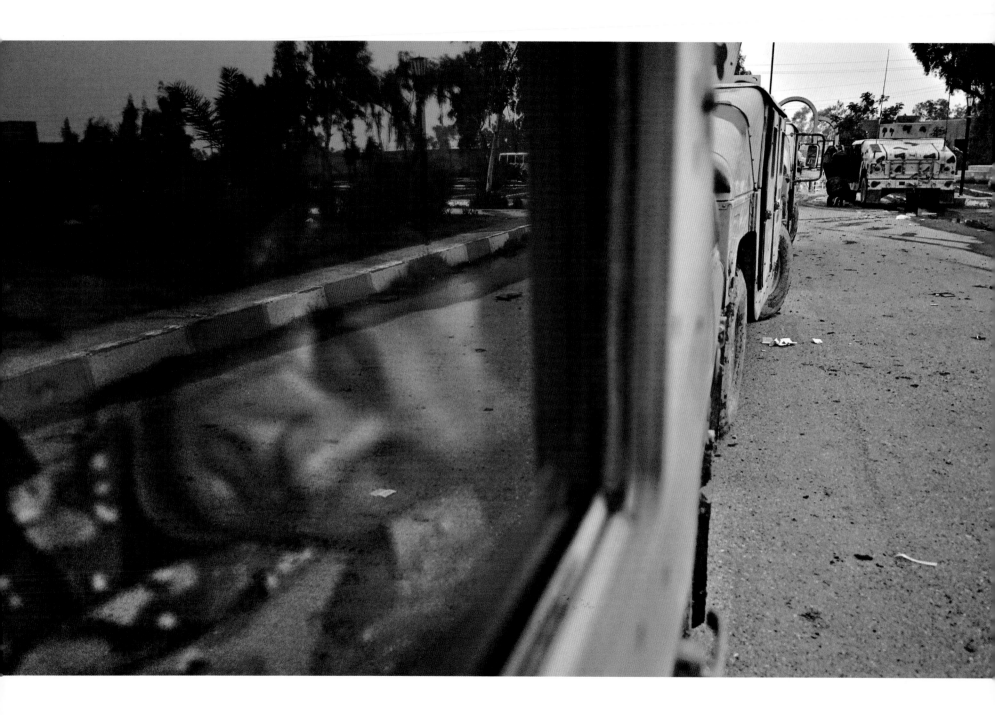

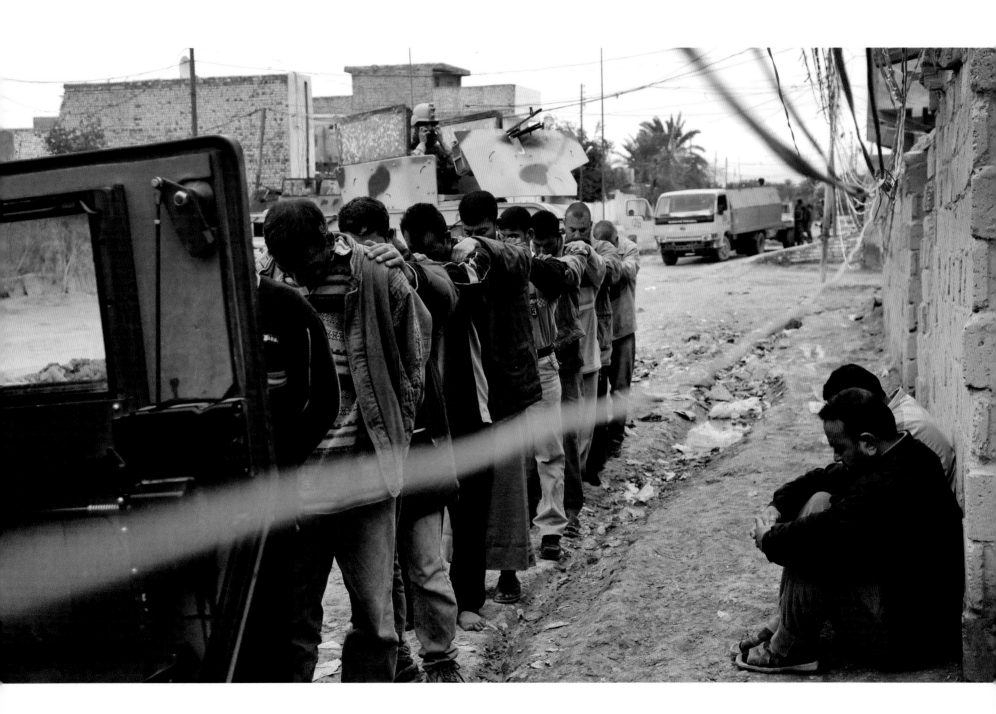

There's no one you can trust. One night before a big combat mission, the Iraqi cook slips poison into the food with the intention of making the Iraqi Army units ill, or worse, killing them and preventing the mission from happening. Thank God, I eat with the American military transition team that night—my usual, Cocoa Puffs cereal.

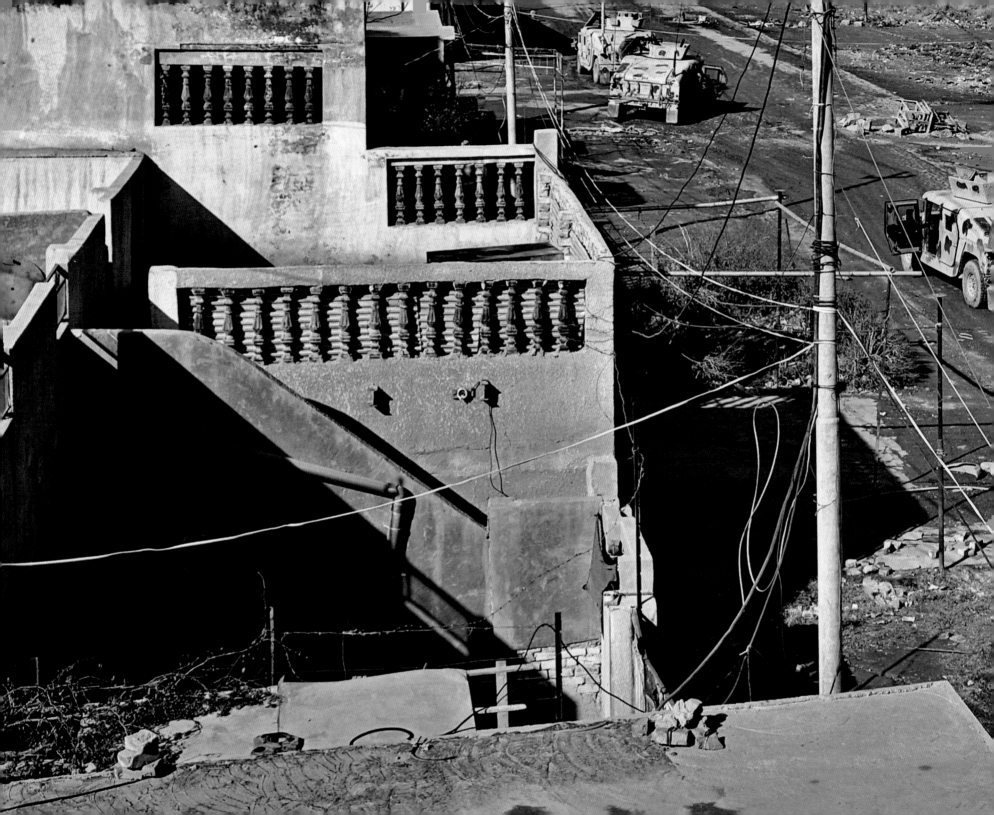

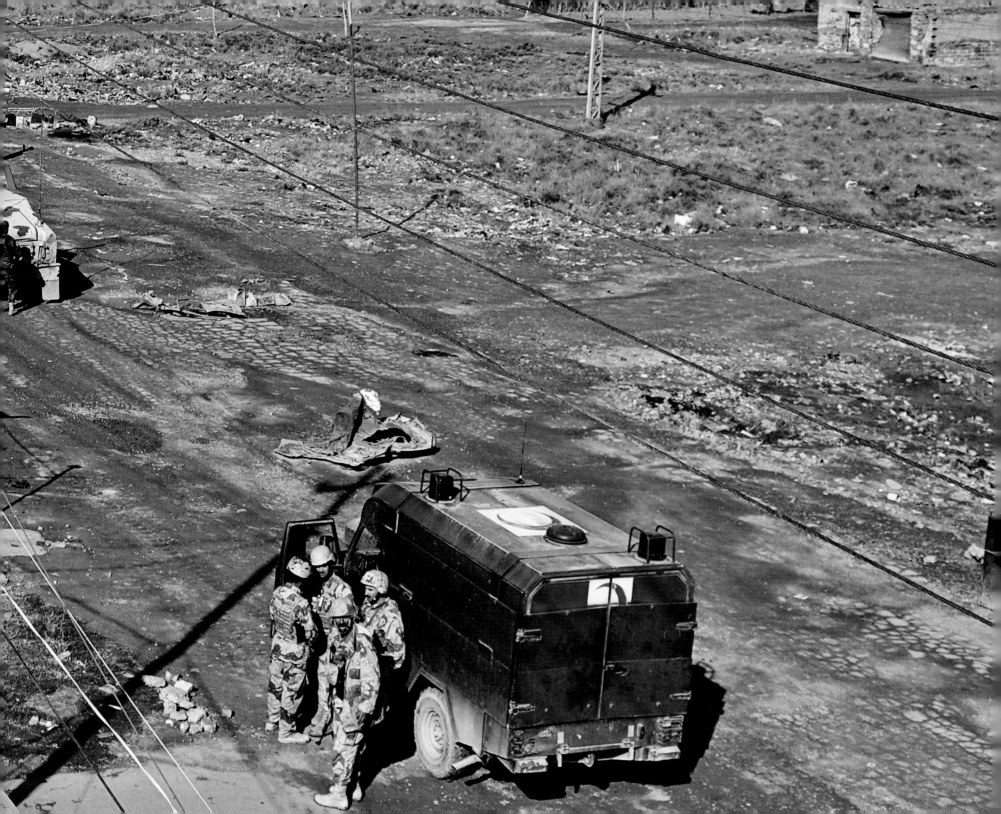

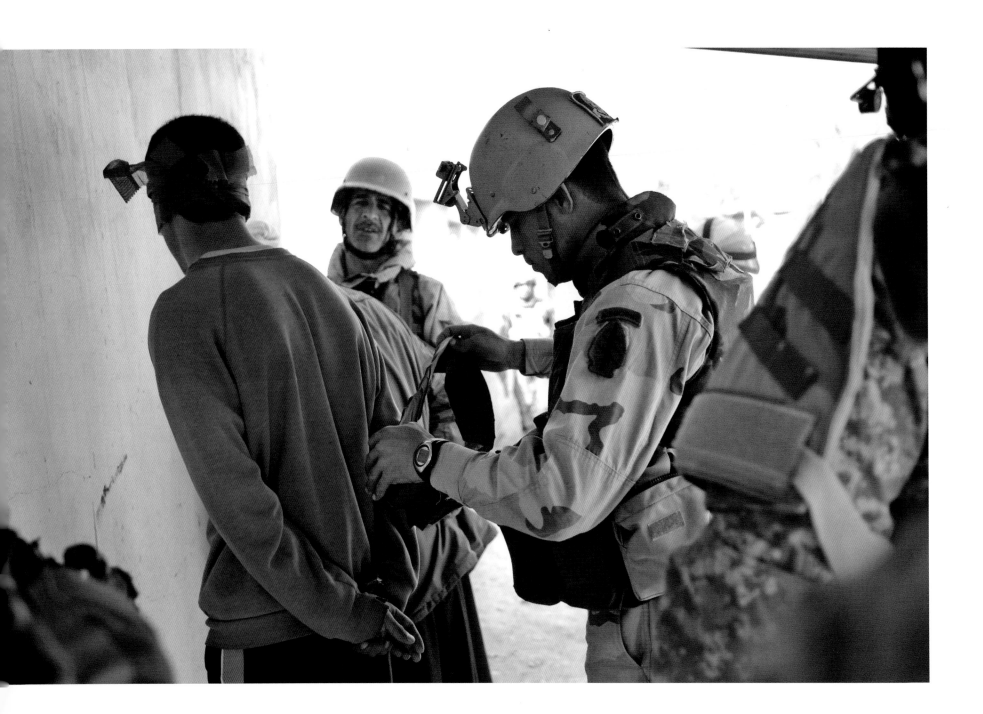

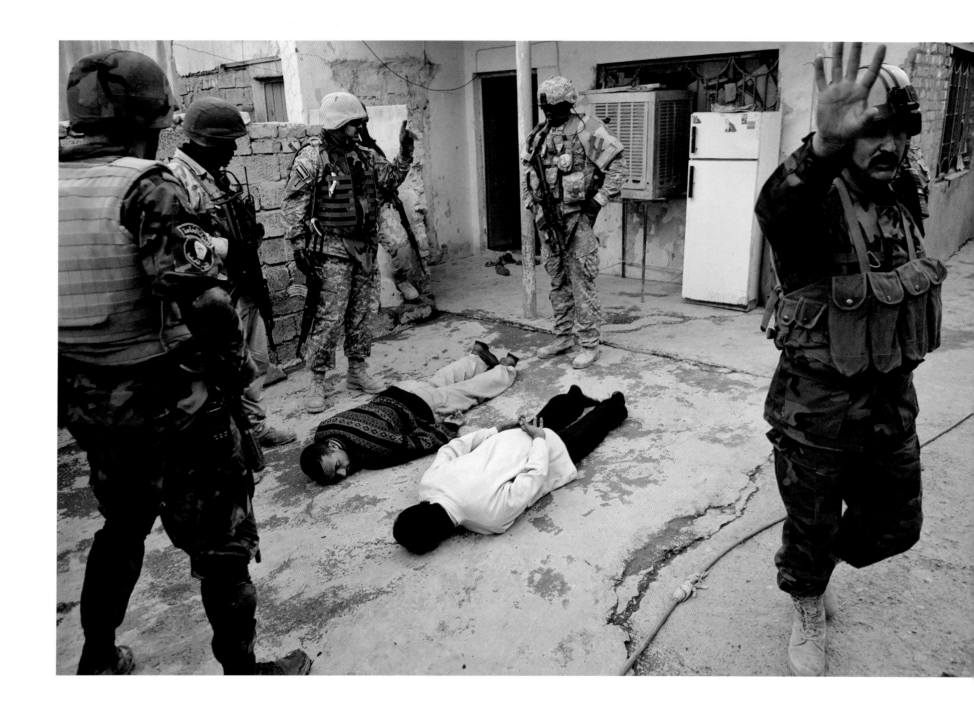

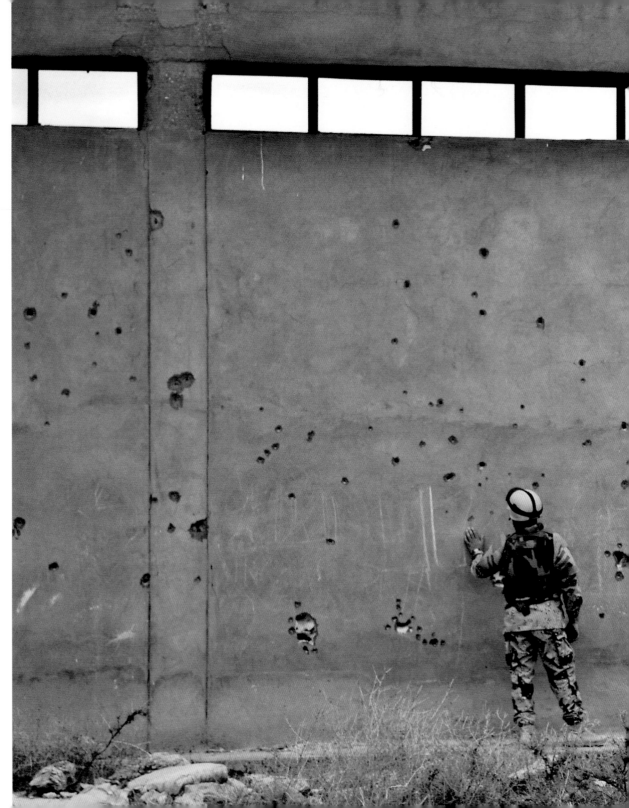

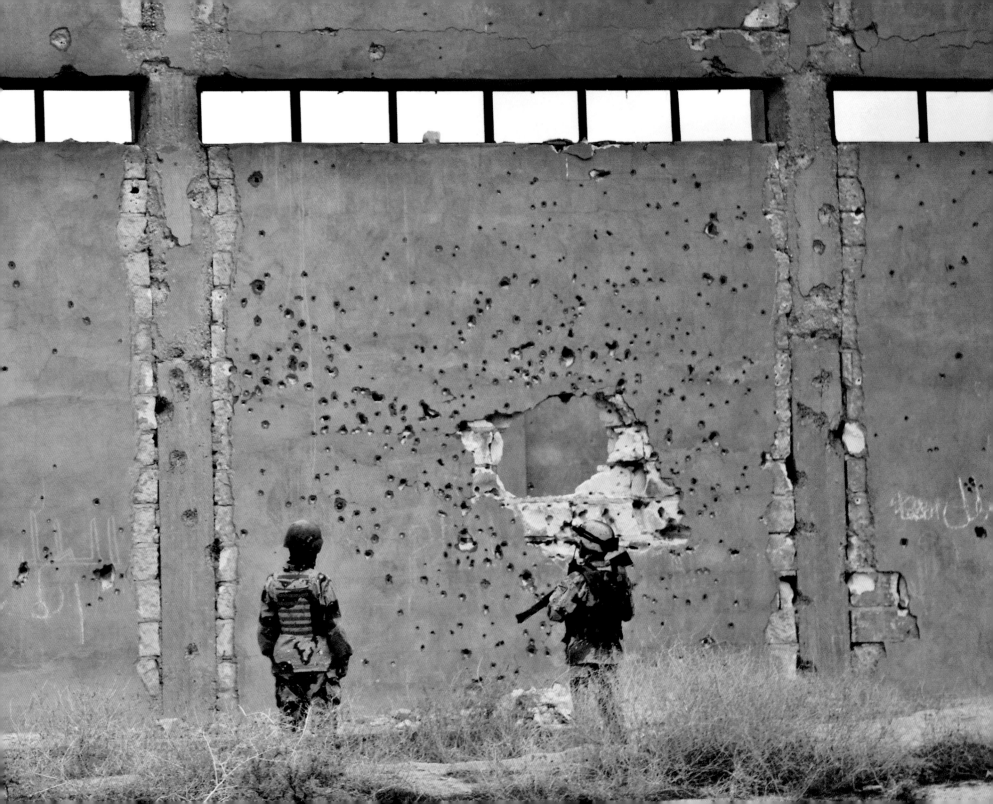

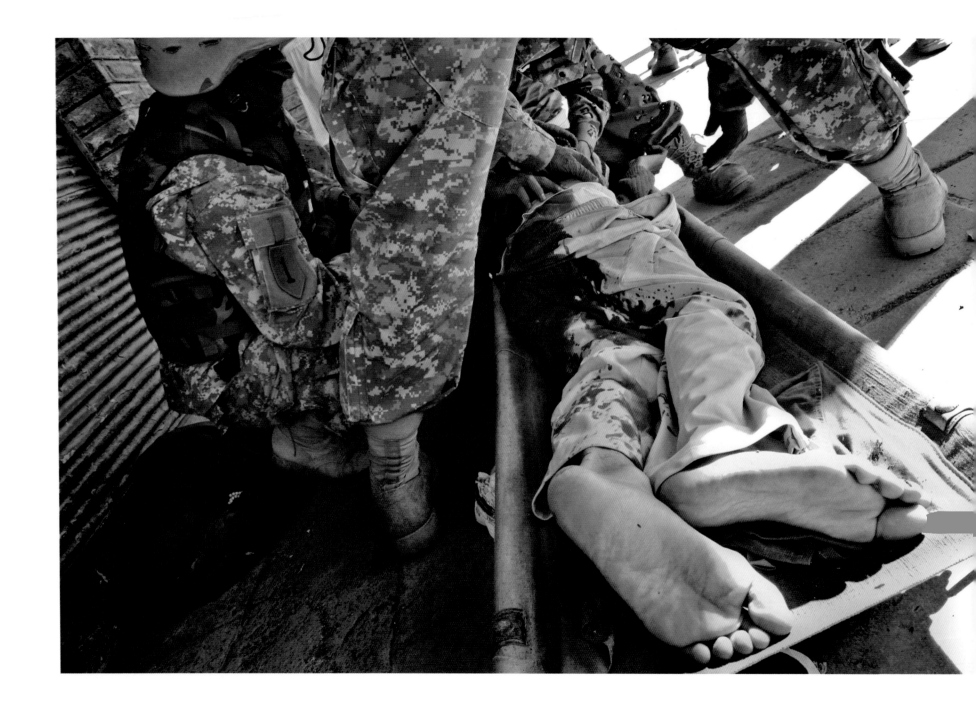

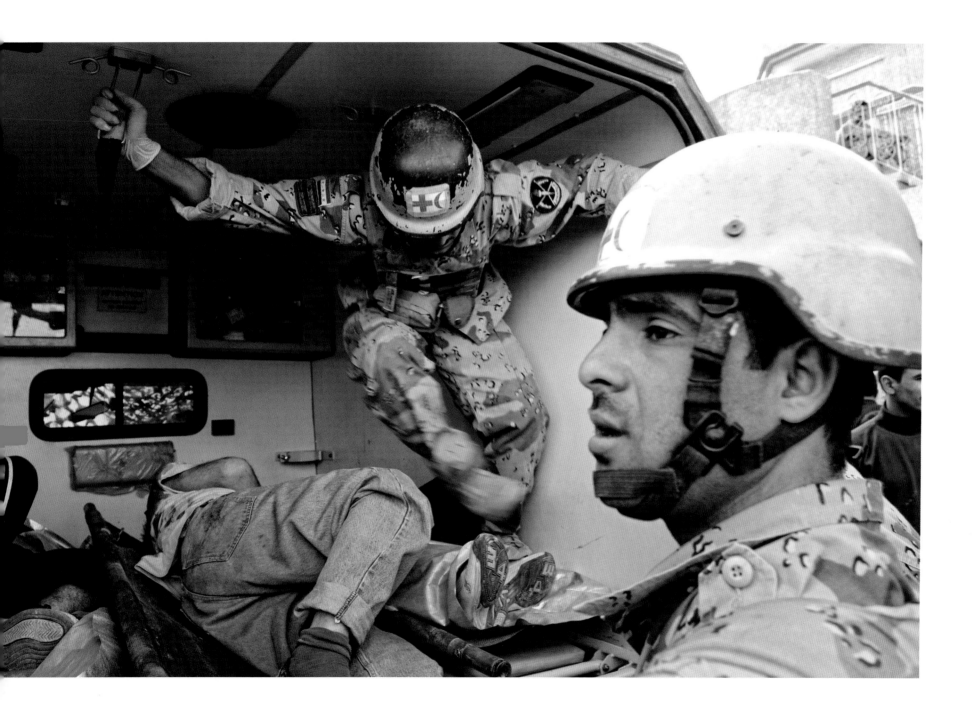

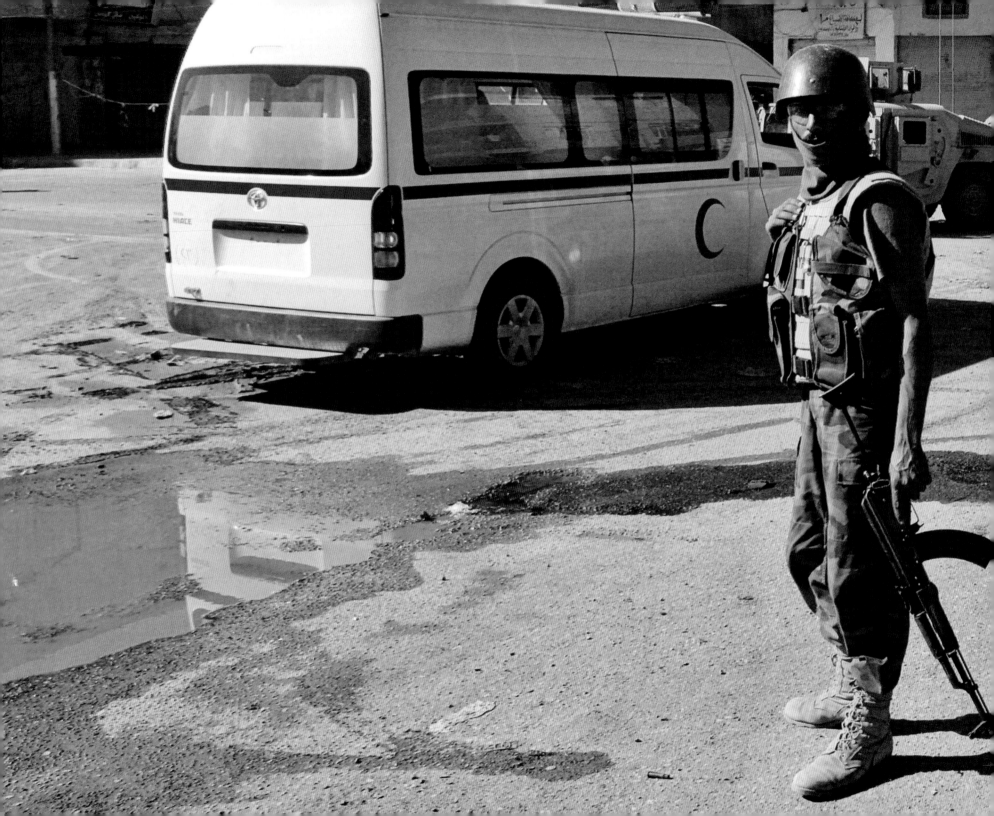

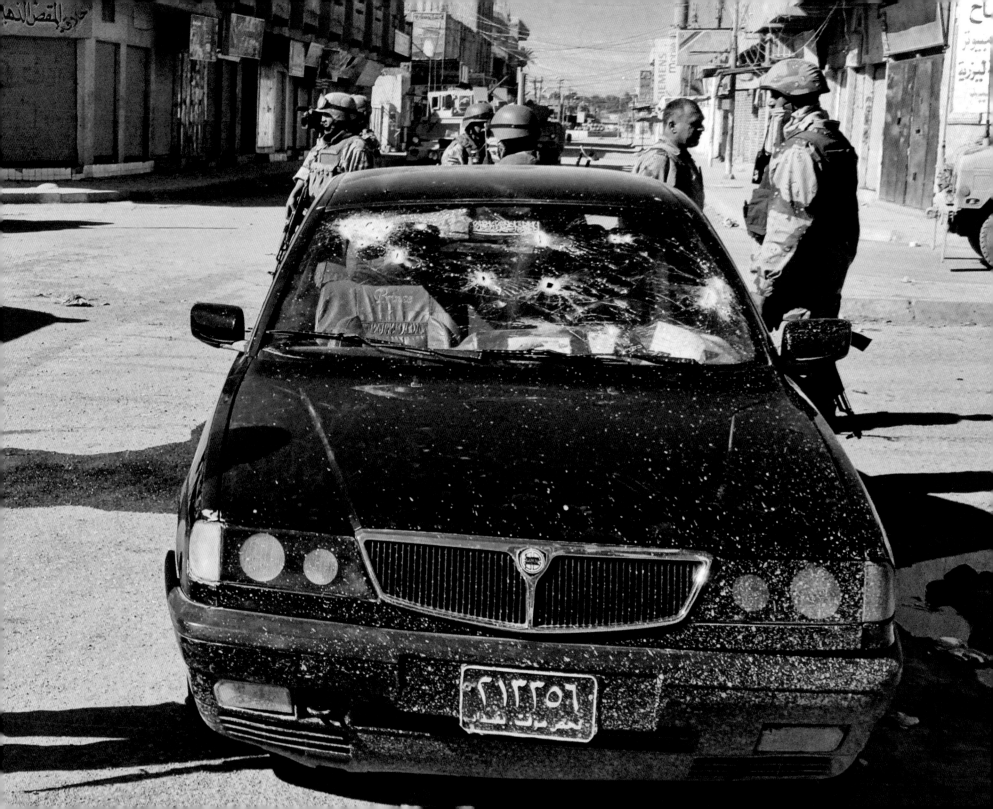

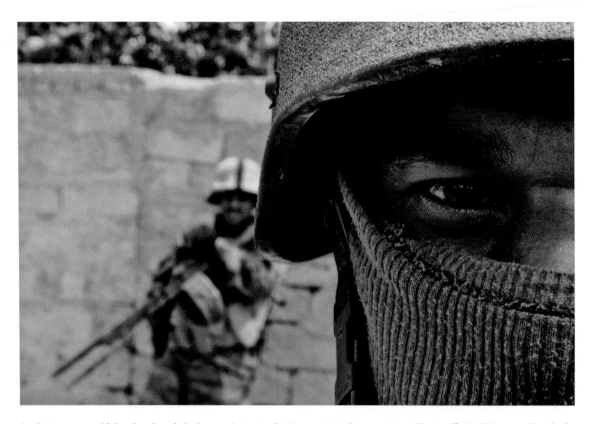

I picture myself in the Iraqis' shoes. I try to fathom what it must be like to fight this war in their hometowns and, in some cases, in their own backyards. They wear ski masks to hide their identities from their childhood neighbors. I suppose out of fear and humiliation, Iraqi soldiers tell those closest to them that they have other occupations, because the army has become synonymous with corruption, pillaging, and injustice. It's unfair; most are decent, kind, generous people.

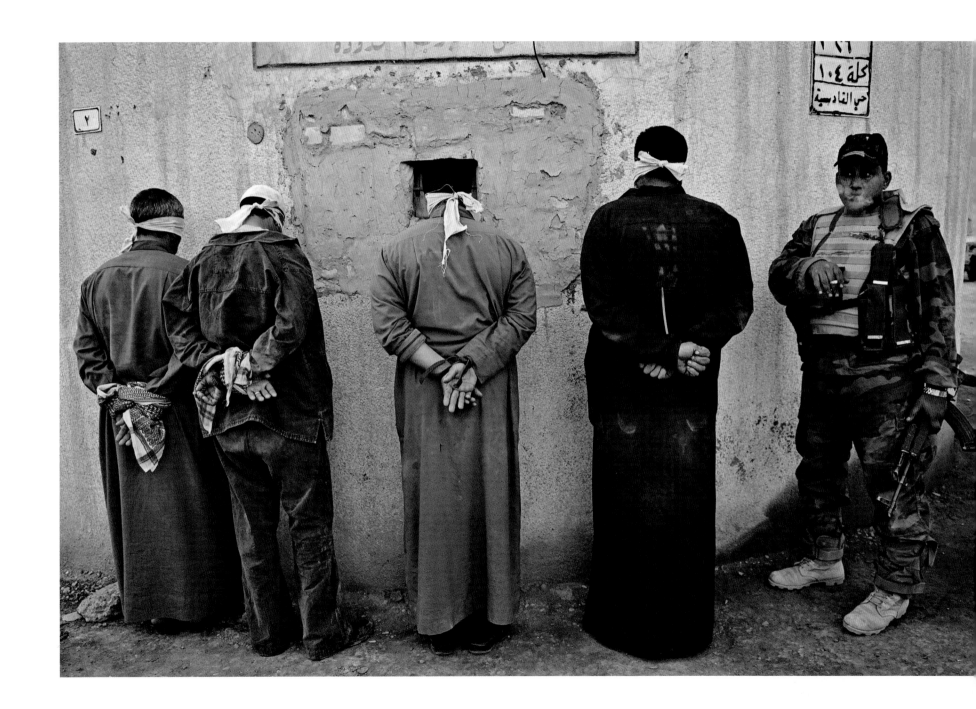

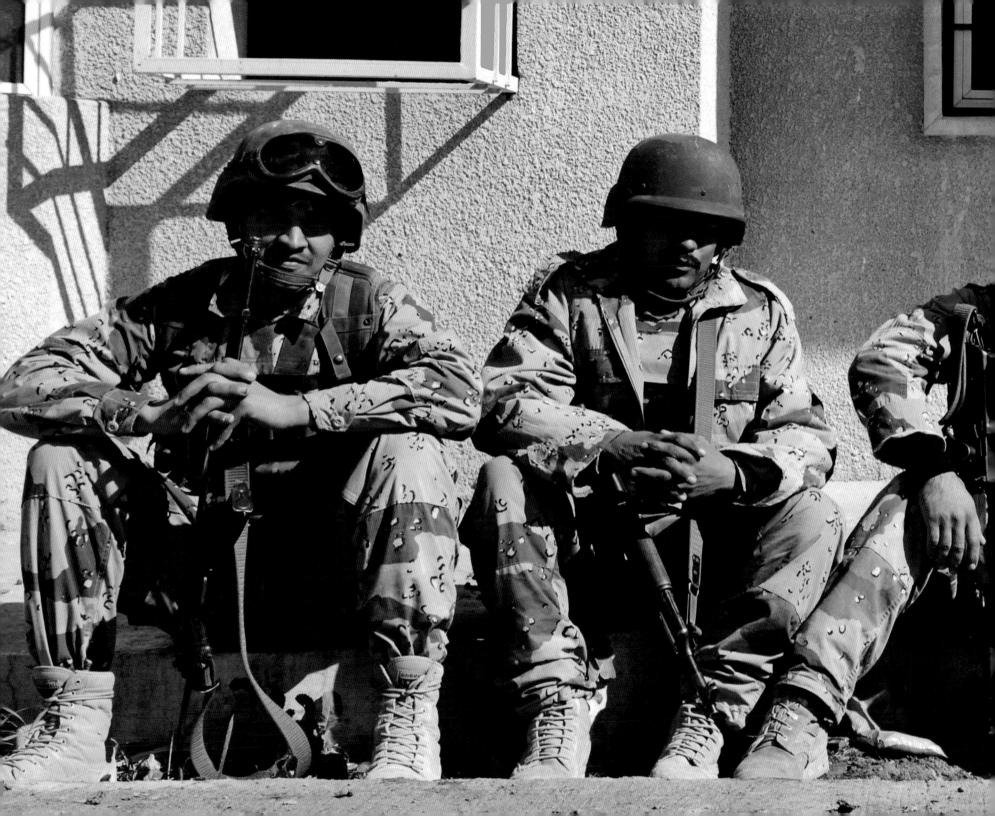

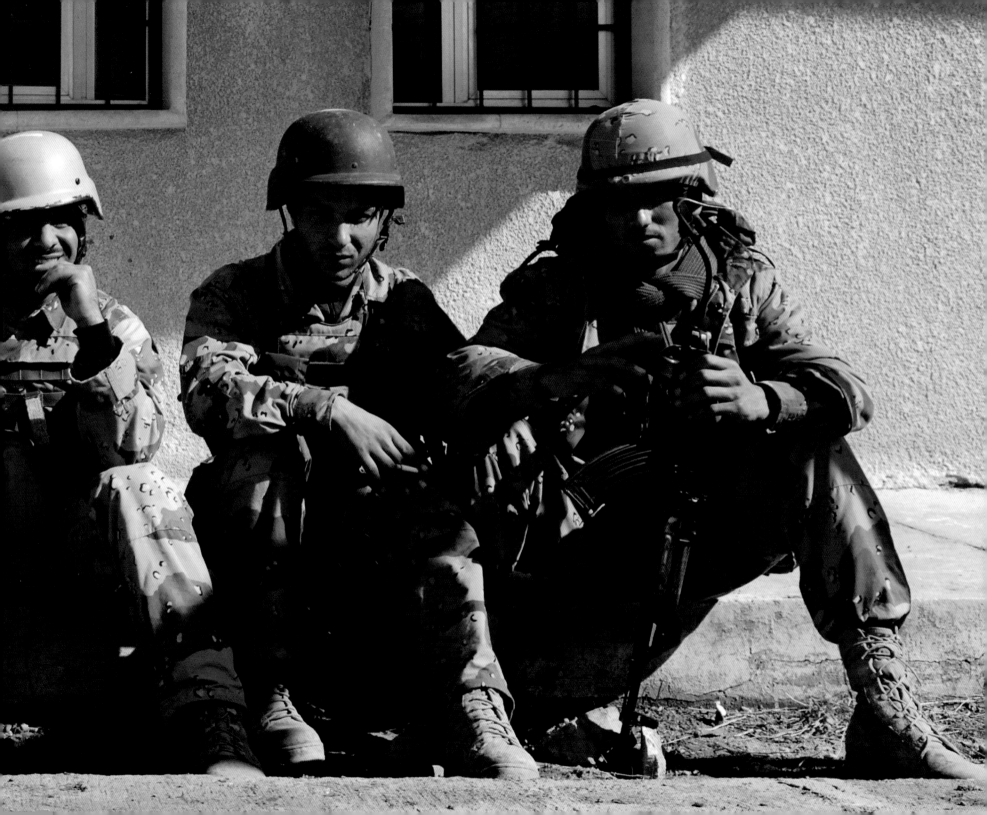

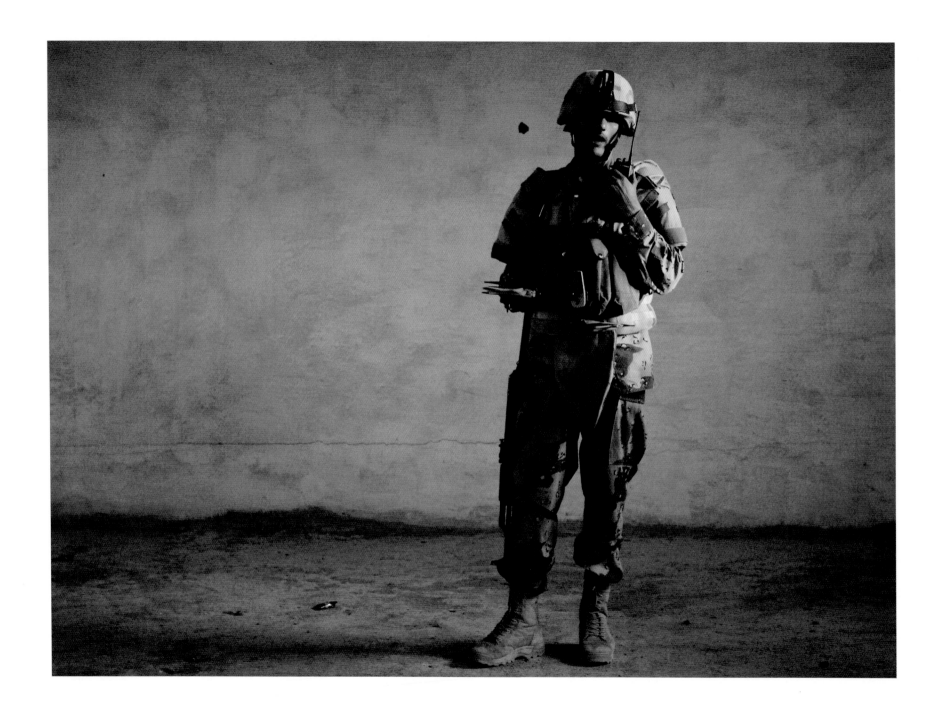

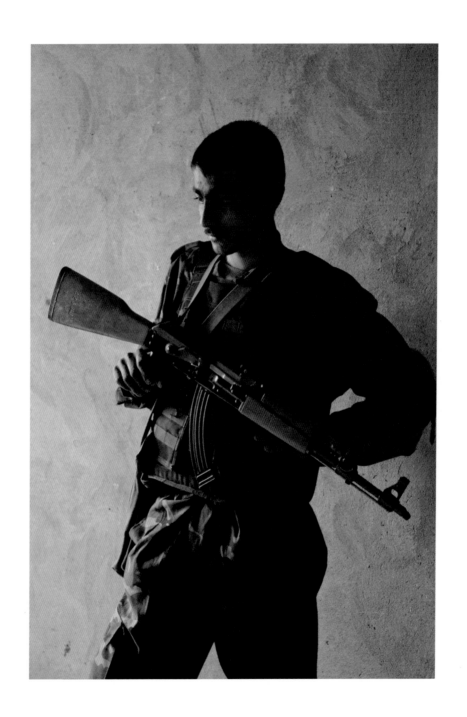

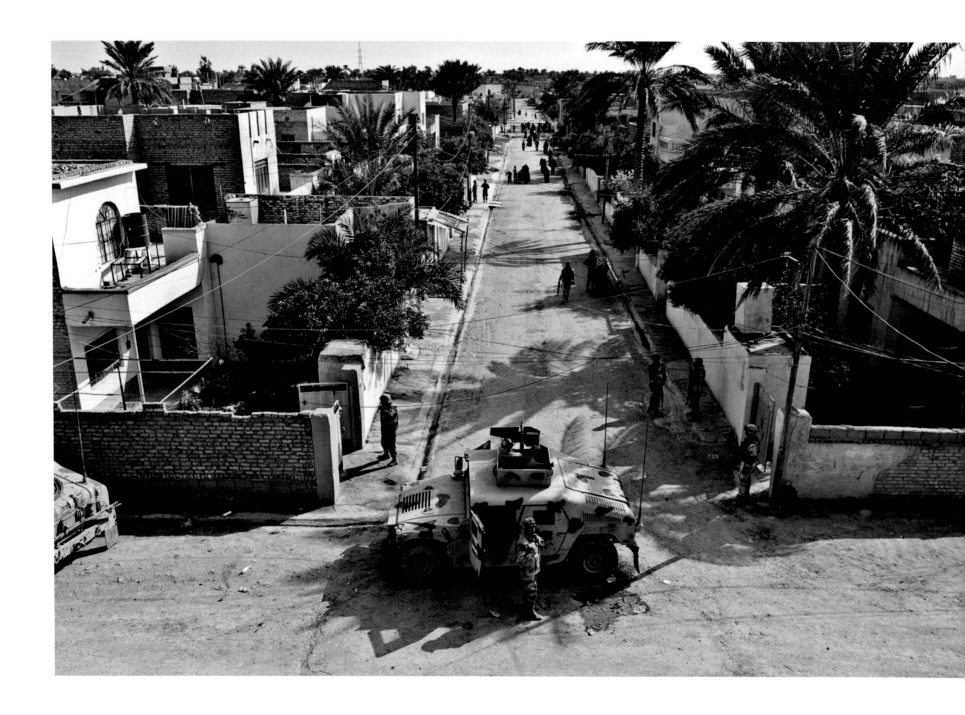

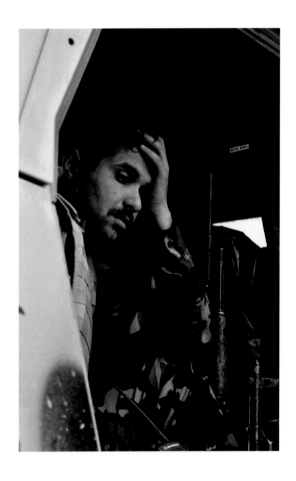

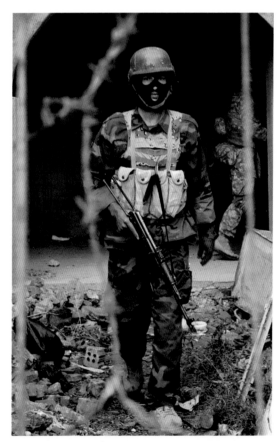

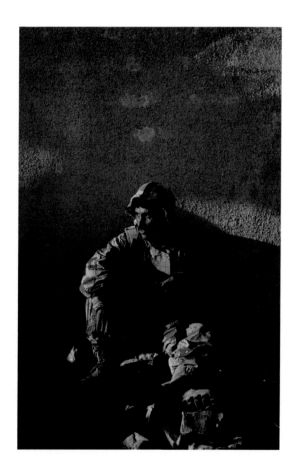

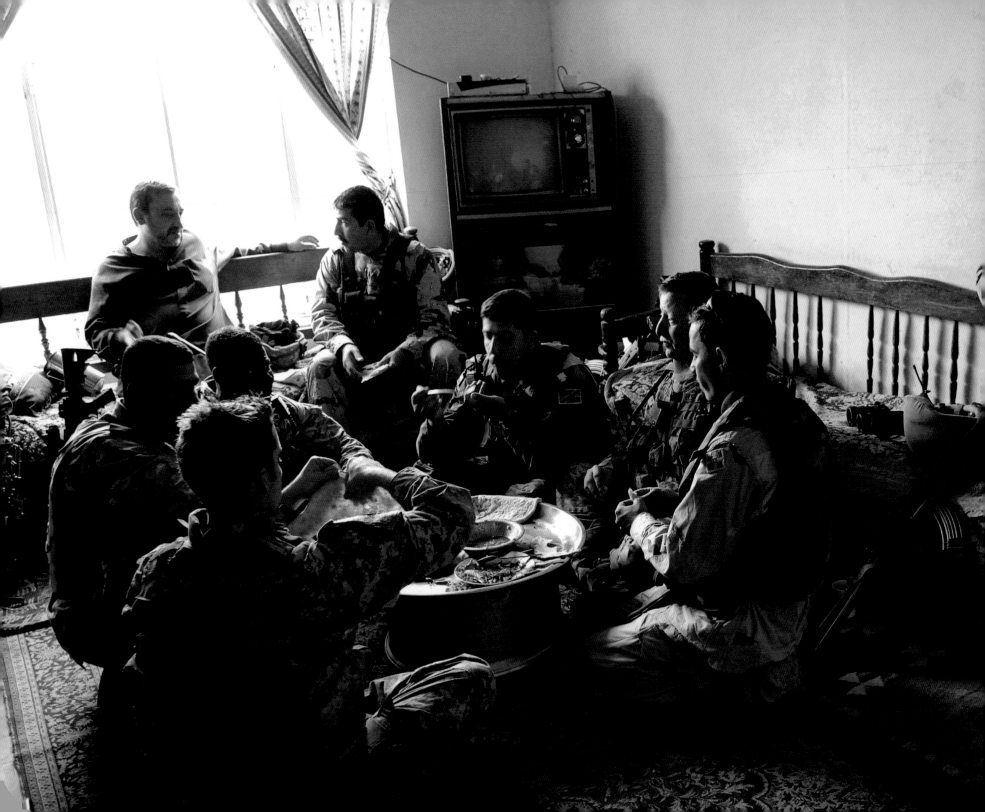

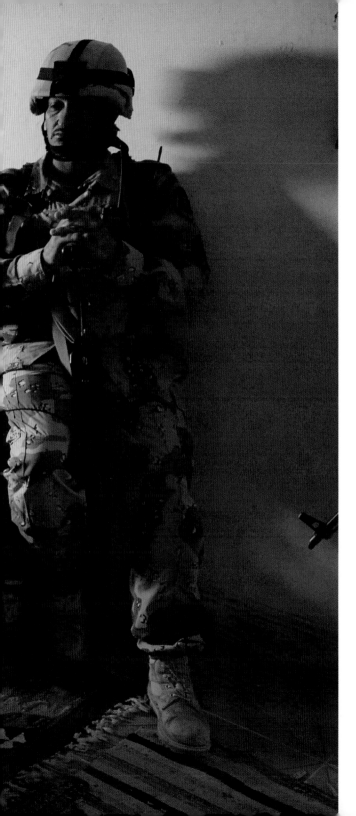
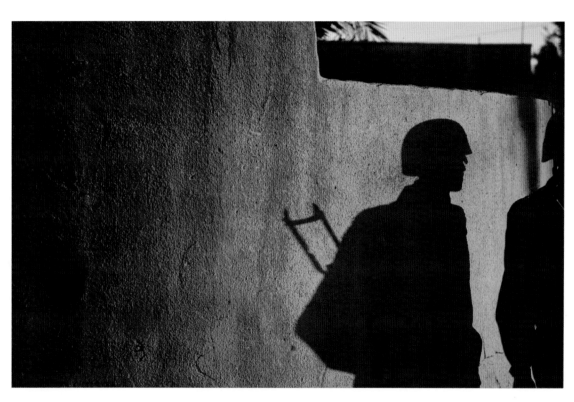

24

Time in combat is filled by death. Every minute we fight, survive, witness, or succumb to it.

Most people fill hours with life. While we're making our way on this planet, we all fill twenty-four hours a day doing *something.* Somewhere on the planet a woman is in labor, another is feeding or scolding her child, and another is burying her child. Someone has just bought a car. Somebody is putting his feet in the ocean for the first time. Someone catches a fly ball for a third out while someone else thousands of miles away tends a herd of goats. Somebody has just found out his wife is having an affair with his boss and thinks it's the worst day of his life . . . and maybe it is. A five-year-old loses hold of her balloon, and it's the worst day of her life, too.

I'm almost certain that the worst days of my life have been in Iraq. I've buried brothers. I've suffered three direct IED hits. I've suffered brain and neck injuries that have changed my life forever. But, then again, I survived. So each day—every single blessed one of them—must also have been the best day of my life.

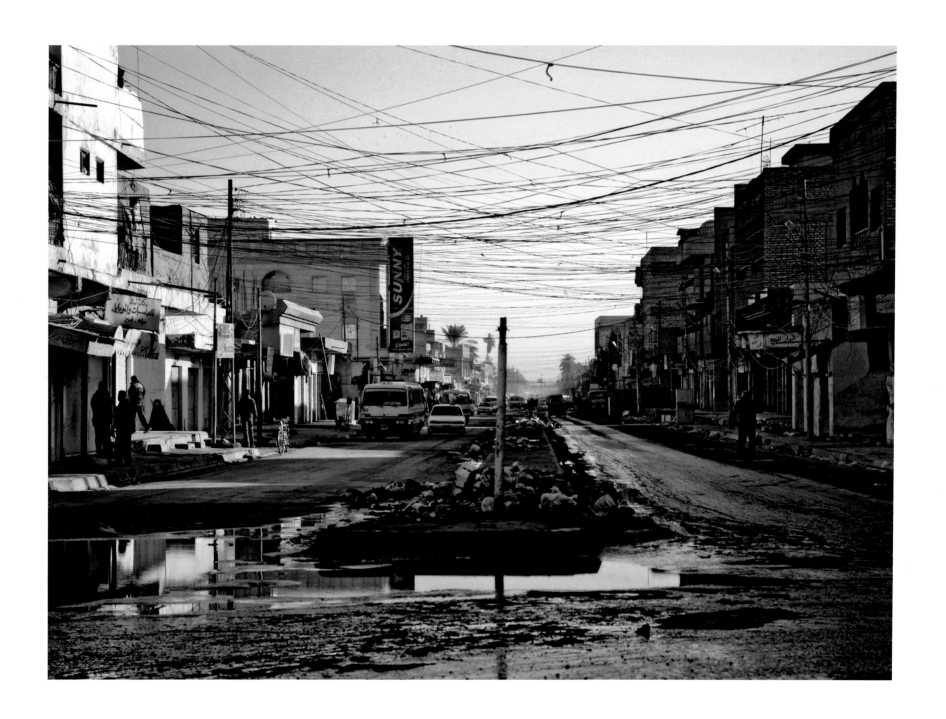

When one serves his or her country in a time of war, a single twenty-four-hour period can feel like a never-ending episode of *Survivor*. It's like walking a tightrope with no safety net. And there's never a break. It's twenty-four hours of nonstop tension. You take your gun to the bathroom. A force field doesn't close up over your rack at night; your living quarters won't necessarily protect you from mortars and rockets. You're always on call. There's no weekend, no happy hour, no bubble bath, no adult physical contact, and you can forget about sleeping in—ever.

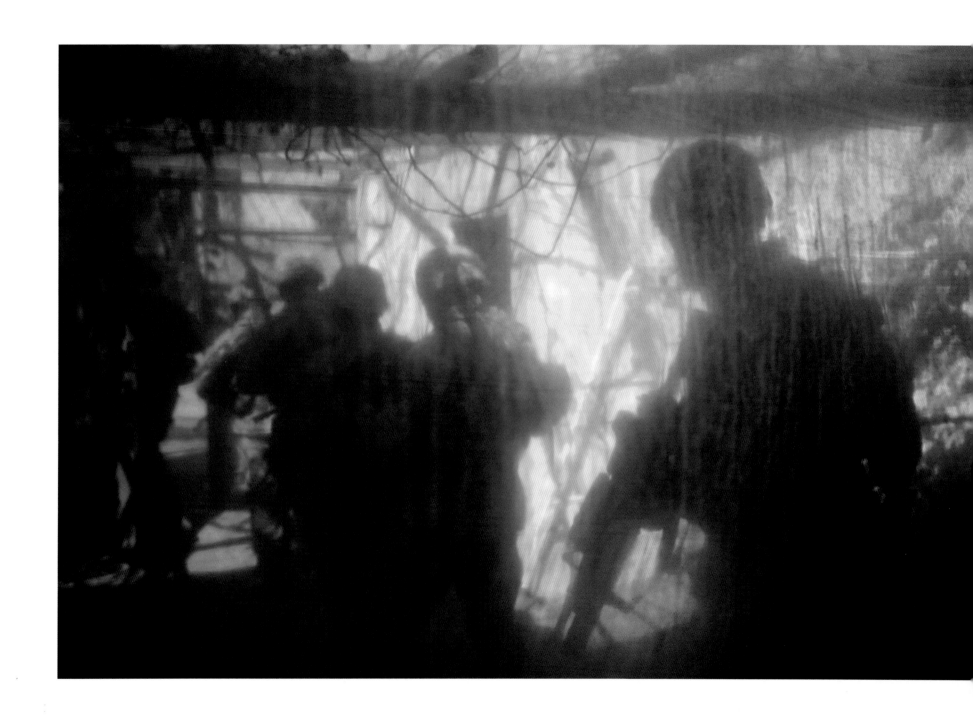

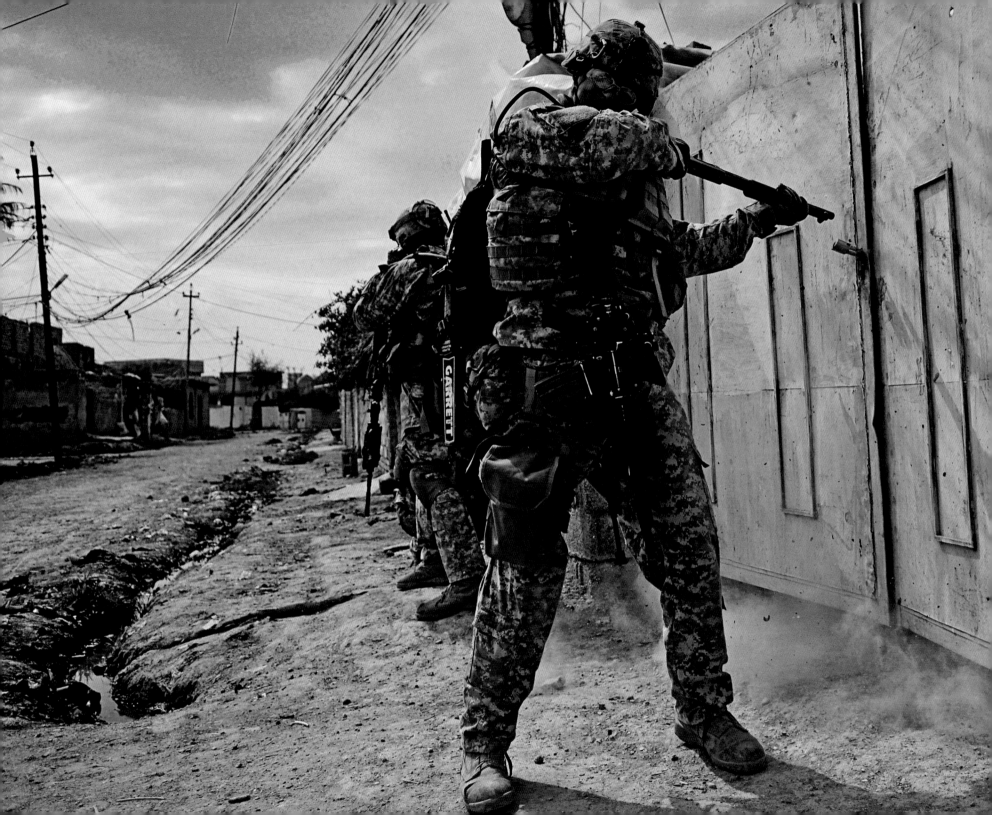

The fight is all you have—it's pretty much all you think about, and you're sick with it. It's your constant. Sure, there's camaraderie. There are moments of brevity and moments of grace. There's spontaneity. But hours seem like weeks, and weeks seem like years. You feel trapped in an endless loop, in a time warp from which there is no escape. Every morning in Iraq, I wake up feeling like I'm in the movie *Groundhog Day,* and a clock radio is about to start playing Sonny and Cher's "I Got You, Babe." It's the worst sort of cabin fever.

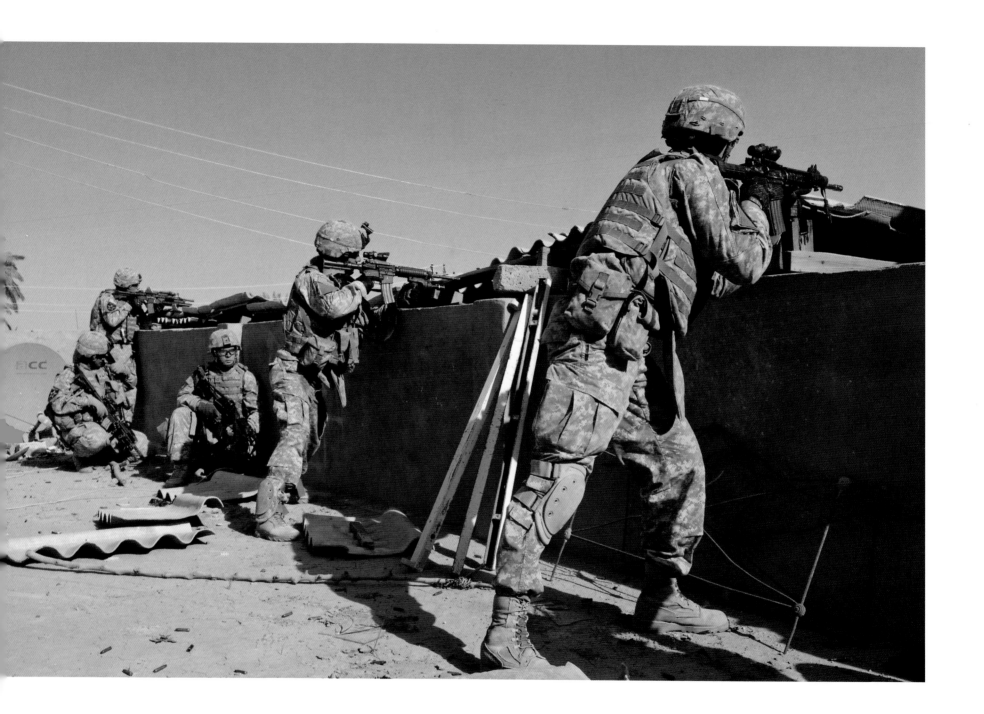

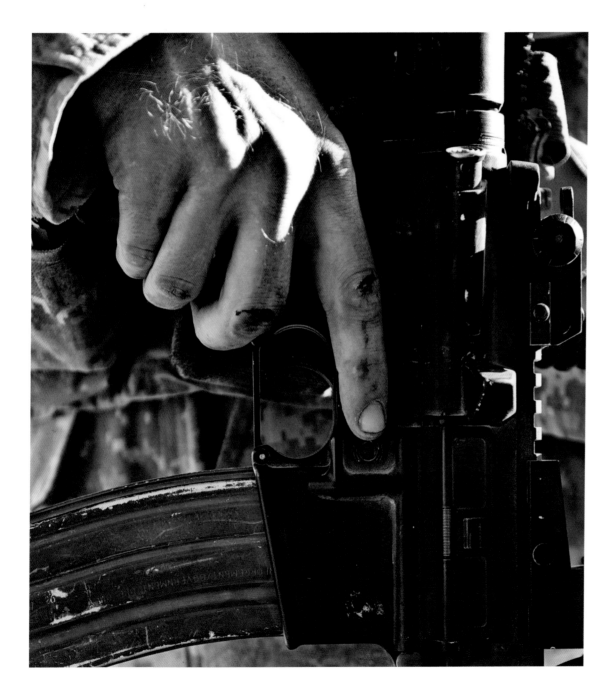

I went to Iraq three times. My first time was at age twenty-three, my final at age twenty-seven. It's not a huge percentage of my life. As I grow older, this percentage will become smaller and smaller; the war's half-life will continue to shrink. As it recesses, I hope its impact—this whole of how war consumes a person—becomes manageable. I once thought life could be chalked up to either mathematics or coincidence. It's not. There's what we can control and what we can't. It's real, and it's now. It's living in the moment—no matter what that moment brings.

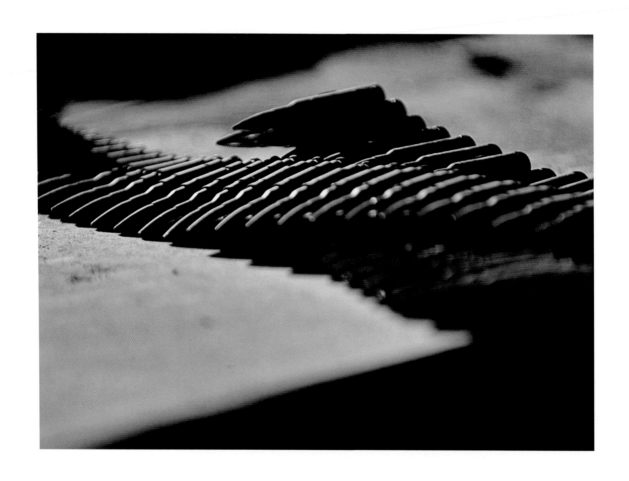

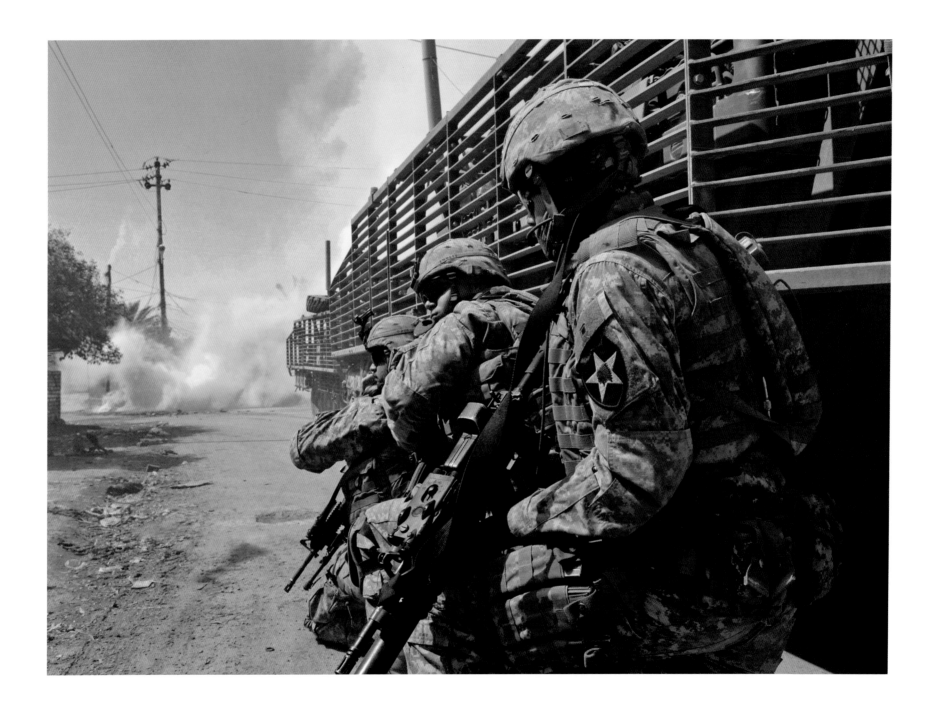

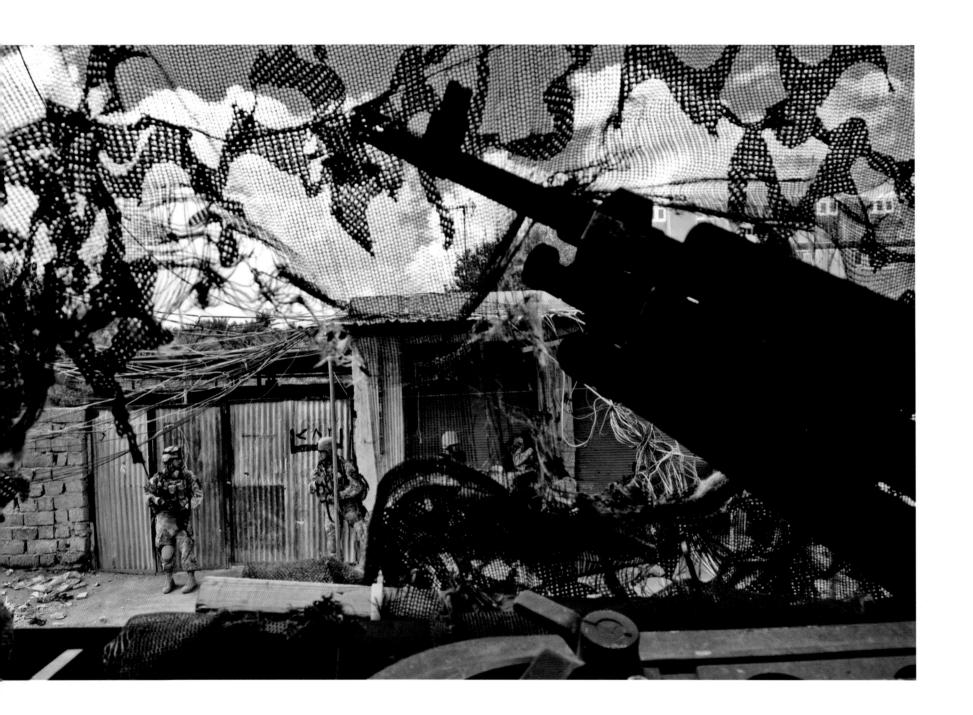

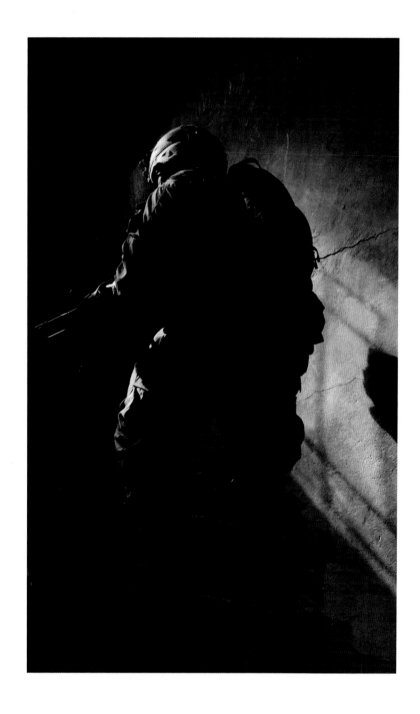

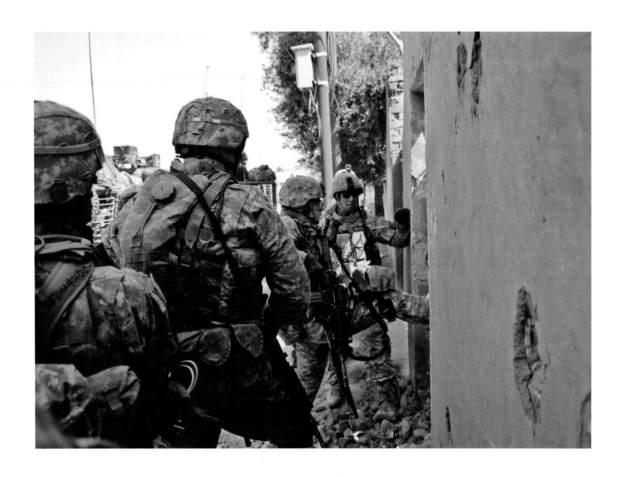

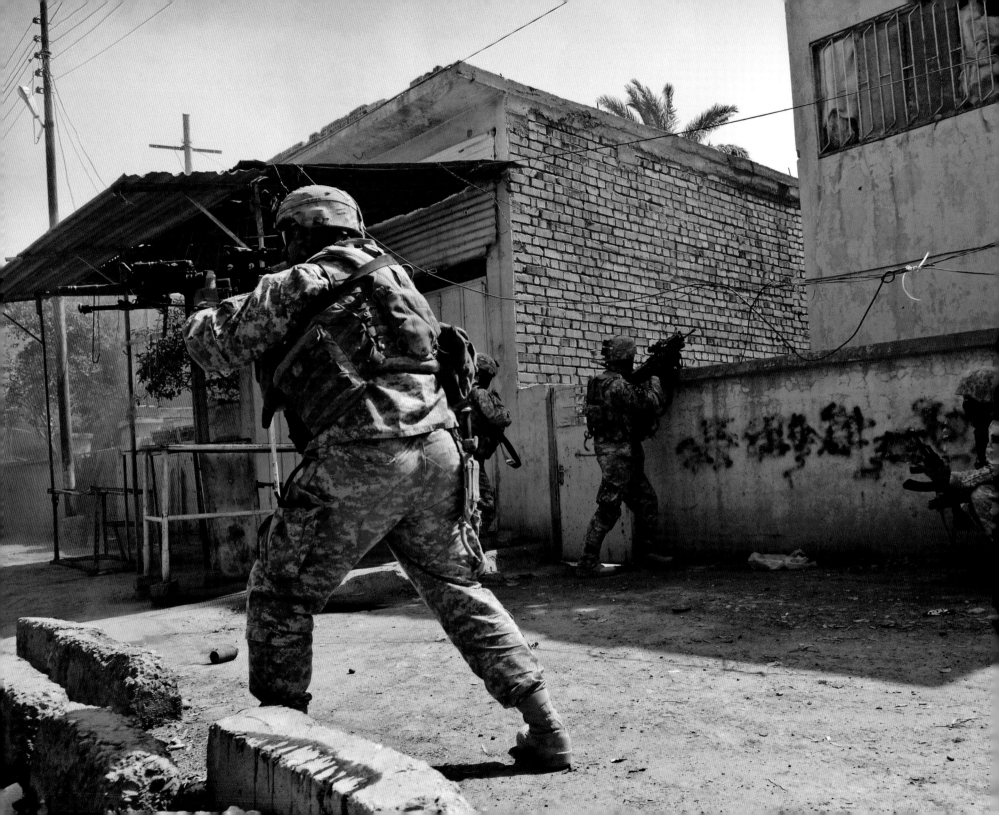

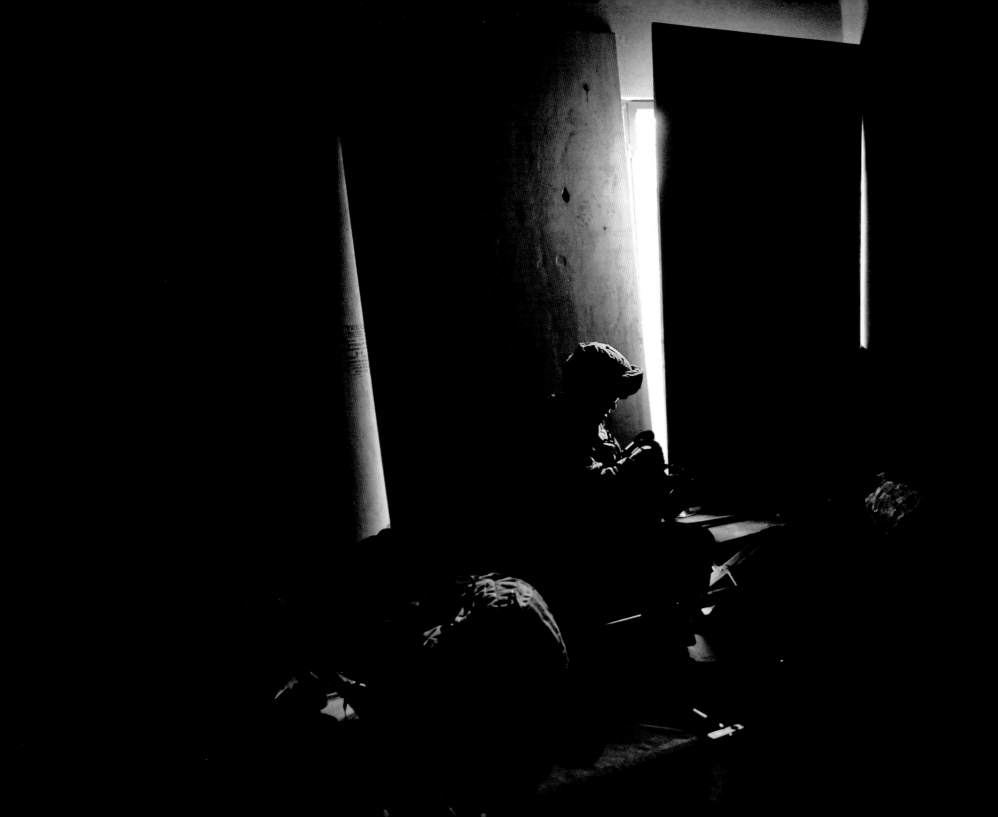

DOWN TIME

When you're stuck on a roof for a couple of days with a bunch of guys, nothing's private.

At the end of the day, we were able to go back to the FOB (forward operating base), and everyone could head off to wherever they were going. Different soldiers do different things. Some play Xbox; some sleep; and some lift weights. Some wrestle with their friends outside the dining facility, testing their manhood and trying to beat the day's stress out of each other. Some Skype home.

Home. You begin to spend less time thinking about home than most people imagine. You're in soldier mode. All of the mundane chores you'd be responsible for at home are no longer on your radar. Other people are there to wash your clothes, cook your meals, and clean the bathrooms. Your sole purpose is to fight the enemy.

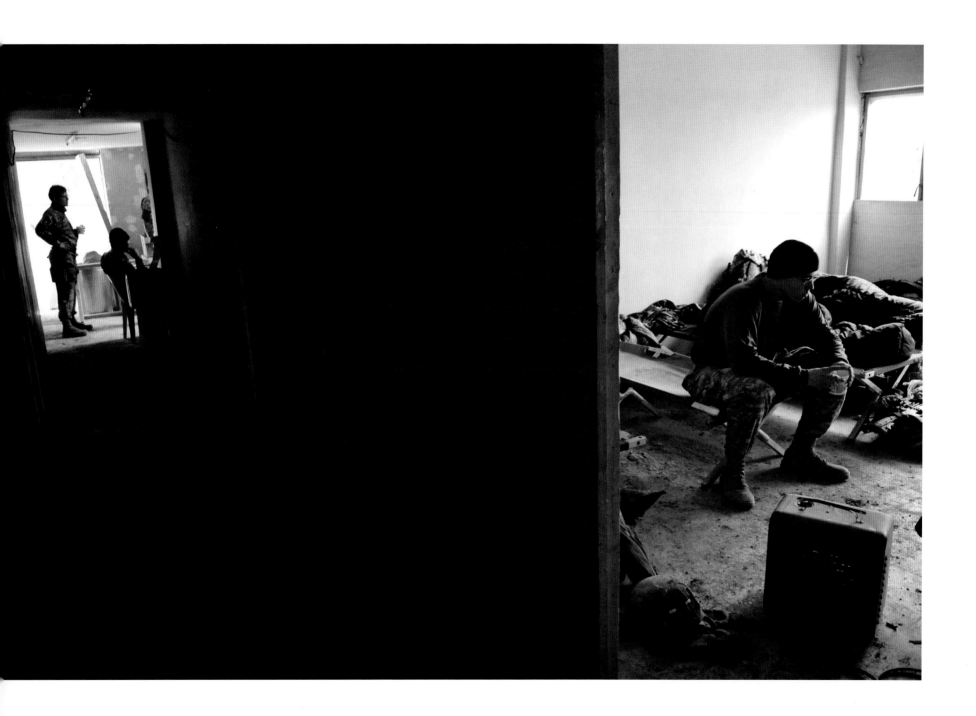

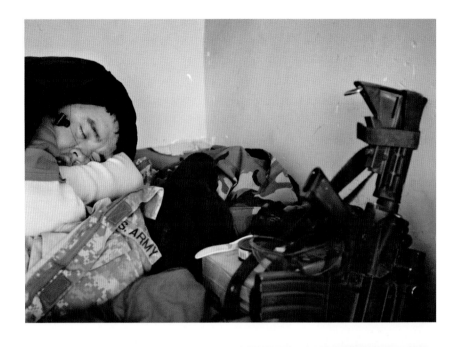

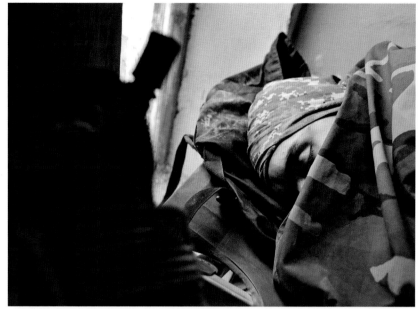

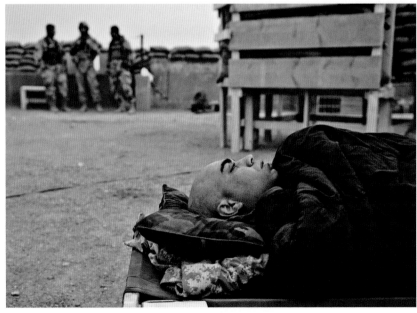

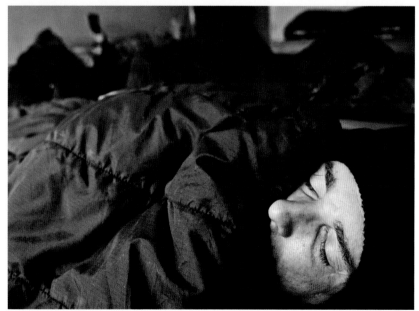

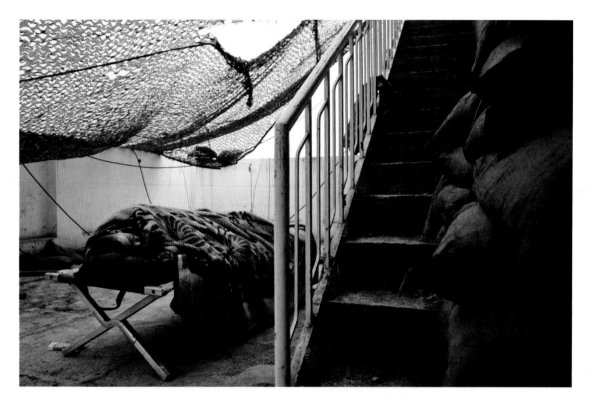

I find peace watching soldiers dream. It's a time when they shut out the war, reconnect with loved ones, or just zone out. I rarely sleep. Although my eyelids feel heavy and fatigue washes over my body, anxiety stirs my soul and adrenaline surges through my veins as I begin to nod off. Sleep is elusive, so I continue to daydream.

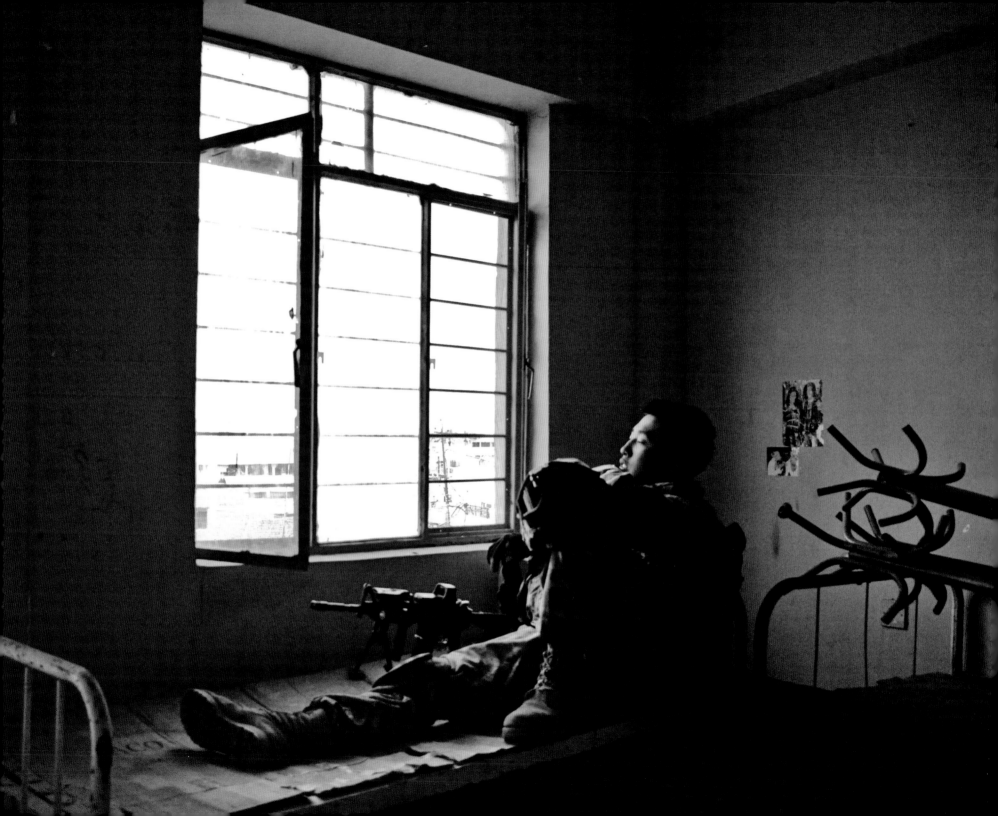

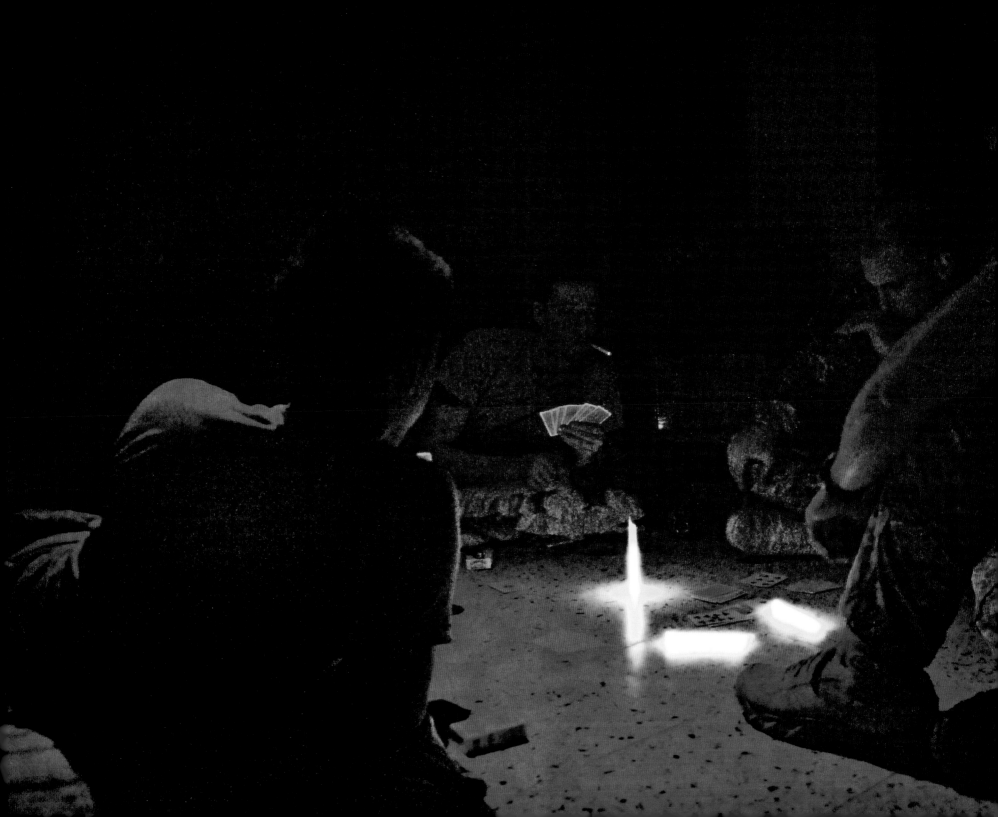

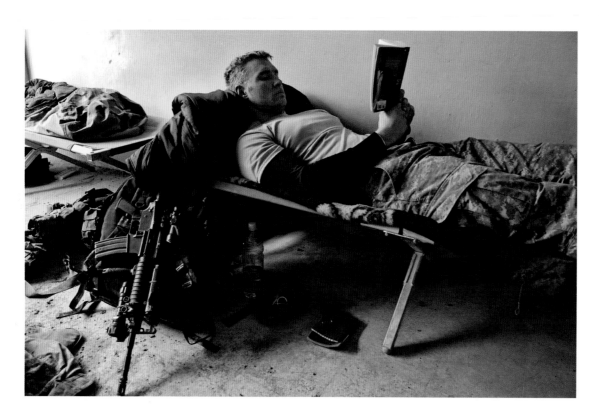

Soldiers sleep where they can—on floors, cots, mats, and boxes; under stairs; in vehicles and out-side on top of vehicles. They sleep as mortars slam the earth nearby and as volleys of gunfire break the night's silence. Weapons are ever-present, as if standing watch; some are clutched in the arms of soldiers while others are perched at attention.

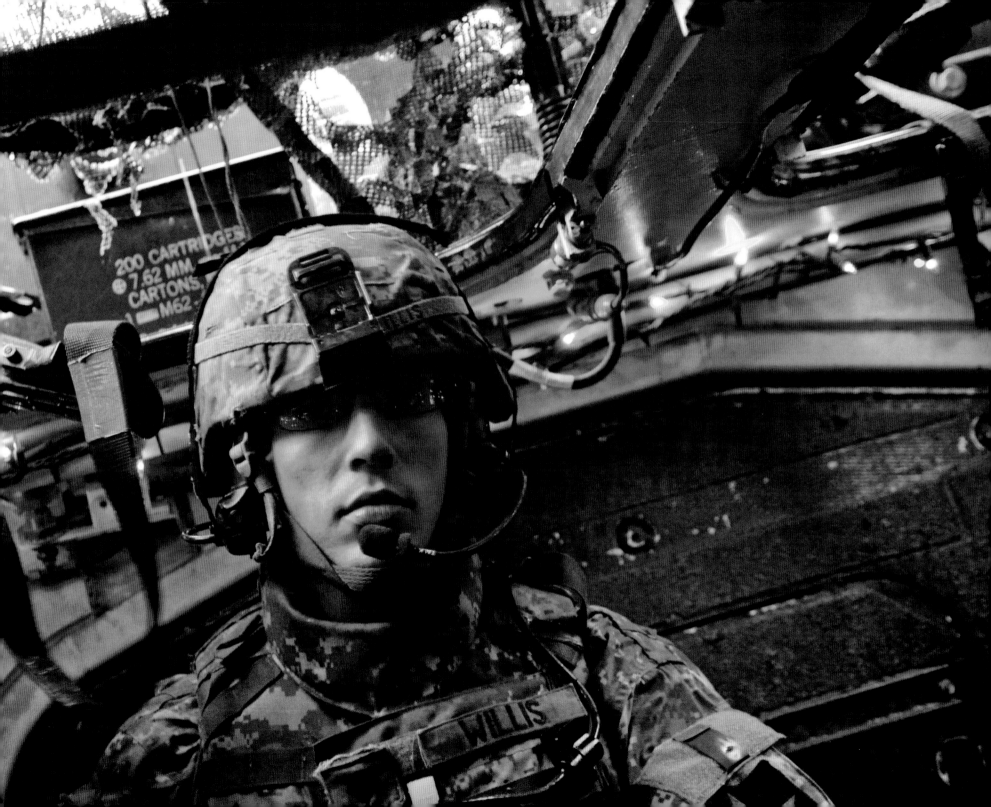

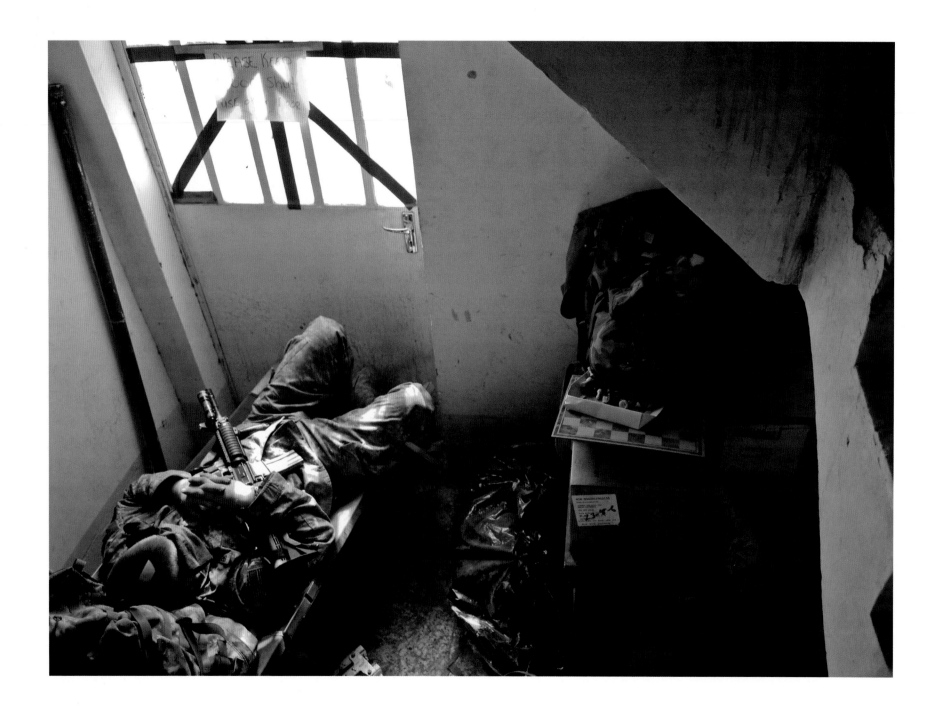

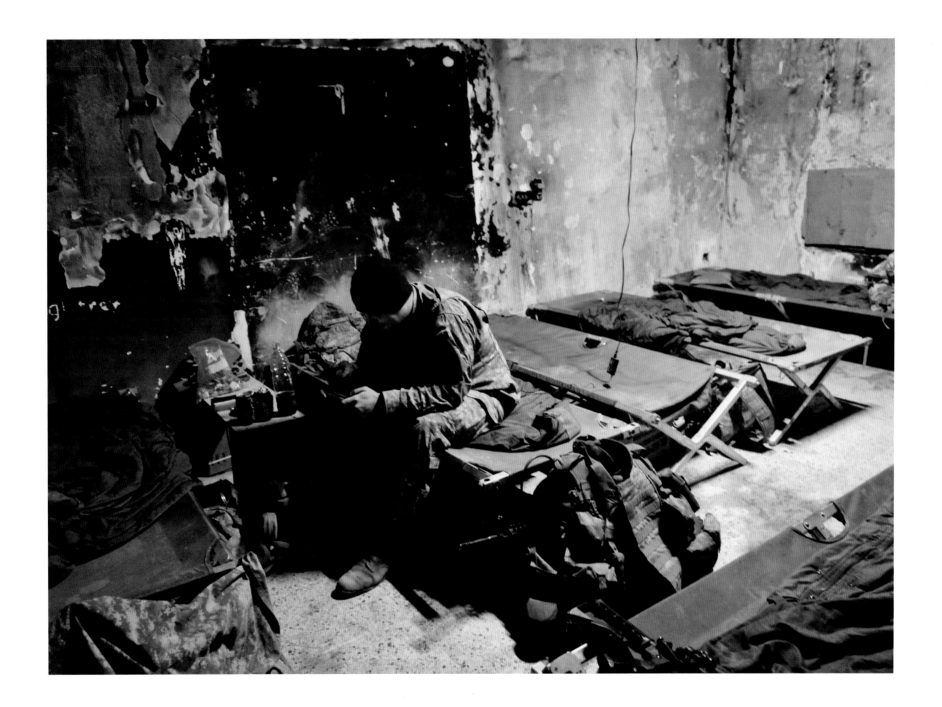

CONTACT

Nothing rivals going into combat with a camera. It's like taking a bicycle to a NASCAR race. It's a true test of courage. Can I survive what I can't see? Perhaps it's what I can't see that's kept me alive.

Under fire, a soldier thinks of duty: finding targets, neutralizing them, detaining others. For me, it's about the intricacies of reading the light, making an exposure, and framing the disaster in a meaningful way. Each moment the concrete bursts with bullet shards, we maneuver, finding cover around a corner and lining up targets. For my brothers, the target is the enemy; for me, it's the image.

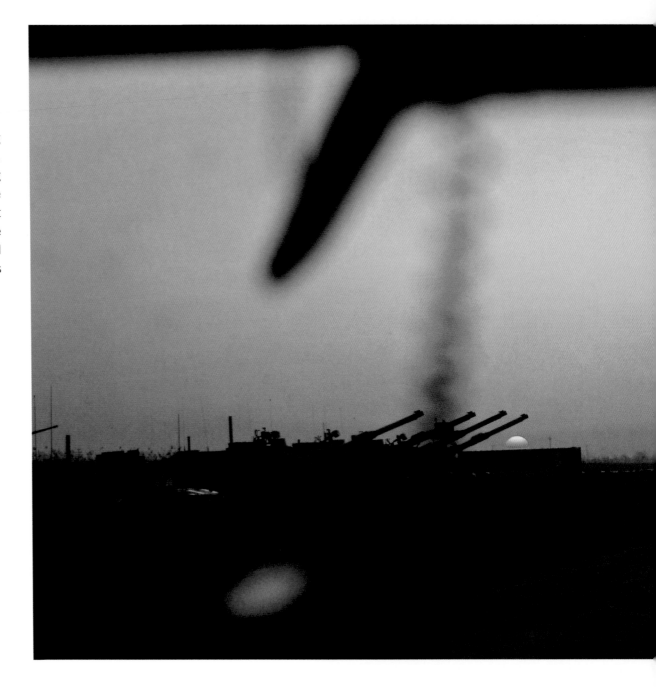

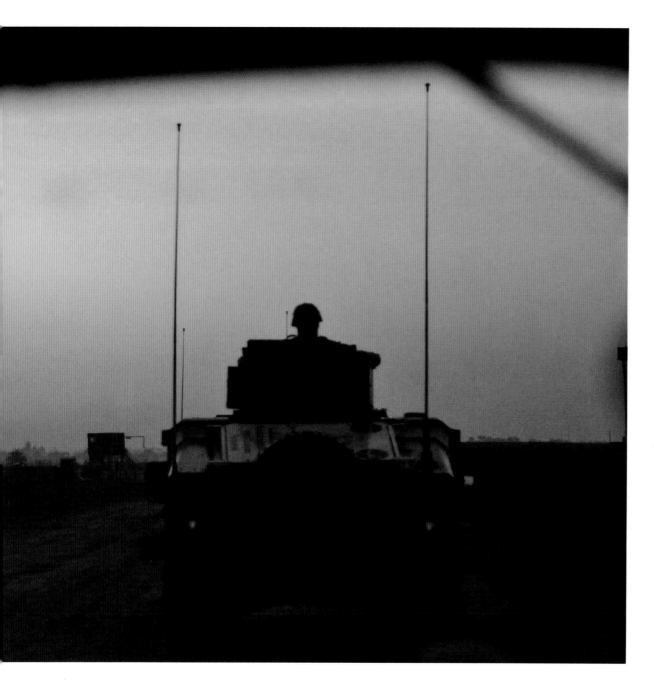

In a combat zone, I try not to let death consume me; I focus on movements. *How many feet to the burned-out car I can duck behind? How many meters to the target in the window?* But, when it gets too hot and I drop the camera, I fight first. I ready my rifle, and the world opens up from the frame of my viewfinder, beyond the iron sights of my weapon. Then, every breath is measured, and everything slows to silent seconds as the small muscles in my trigger finger contract and loosen, the rounds echoing off bombed-out Iraqi buildings. When it's over, I think, *I'm still alive.*

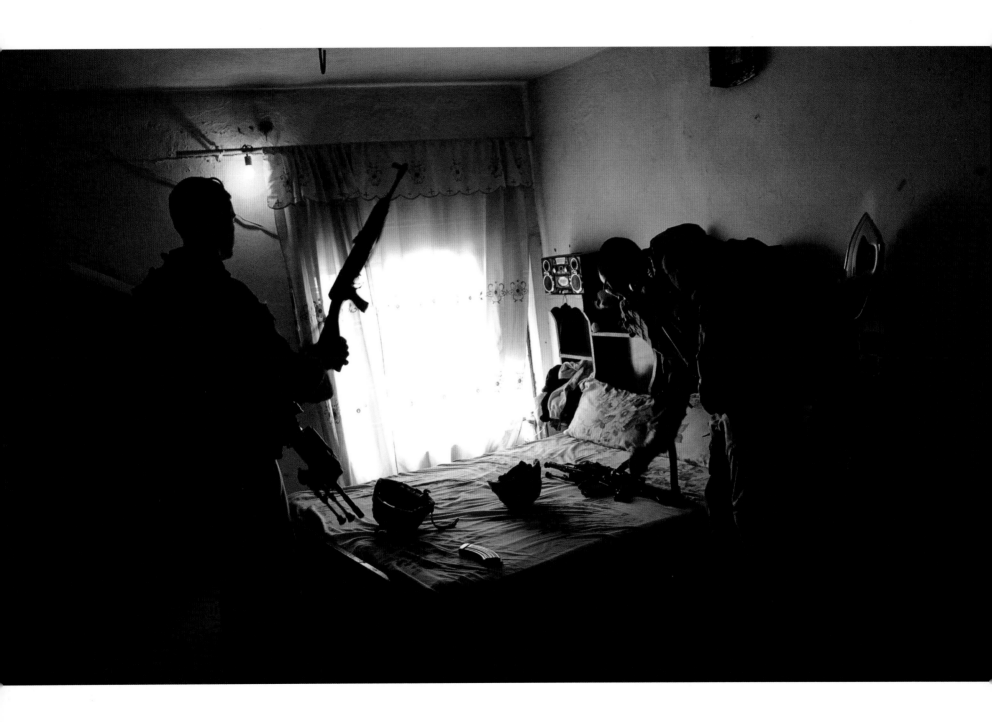

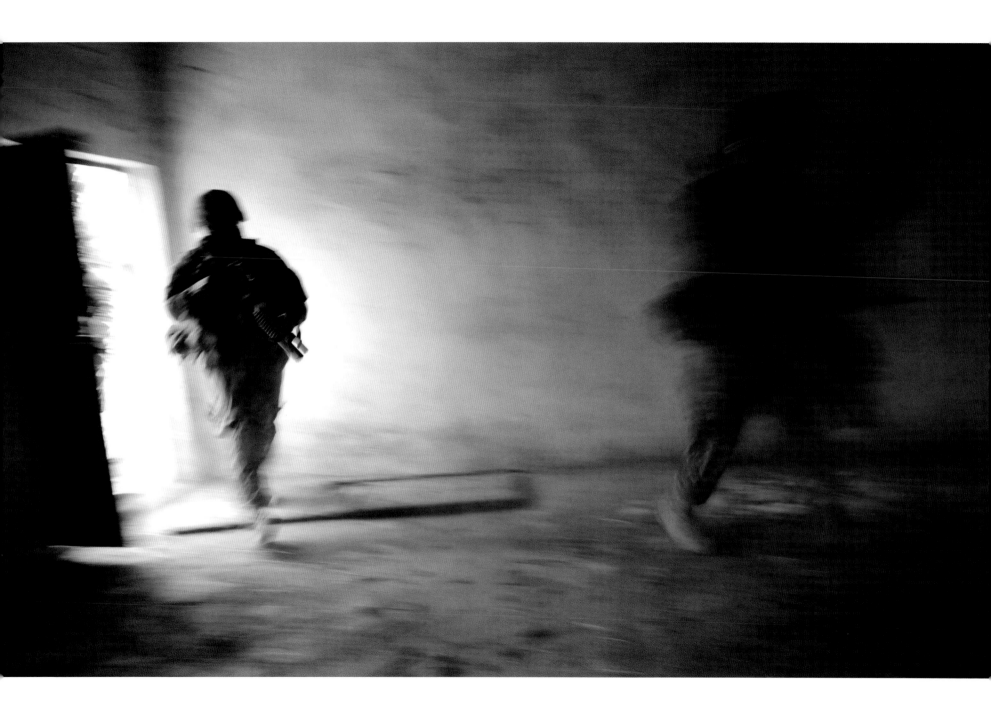

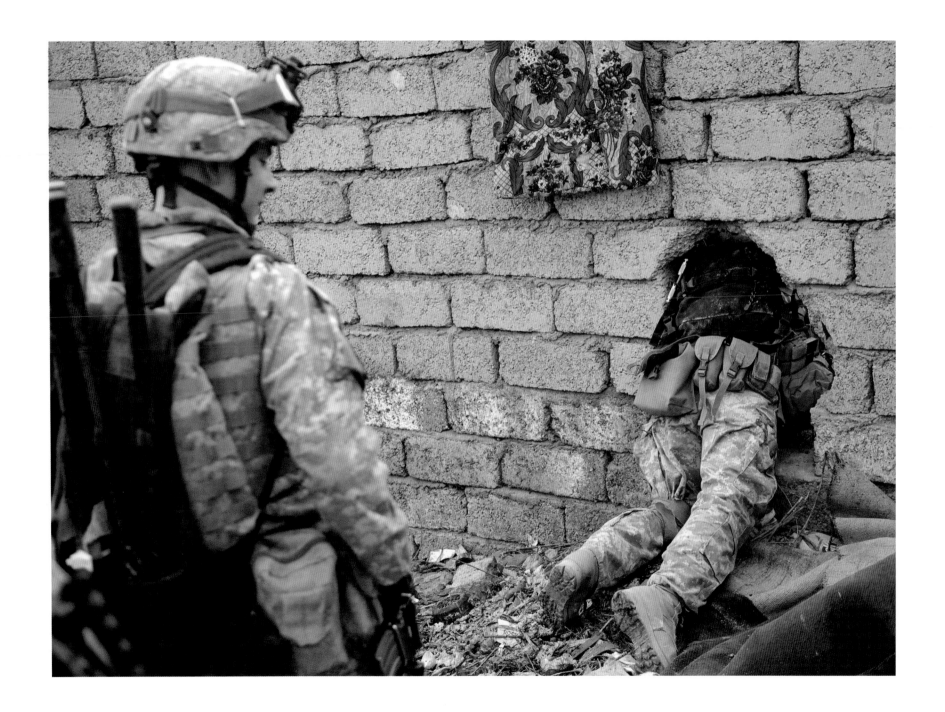

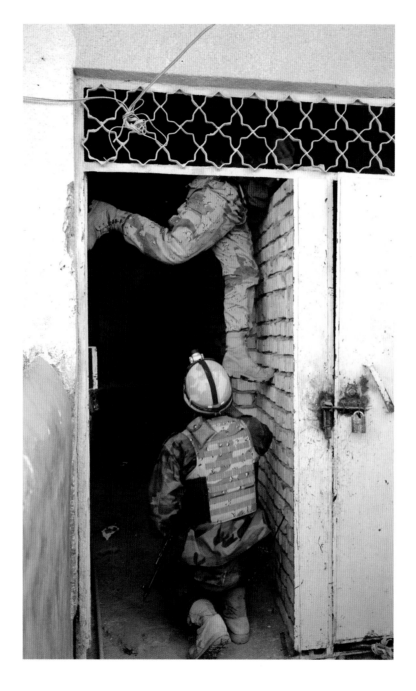

Combat isn't romantic. It's not Hollywood. Soldiers trip and fall, get stuck in holes, miss targets, and make simple mistakes. We're human.

During a firefight, I scale a wall that divides two rooftops. I lose my balance at the peak; gravity takes hold of my heavy body armor and pulls me downward. I tumble head over feet. I try to maintain my military bearing, but I can't hold back the chuckles. Neither can the other soldiers.

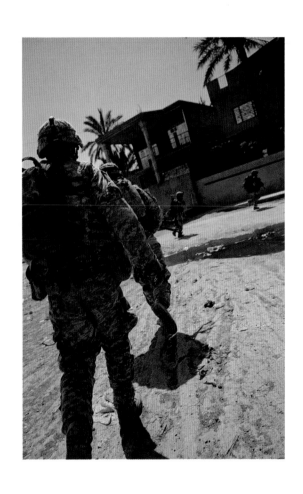

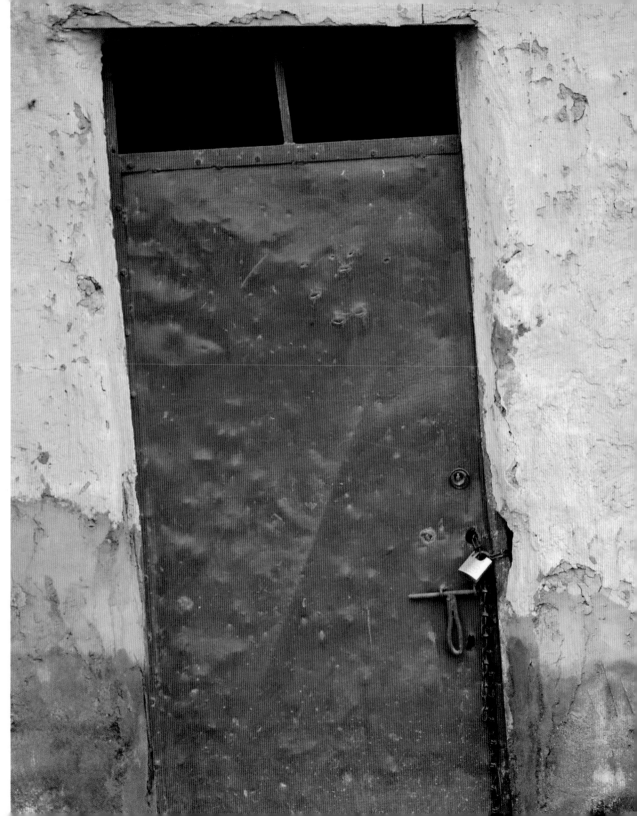

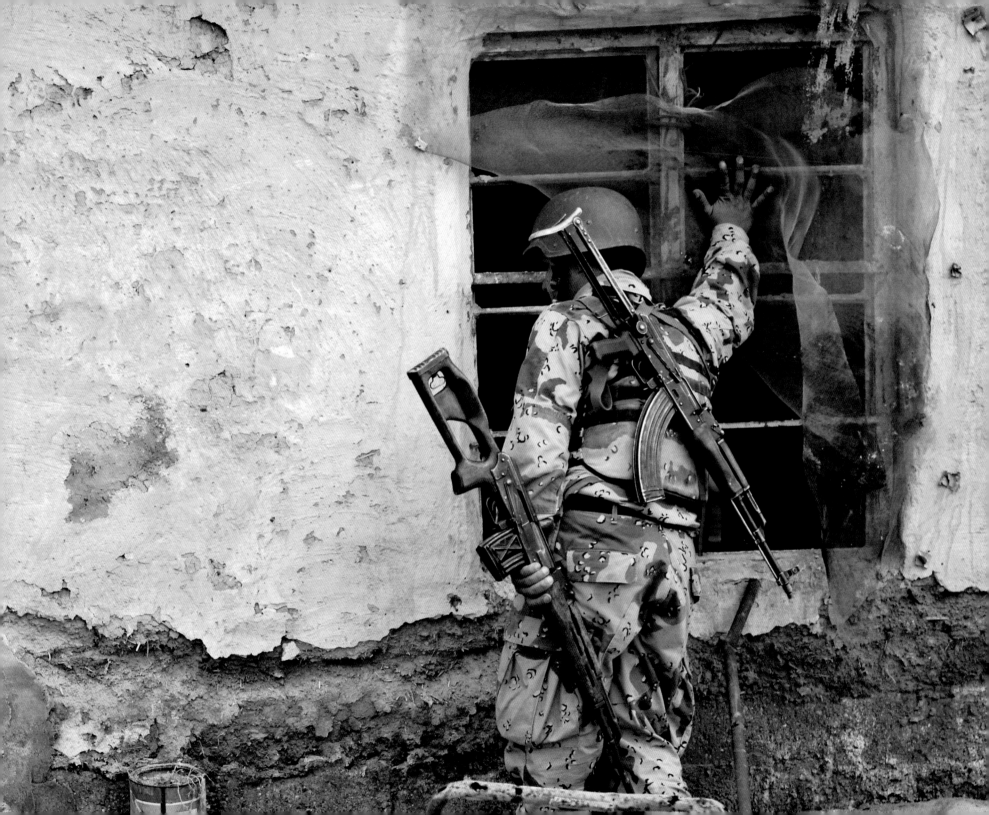

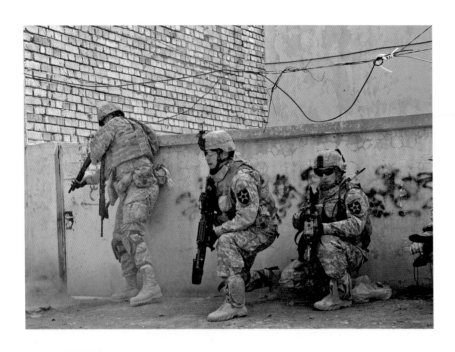
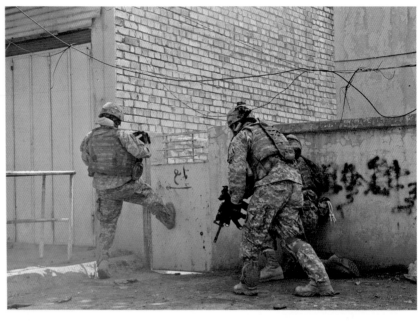
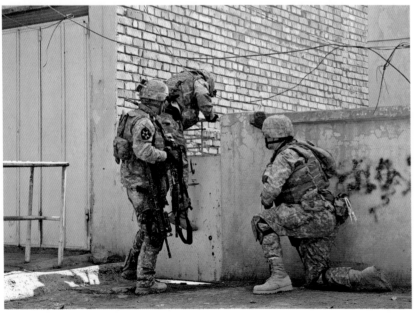
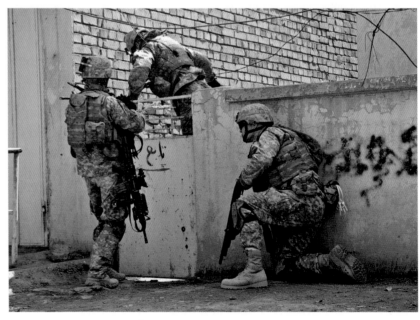

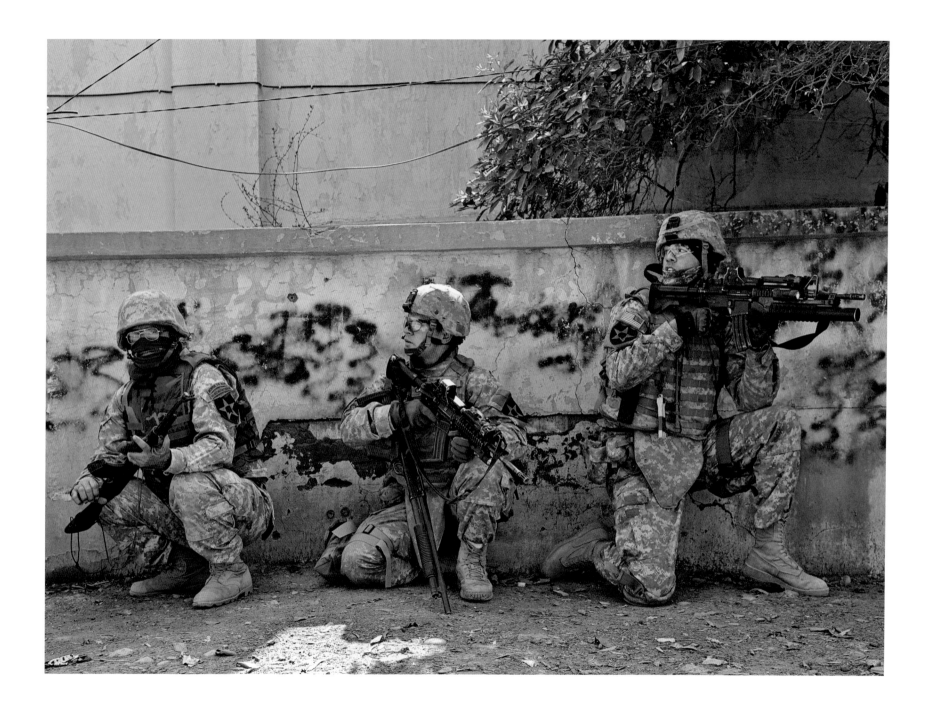

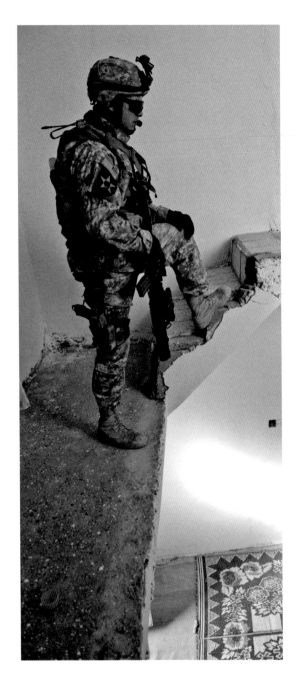
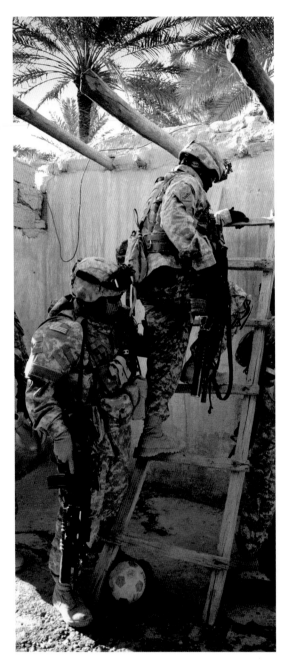
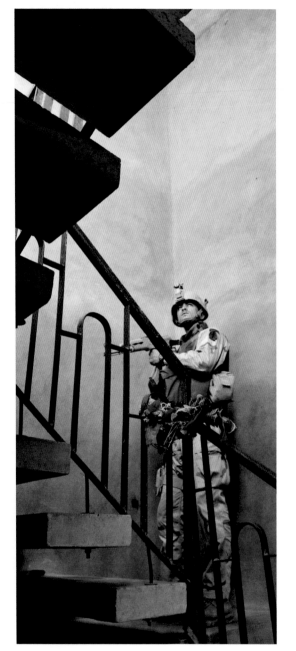

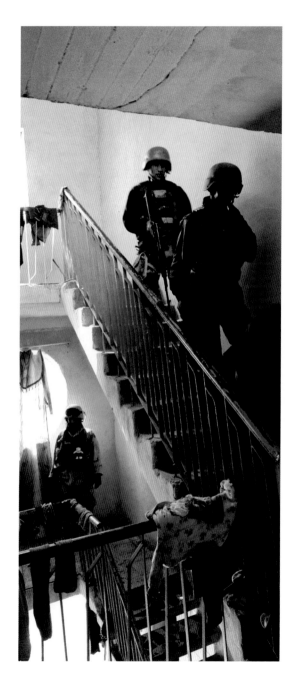
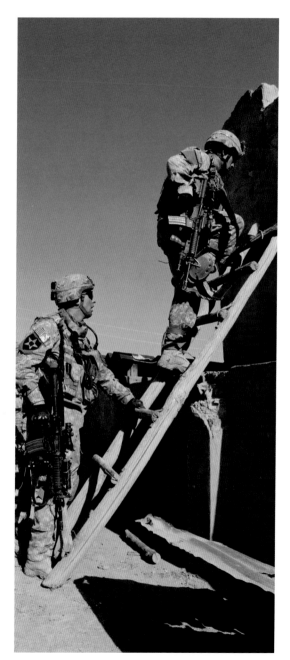
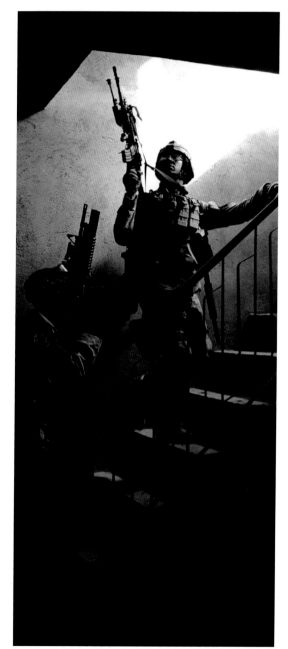

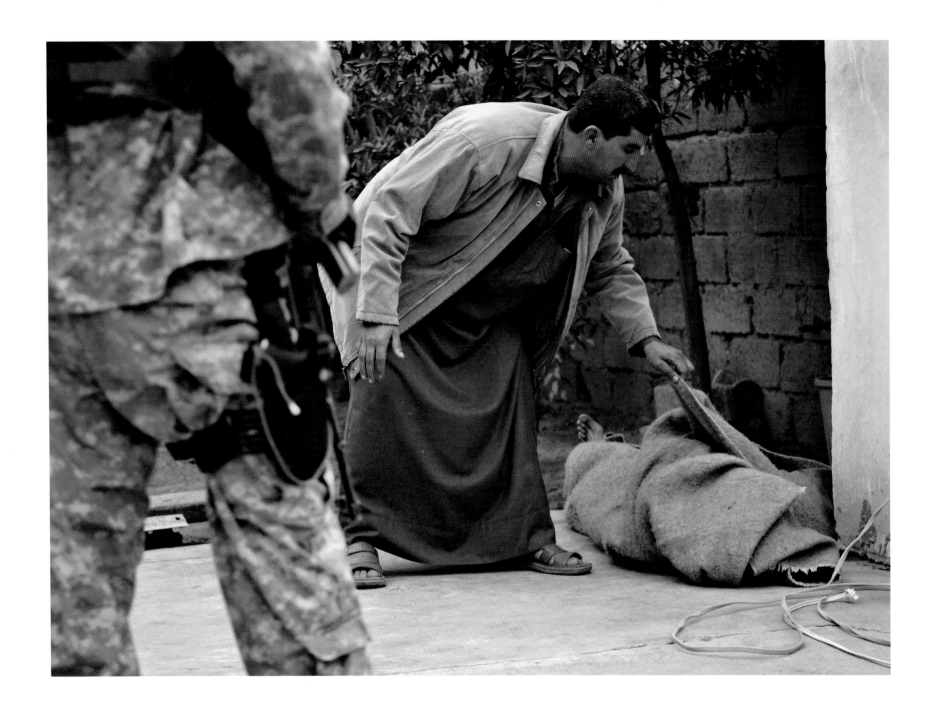

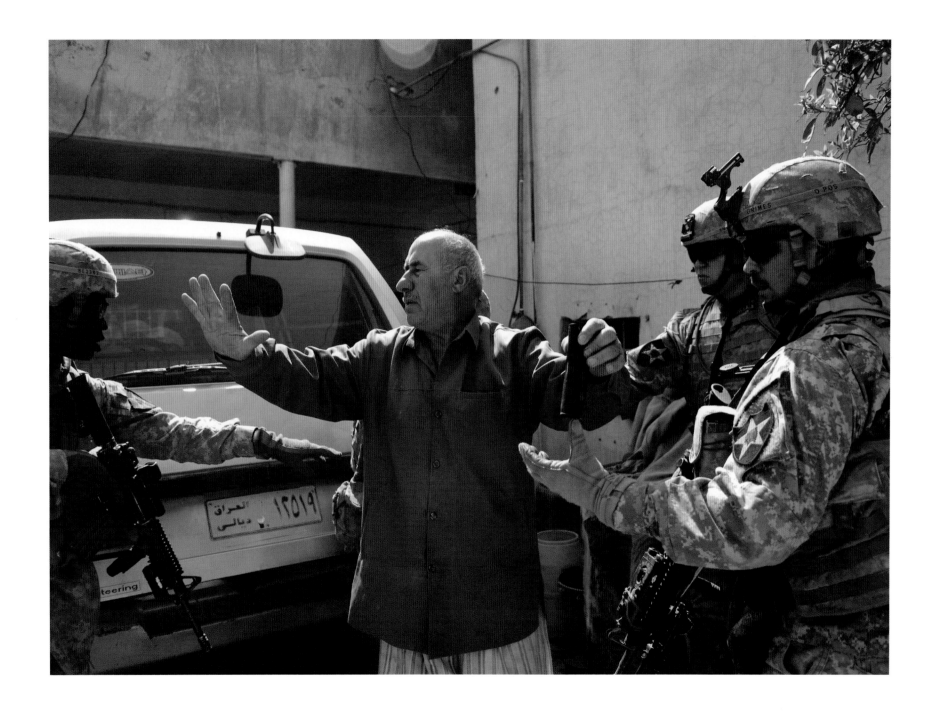

With every cordon and search, we find all types of war implements, such as bomb-making materials, mortars, mortar-launching tubes, improvised explosive devices, ammunition, and weapons. We see windows pierced with bullet holes, cars on fire, and trails of blood.

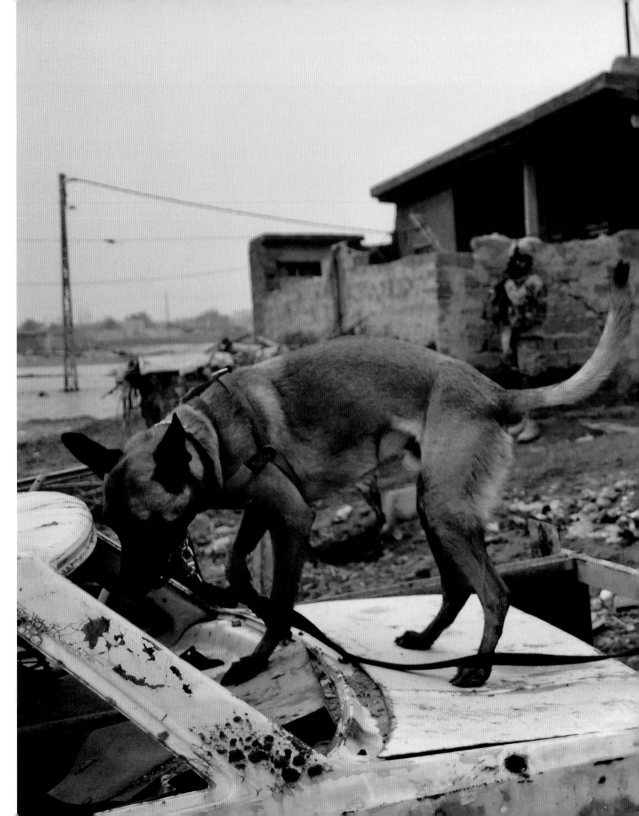

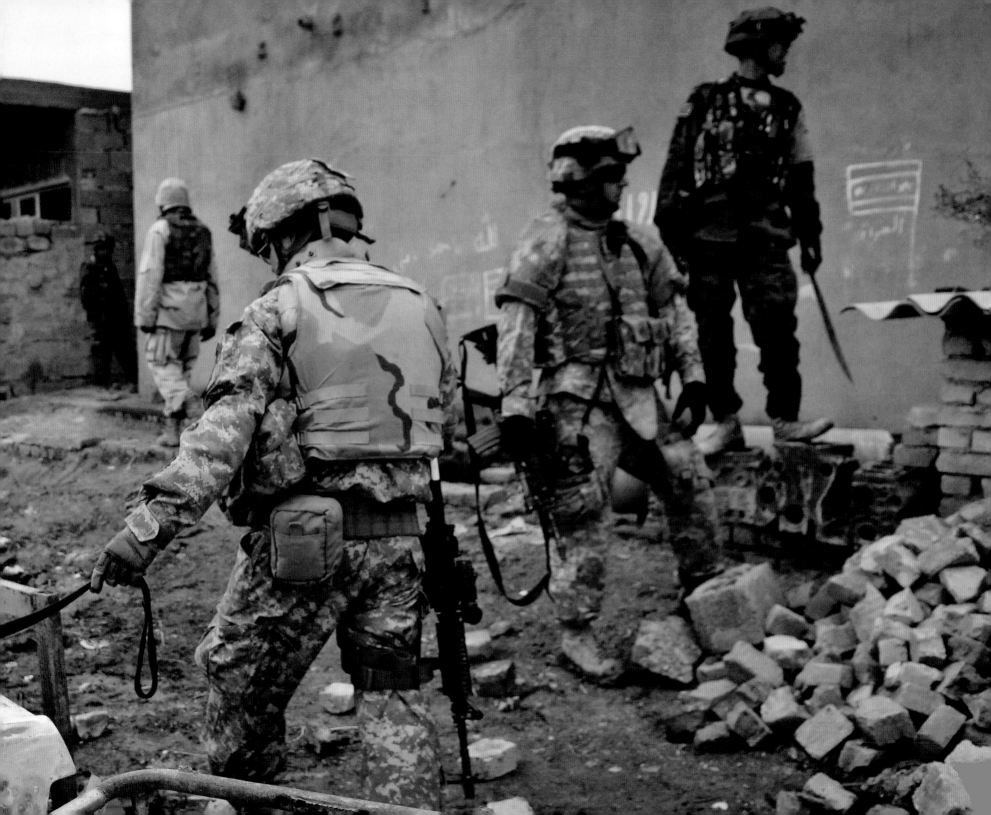

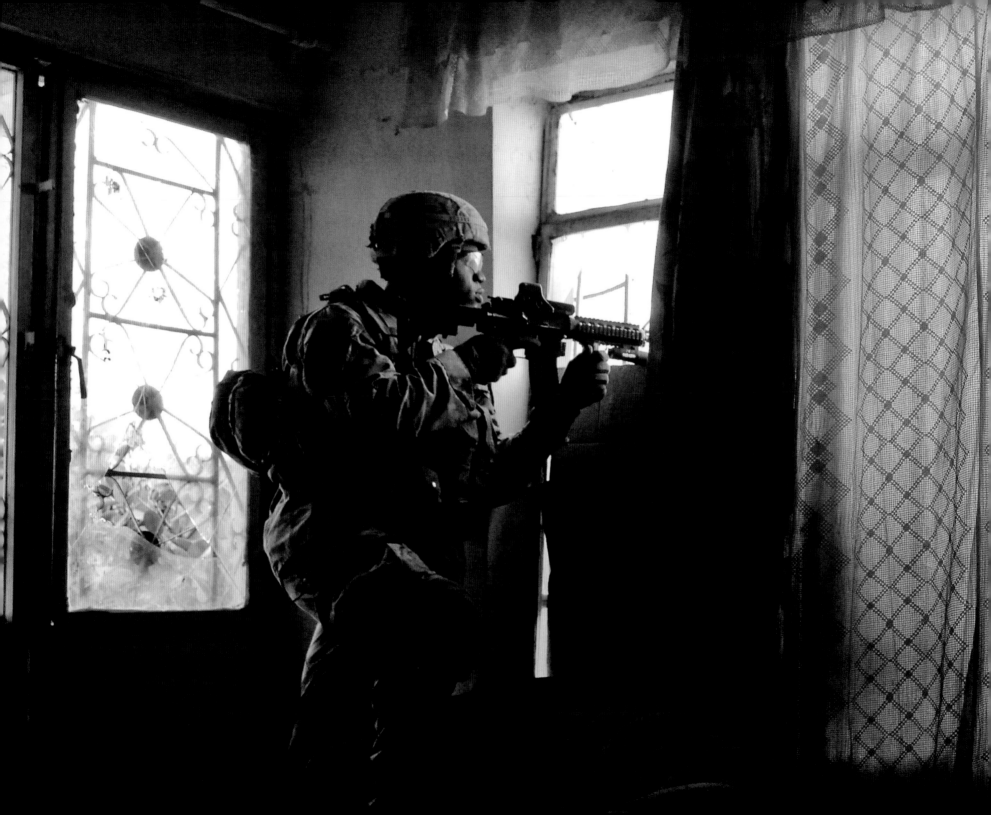

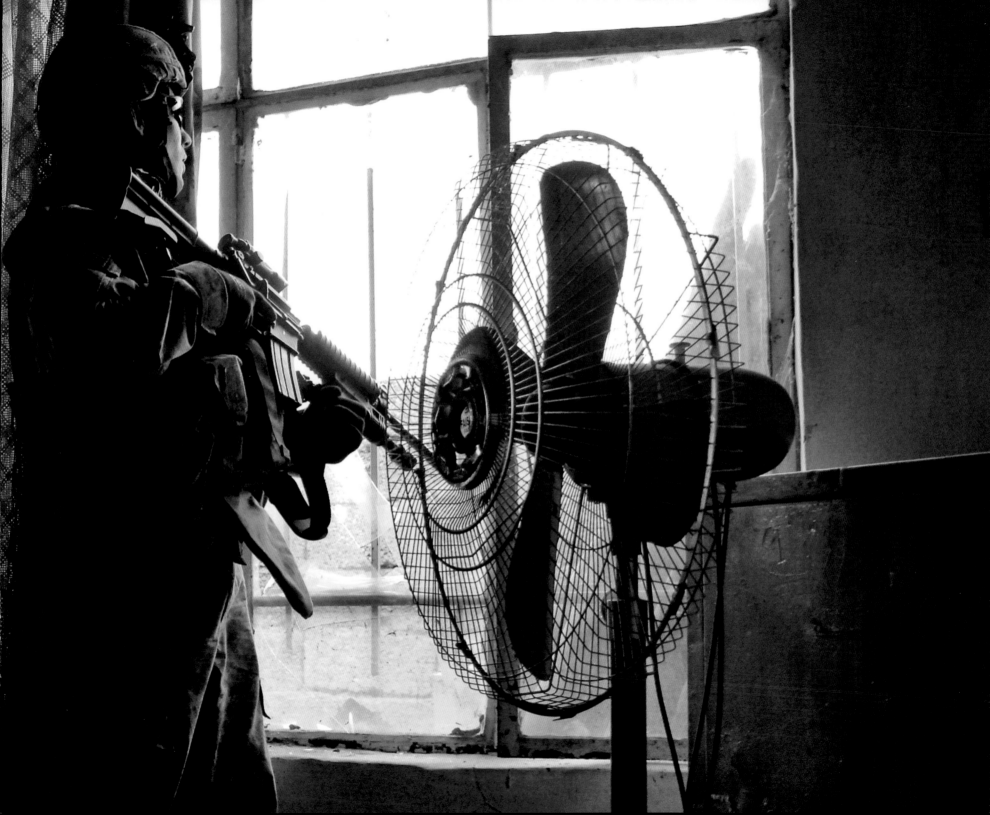

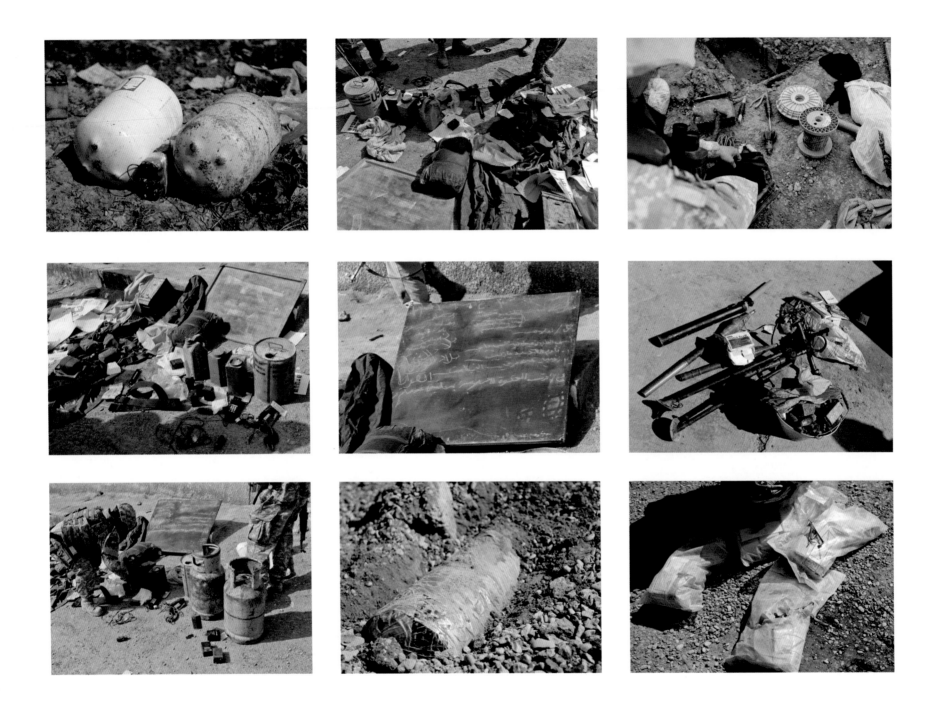

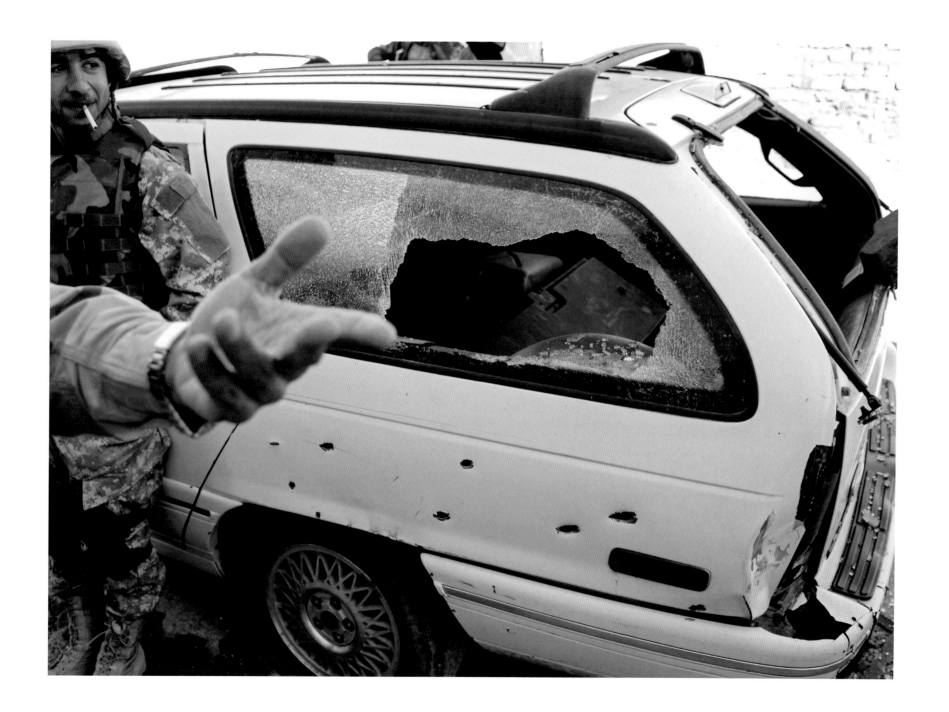

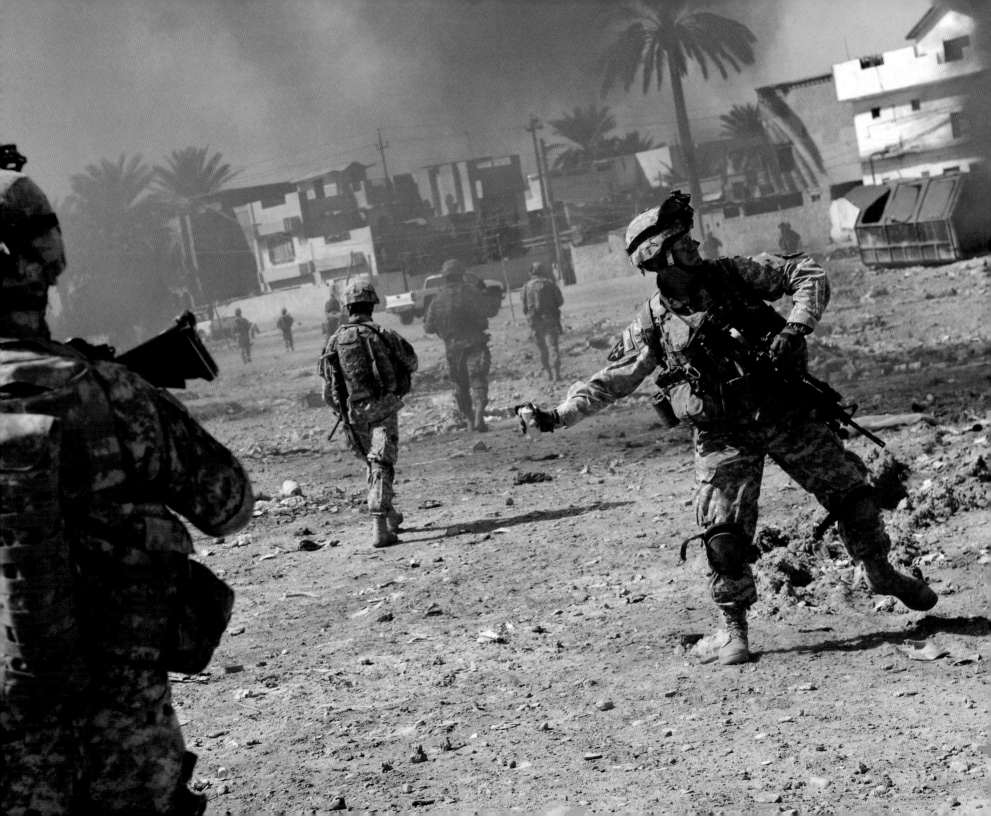

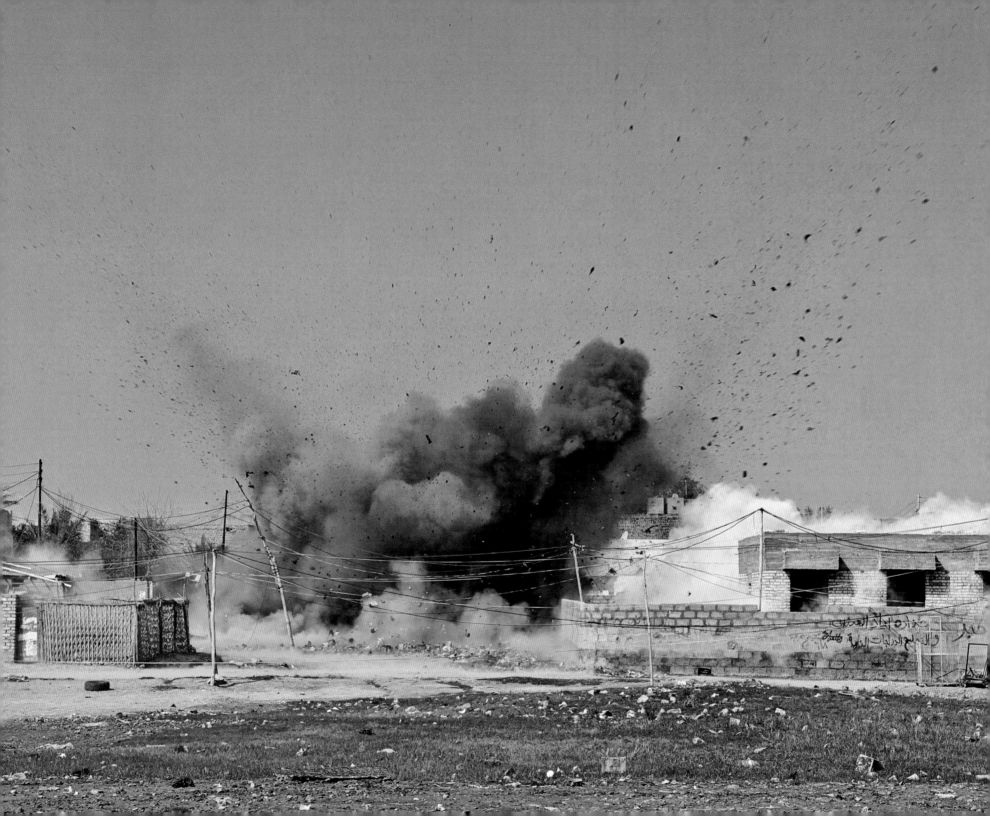

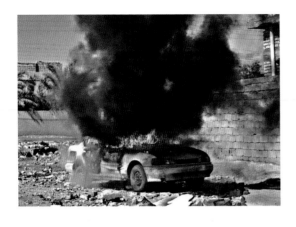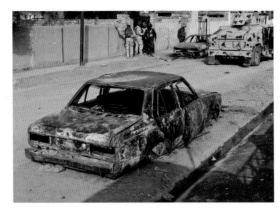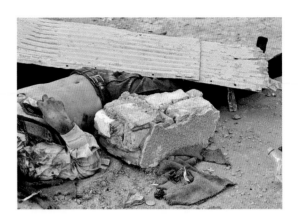
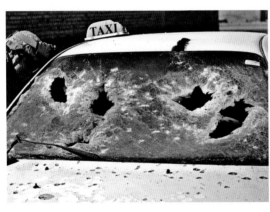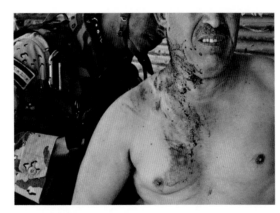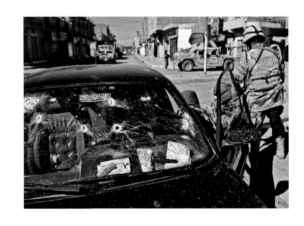
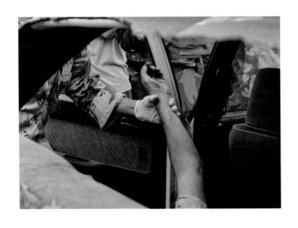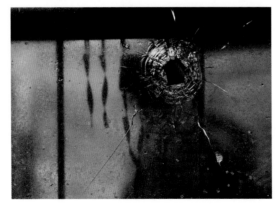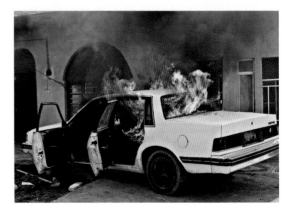

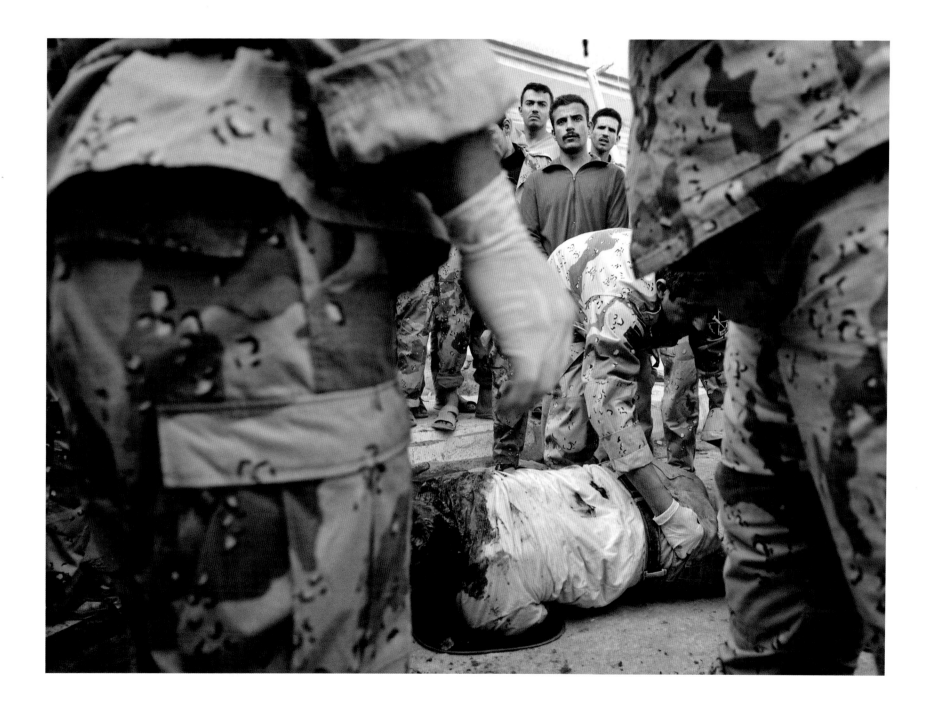

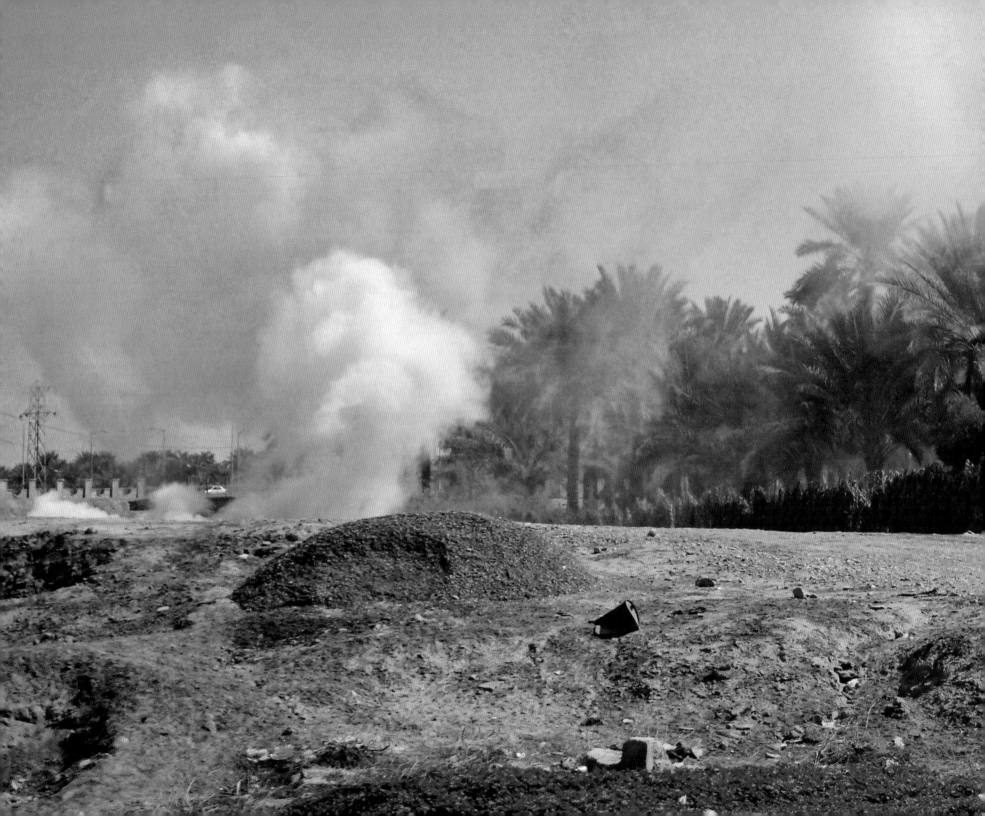

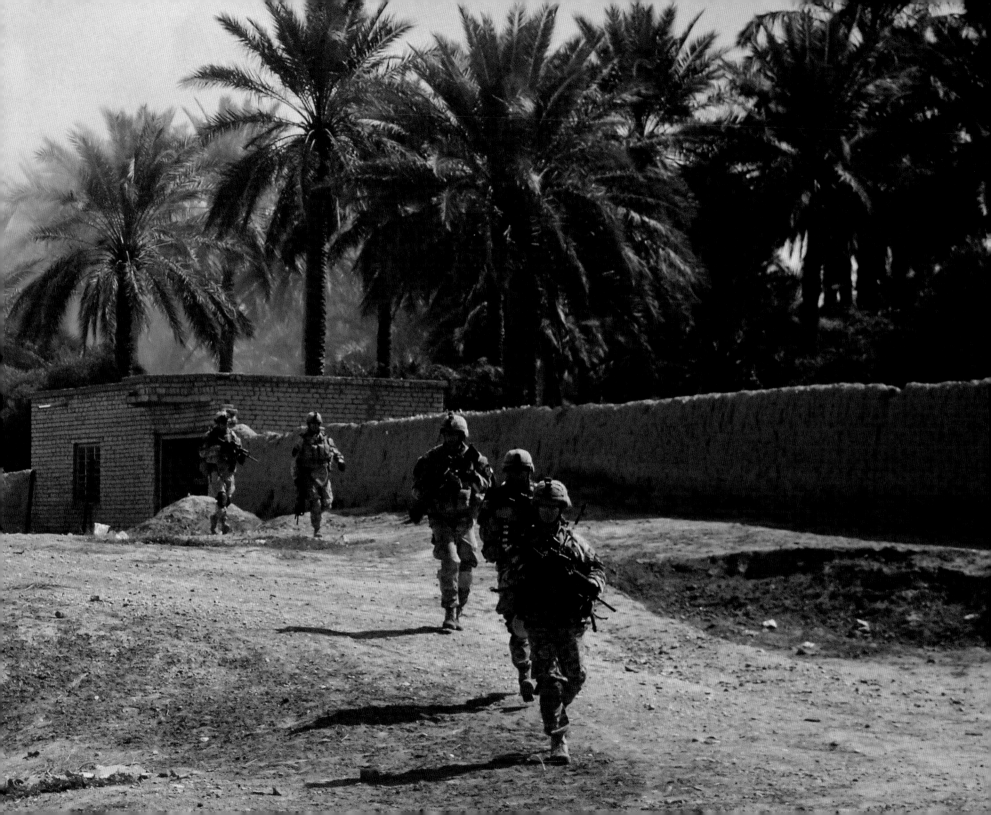

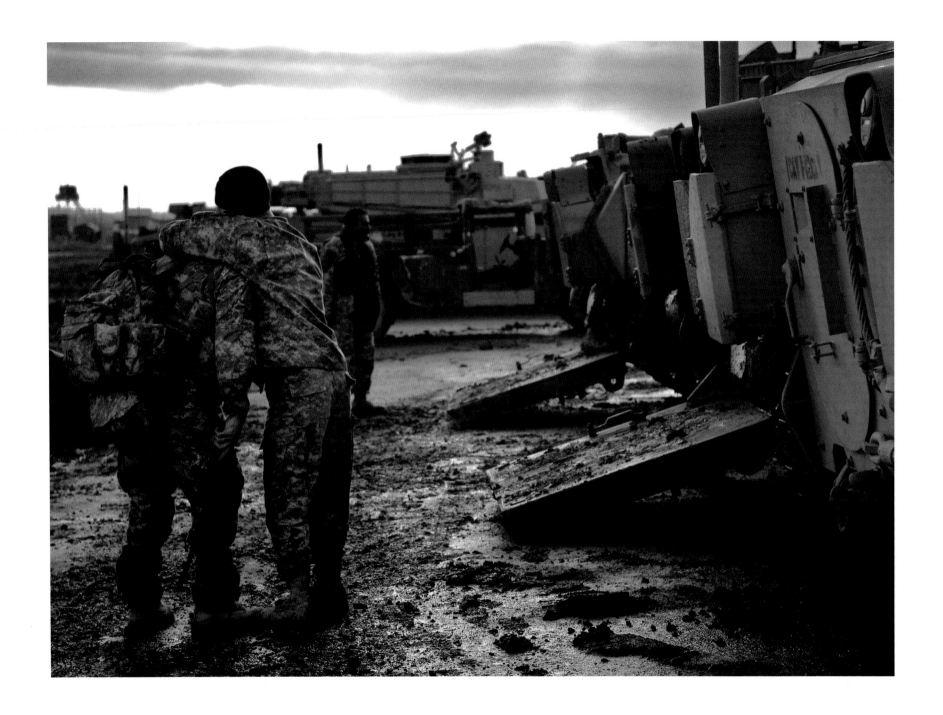

IRON

The thing about smoke: It can come from rifles, burning buildings, or your brother's lungs as he enjoys a Marlboro after walking away from the first two.

In the aftermath of battle, the space is filled with hurt, shame, adrenaline, and the need for someone to remind you that the world has not ended . . . that you're still human. These bonds forged in crises are a soldier's connection to what's good: The relief that follows walking away from something no one else survived. The laughter that follows a smoke. How a hot meal feels like God is watching out for you. How the sound of your boots on sand is the only company you have, until you return to base. There, your brothers who have survived, too, can see by your eyes not to mess with you, so they hand over a smoke, get you in a headlock, and lead you to the latrine threatening bad things.

When you're in Iraq, human touch doesn't exist, not like at home. Someone is grabbing for help or out of anger or to hold on. Your battle buddy, though, knows how to help you to be strong when you need to be strong, and you're strong when he's vulnerable. No one cries. It's an unspoken rule. If someone starts to break down, the rest bust out cards, crack jokes. They are present in the hardest moments.

Brothers aren't born; they're made. These are the people you'll find again twenty years down the road, and it will be as though no time has passed. You will never know people the way you know your brothers in combat. The ones who survive live for the ones who didn't and for those who come after.

There's joy, too—when you return home and the rigors and horrors of war begin to fade, you forget the way the sand gets under your eyelids or that you no longer constantly think about cleaning your weapon. You fondly recall the guy two bunks down, whose guitar playing at night brought calm over you. And then you remember the day he gave the ultimate sacrifice on the day his son turned four. What memories remain? The look in his eye before that awful day. The desert horizon at sunset. The iron that sharpens iron in each other.

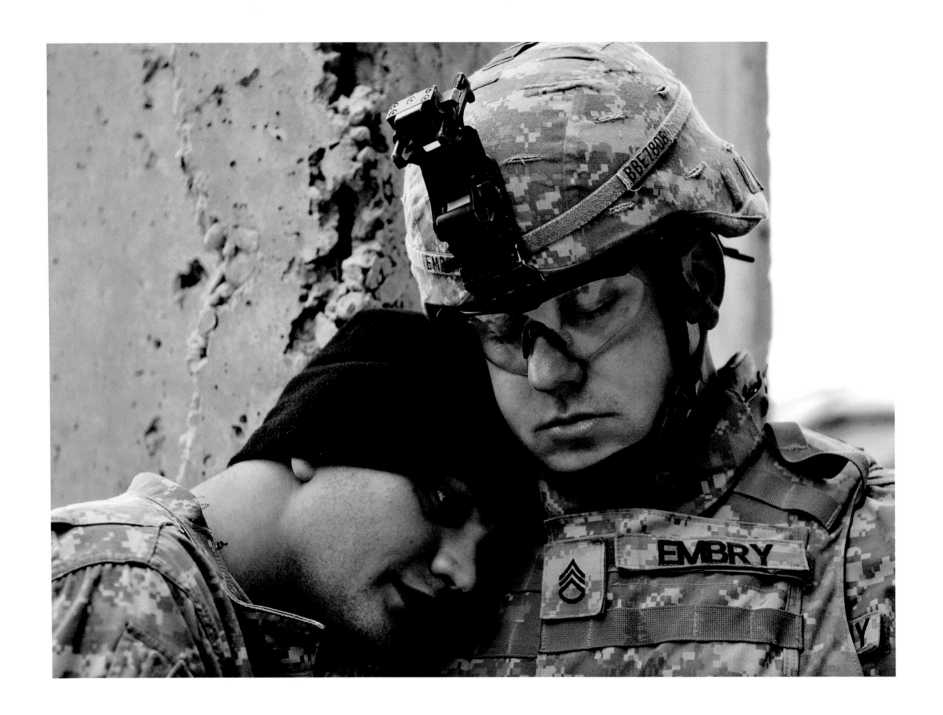

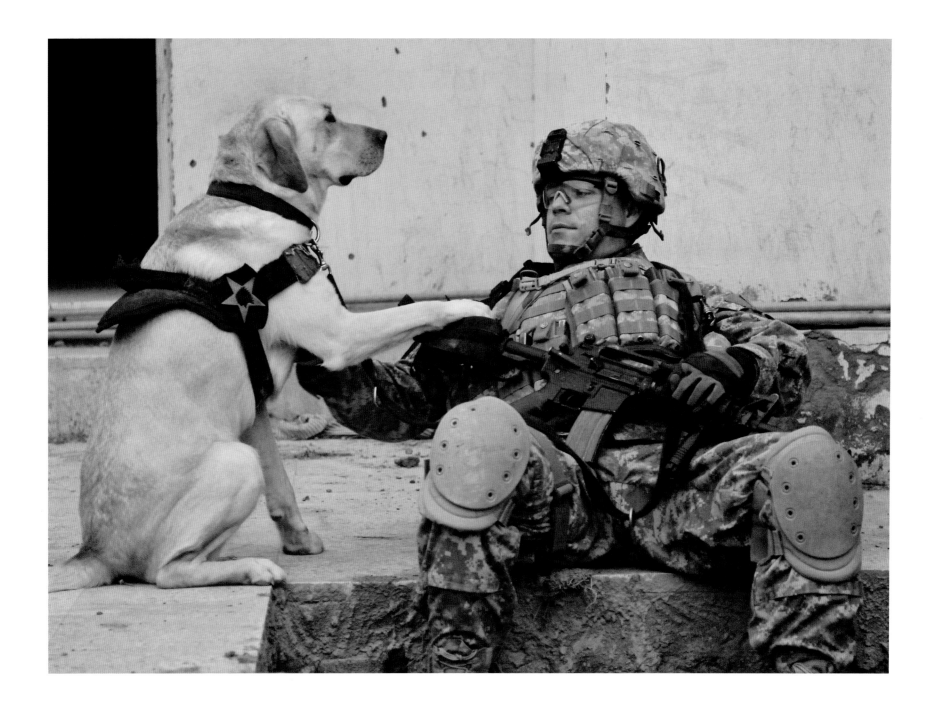

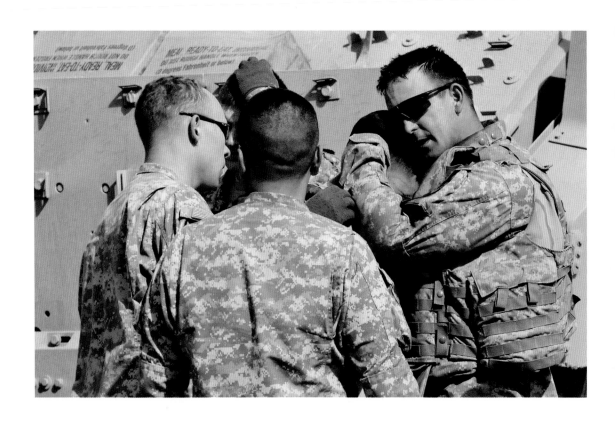

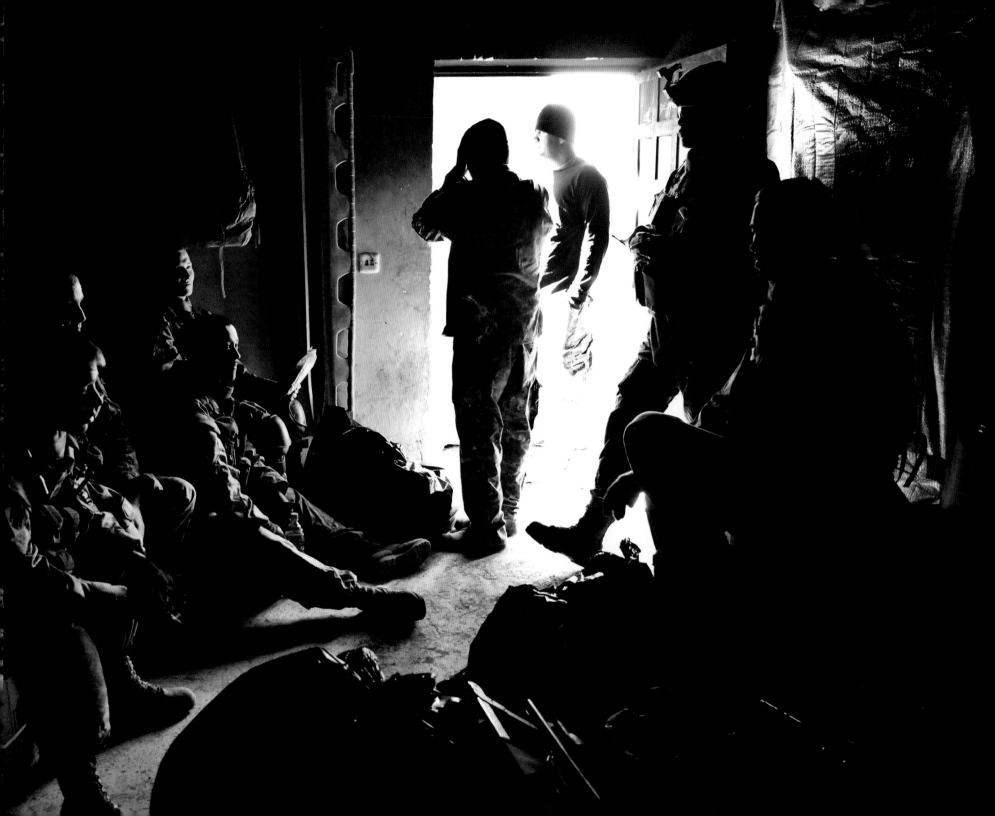

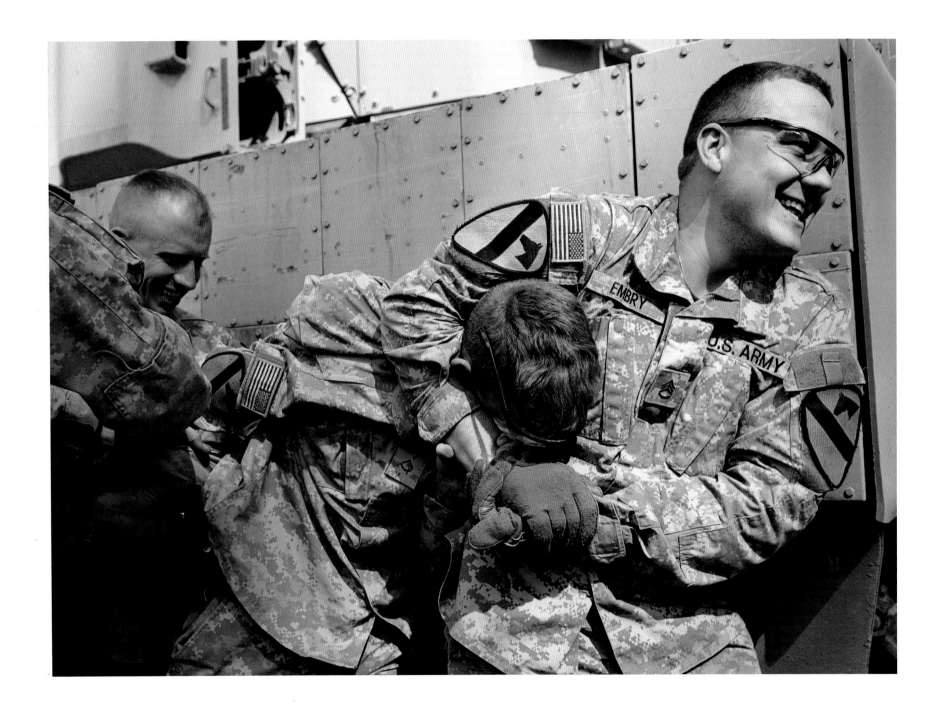

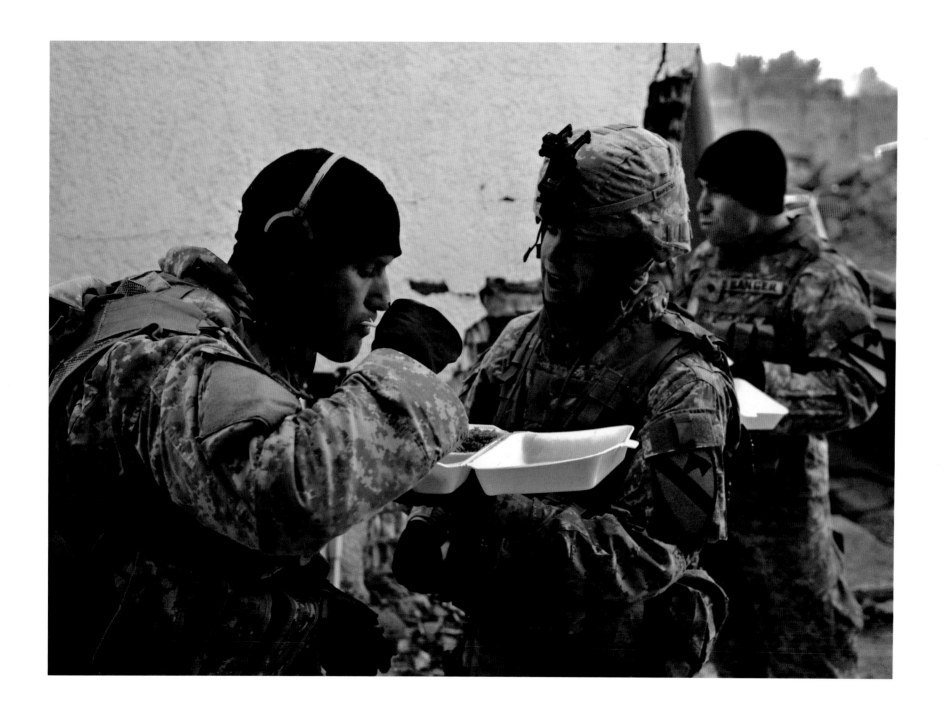

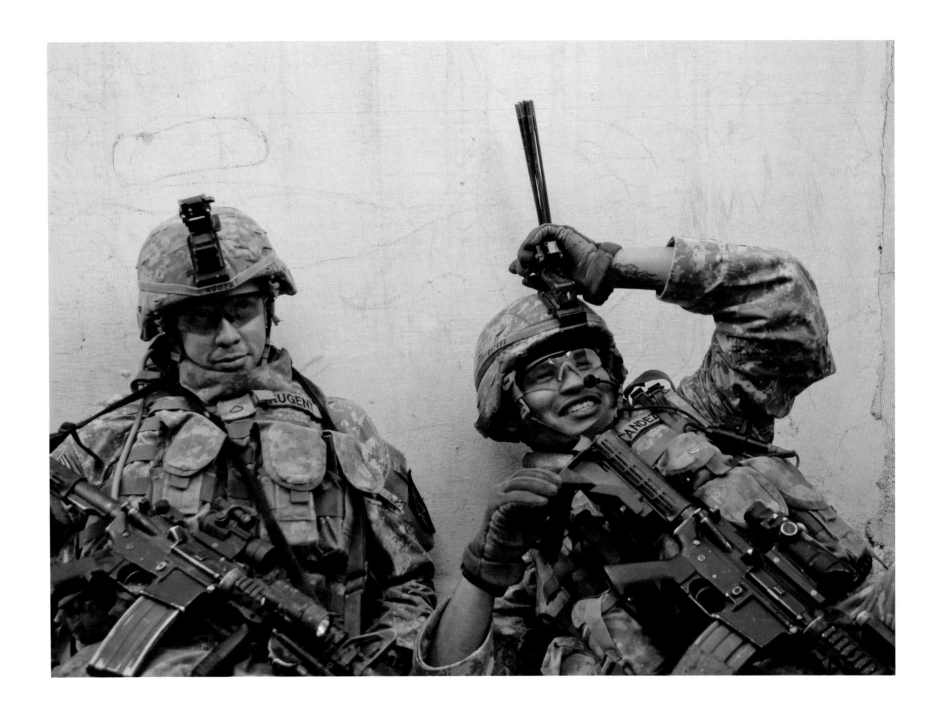

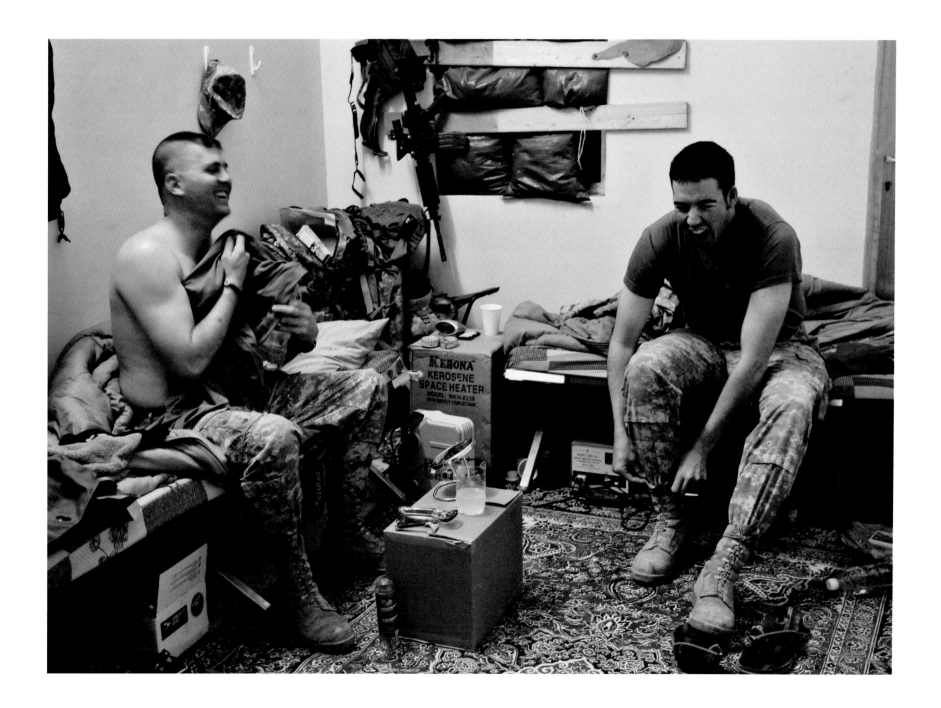

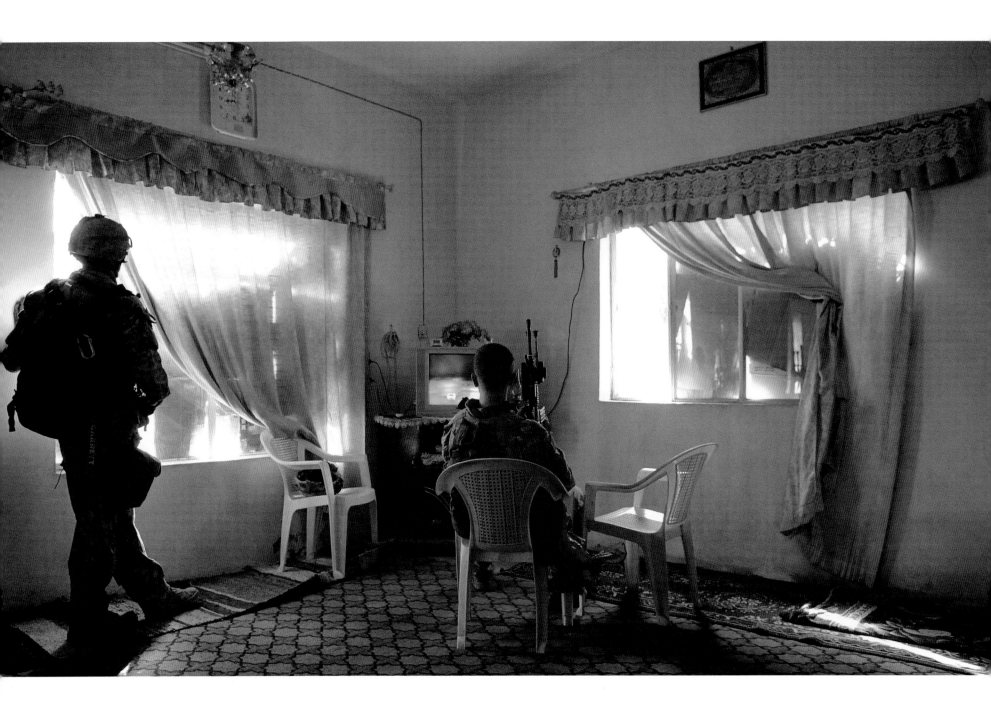

It's strange how war can become routine, but it does. Send up the breach, kick in the door, search the house, get the bad guys, maybe fire a round or two, and then move on to the next house. Sometimes, if we are lucky, we can be human for a moment—enjoy some television or swing with a friend.

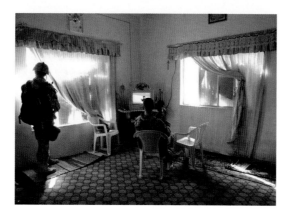

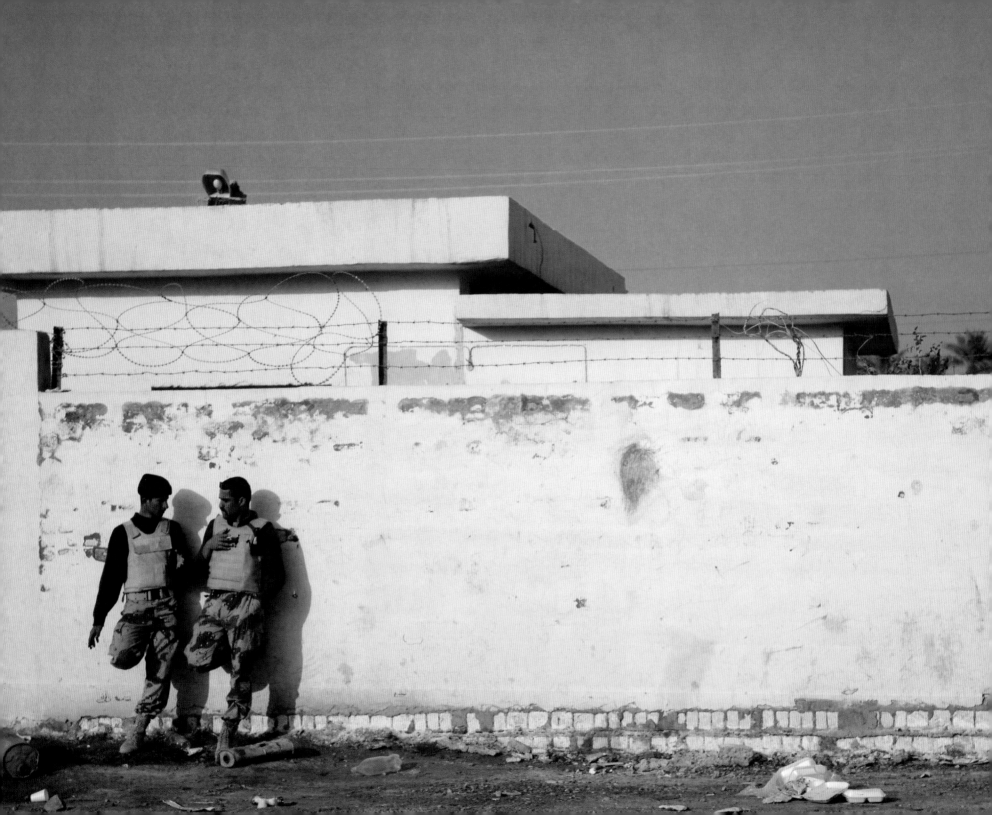

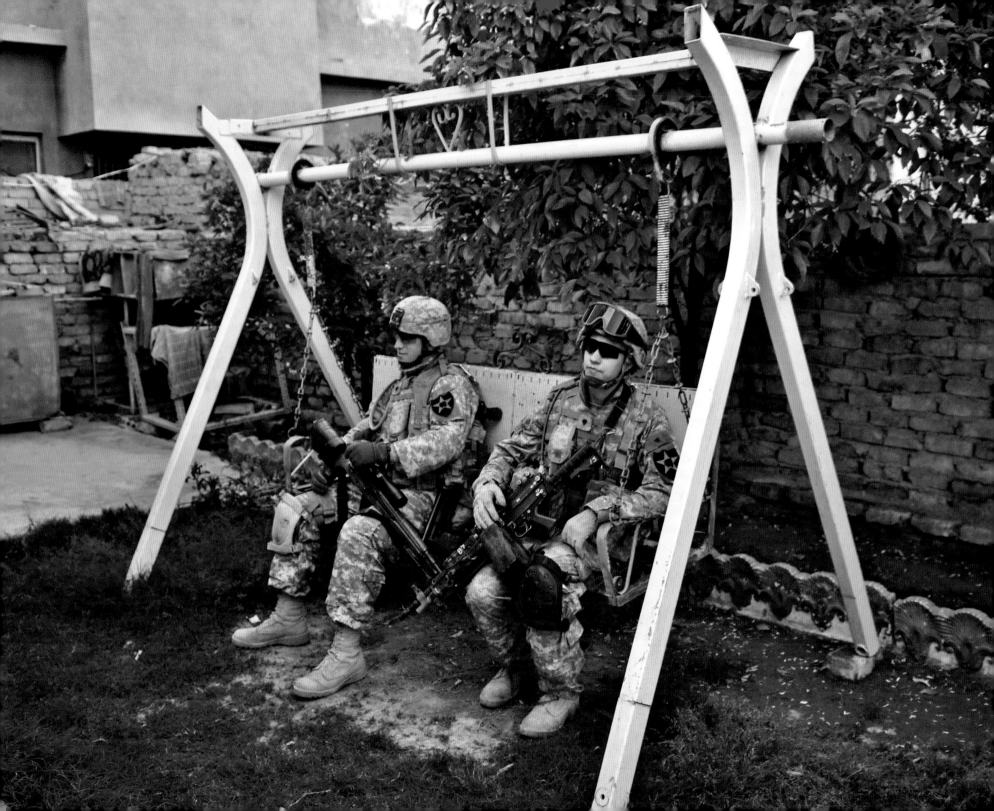

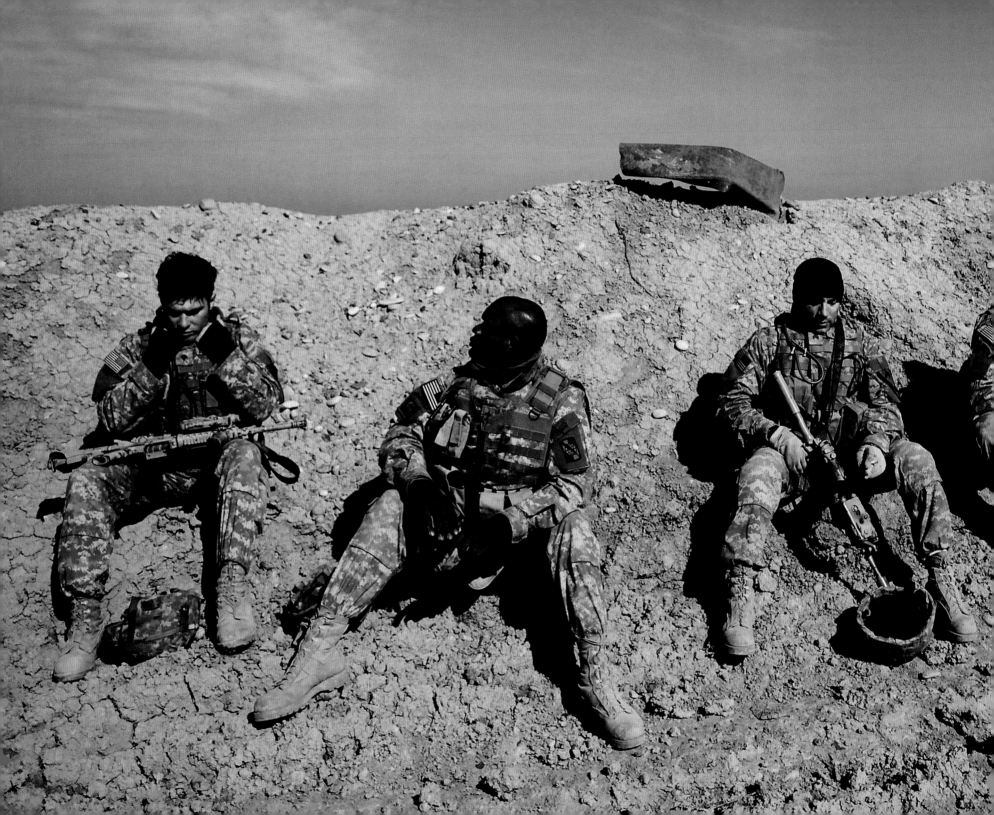

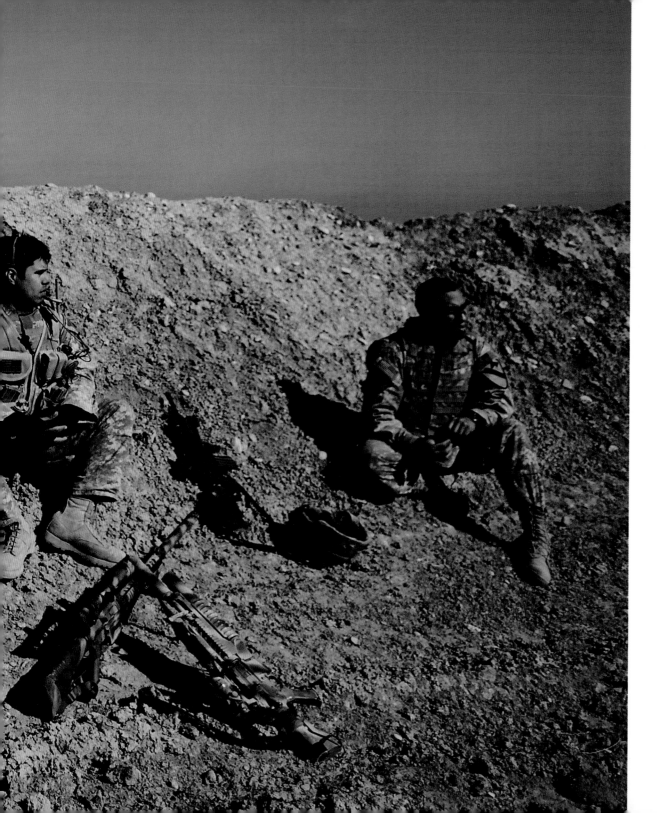

For every inch of ground gained, three are lost. For every insurgent eliminated, a new one comes along. There's futility in war.

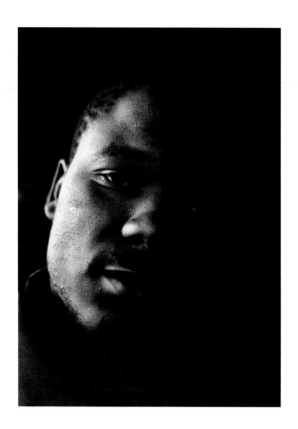

LAST LIVING PICTURE

There's an unwritten law: In the military, we don't acknowledge death or her maidens. It's the elephant in the room—these fallen troops. It's a boundary soldiers rarely cross.

The Latin term *photos* translates to light, and *graphein* means write. A camera is a black box devoid of light. In Diyala, I cast light in a dark place. Through my photographs I write, in this case, a history, so that I might openly and honestly communicate the accounts of the soldiers I serve alongside. I commit myself to the responsibility that I might be the person to capture their last living picture.

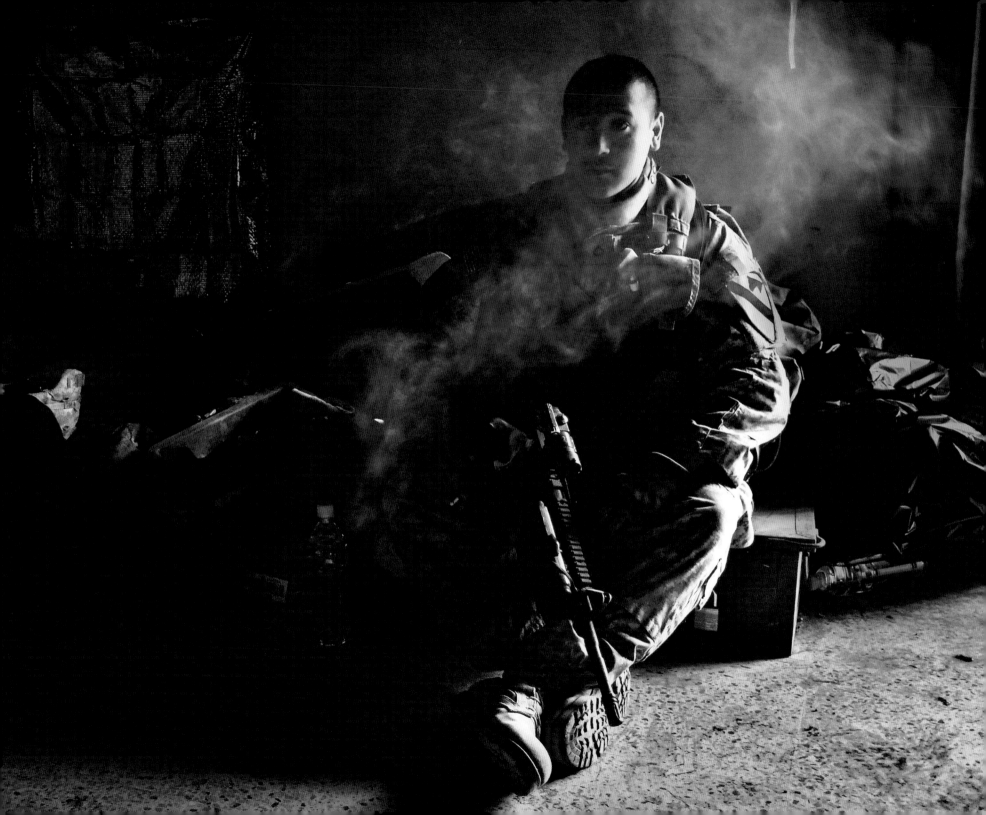

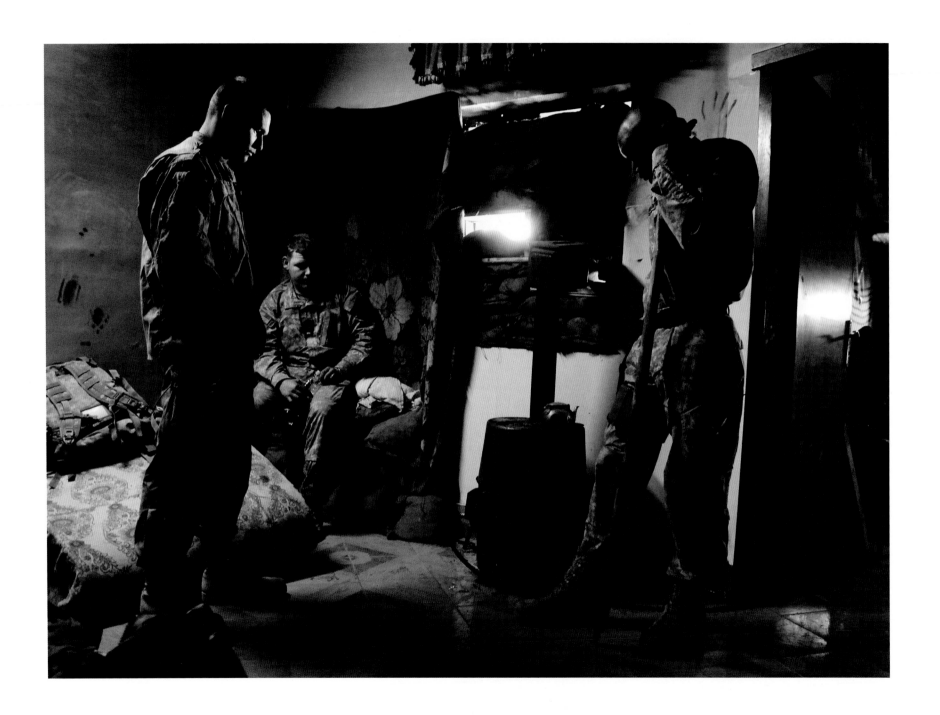

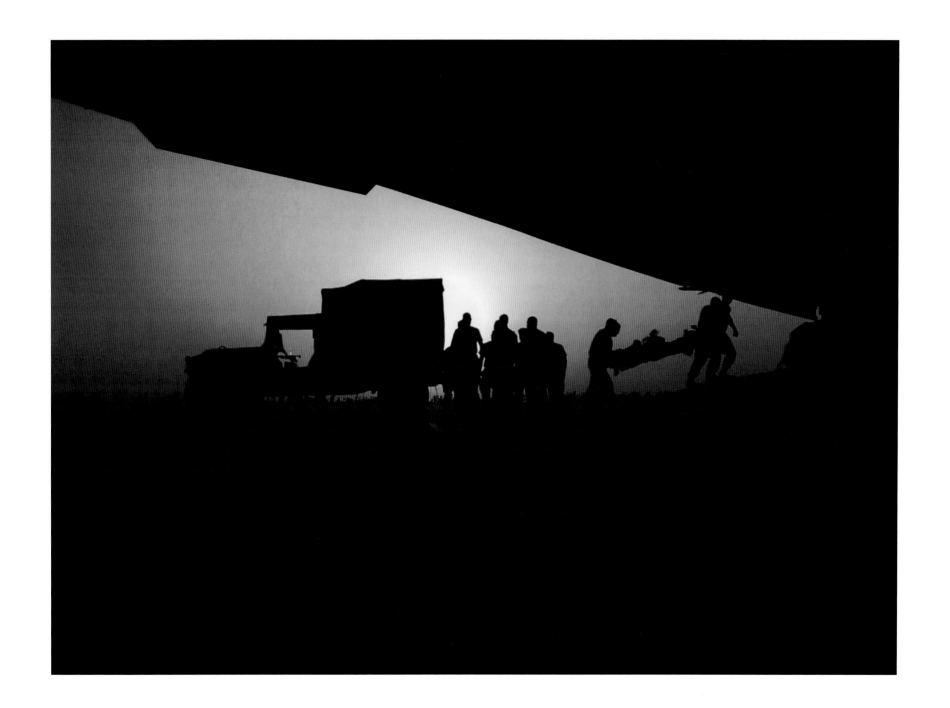

ACKNOWLEDGMENTS

I am indebted to those I served alongside, who protected me, and who are the subjects of my photographs. Without you, I couldn't have made the pictures that fill these pages. For my friends who are not alive to see this book, I'm eternally grateful for your sacrifices and will never forget you. You are my heroes.

They say that behind every great man is a great woman. In this case, it's the other way around. I'm not saying I'm great, but I really think my husband is. After being wounded in Iraq and in the dark days that followed, he was, and still is, my reason for living.

It has always been those who believe in me that have given me the strength to trust in my work and myself. Dane Sanders is one of those incredibly generous and supportive people. Without his help I would not have known where to start, nor would I have met Danielle Svetcov. I had little idea how to even write a book proposal until I met her. Not only is she my agent, she is, in many ways, my mentor. Even though this endeavor took much time and effort, she never ceased to believe in the book or me.

I'm blessed that Ellie Maas Davis came into my life when she did. Her knowledge, energy, enthusiasm, and creativity really made an impact on me personally and this project as well. Through the laughter, tears, and emotional roller coasters, she has been incredibly patient, considerate, and thoughtful. She gets me. I'm proud to call her friend.

Lara Asher happens to be the fairy godmother in this tale. She recognized the worthiness of the story and truly understood the importance of my photographs. To Lara and the rest of the publishing staff at Globe Pequot Press, thank you.

To my loving family, friends, and all those who've touched my life and career, I thank you, too.

ABOUT THE AUTHOR

Stacy Pearsall enlisted in the US Air Force at age seventeen, and she spent the first four years as a U-2 spy plane intelligence film processor at the US Strategic Command and then the European Command. She entered the Combat Camera Squadron in January 2002. After multiple combat deployments her outstanding portfolio of images earned her top billing from the National Press Photographers Association, Military Photographer of the Year in 2003 and 2007. She is one of only two women to hold the title, and she is the first active duty female to receive the honor. She's the only woman to earn it twice.

Her work has been published in a variety of media, including: *Time* magazine, *Newsweek, New York Times,* CNN, BBC, *LA Times, USA Today, Soldier of Fortune,* PBS's *Operation Homecoming,* and *GQ* magazine's "This is Our War." Collections of her combat photographs have traveled nationwide, and the money raised from the exhibitions has been donated to nonprofit organizations benefiting disabled veterans. She has graced the pages of *Harvard Business Review* and *PINK* magazine, on which she made the cover. PBS and the Air Force Band honored Pearsall as the Air Force Veteran of the Year; the same year, her hometown of Charleston, South Carolina, presented her with the American Hero Award.

After being wounded in action in Baqubah, Iraq, she was medically retired from service. She began advocacy work through programs such as Wounded Warrior Program and Disabled American Veterans, and she is featured in nationwide public service announcements for Veterans Affairs and Real Warriors that are viewed by millions of Americans every day.

She is now the owner/director of the Charleston Center for Photography (www.CCforP.org). Her facility offers photography classes and workshops, youth art programs, photo galleries, photography services, and more. She founded her photography business, F8PJ, after her retirement from service and focuses on military and law enforcement subjects. She continues to travel the world on photography assignments, teaching photography and giving lectures about her experiences.

Stacy began a personal photography endeavor, the Veterans Portrait Project, in Charleston, South Carolina, while she recovered from her combat injuries. While she sat for hours in the waiting room of her local VA hospital, she began to notice the men and women around her. She reached out to hear the stories of veterans from every branch of service, generation, and conflict and felt inspired to bring her camera and take their portraits, leading to the project that now fills the walls of the main Ralph H. Johnson VA Medical Center in Charleston. She continues her project in other states and has amassed hundreds of portraits from WWII and Vietnam War ex-POWs, Pearl Harbor survivors, and Korean War infantrymen to Operation Iraqi Freedom medics and Operation Enduring Freedom Special Forces veterans. She has personally funded the project and, as she looks to continue forward, she hopes others will help support her quest to capture portraits of America's heroes.